Out of the Kitchen

Out of the Kitchen

Adventures of a Food Writer

Jeannette Ferrary

John Daniel & Company
McKinleyville, California, 2004

Portions of some chapters have appeared, in different form, in the *New York Times,* the *San Francisco Chronicle* and *San Francisco Focus Magazine.*

Cover photo: Ferdinand Ferrary / Grandma DeeTee's Kitchen, circa 1942

Book design & typography: Studio E Books, Santa Barbara CA

Published by John Daniel & Company
A division of Daniel and Daniel, Publishers, Inc.
Post Office Box 2790
McKinleyville, CA 95519
www.danielpublishing.com

LIBRARY OF CONGRESS CATALOGING-IN-PUBLICATION DATA
Ferrary, Jeannette, (date)
 Out of the kitchen : adventures of a food writer / by Jeannette Ferrary.
 p. cm.
 ISBN 1-880284-78-2 (pbk. : alk. paper)
 1. Ferrary, Jeannette, (date) 2 Food writers—United States—Biography. I. Title.
TX649.F47A3 2004
641.3'0092—dc22
 2003025774

To my dining companions,
Peter and Natasha

L'chaim

AUTHOR'S NOTE

Much of this book would still be in the procrastination stage were it not for the more or less regular monthly meetings of my writers' group. Thanks to Faye Bremond, Janice Sweeney and Wendy Witt for their adroit criticism, unwavering support and really good snacks. As the chapters in this book demonstrate, I owe much to many for their wisdom, good company and advice in and out of the kitchen: my profound gratitude to my dear friend, writing partner and co-author of six cookbooks, Louise Fizer; to M.F.K. Fisher, Julia Child and Margot Slade of the *New York Times* for their always-encouraging words; to Fred Hill and Jane Dystel for their lock-and-load sense and sensibilities; to John Daniel and Susan Daniel for guiding this book through with elegance and wit; to my mother, Loretta, for her inability to find fault with anything done by a family member; to my father, who found the world full of interesting things and passed it on; to my brothers Ferd, Rich and Matt, who always made everything fun, and still do; and to Peter and Natasha for the meals, the movies and the best years of our lives.

"Occasionally we were taken to Chinese restaurants or Italian pizza parlors. We were introduced to Hungarian goulash and Irish stew. Through food we learned that there were other people in the world."

—Maya Angelou
I Know Why the Caged Bird Sings

"The nectar is in the journey, not in the goal."

—John J. McDermott

Contents

Preface

"WHY DON'T YOU COME FOR LUNCH?" Julia Child chanted into the phone in her sing-song warble. "Around one o'clock."

"Fine," I said. "Whatever's good for you."

I immediately checked a bunch of Santa Barbara websites for information about hotels near her home. I would drive down the day before—it was a five-hour journey from my home near San Francisco—so I'd have to spend at least one night. By carefully negotiating some online maps, I located her street and traced it with my finger. What would it be like, I wondered, an "assisted living community," as someone had described it. She'd just sold her home in Cambridge, Massachusetts, donated her kitchen to the Smithsonian, and was still in the process of moving.

When I read that she was moving to my neighborhood—well, driving five hours is better than flying cross country—I was in the midst of writing the chapters for this book in which she played an important part. I'd first met Julia Child in 1978 at a party at Simone Beck's in Grasse, France, where I'd enrolled in a cooking course at L'Ecole des Trois Gourmandes. Julia and Simone were next door neighbors. On several occasions after that, I had the opportunity to enjoy her presence, once at an informal lunch with her and her sister prior to an interview I conducted; another time "helping" her chop garlic for a cooking demo/book signing; also at a dinner with René Verdun in his San Francisco restaurant; and once wandering with her through the kitchenware department at Macy's. Most of these meetings were in conjunction with articles I was writing about her appearances, her activities, her overall impact. She always responded

to the publication of my articles with personal notes or letters which were complimentary, encouraging and gracious. Naturally I kept them all.

It was while rereading them for this book that I felt an overwhelming desire to see her again, and soon. We exchanged letters, we chatted at the opening of Copia, and the next thing I knew, I found myself driving to Santa Barbara. It was a Friday, January 11, 2002.

The big wooden door to her home was wide open. I could see through the screen door a living room filled with golden Santa Barbara sunlight and lined, at the far end, with the telltale cardboard boxes of a person in transit. I knocked. I called her name. Where was she? I said Julia, with a question mark at the end. Again. Should I open the door? I could just barely see another room to the right, a bedroom perhaps. And then, suddenly, a fluff of apricot colored hair.

"Julia? It's Jeannette. Julia?"

"Oh, yes, hello. Hello, Jeannette," came the response, full of color and bluster, a bit breathy. "Come in."

We exchanged hugs and highway driving conditions, weather reports.

Where did you park?

Just where you told me not to.

Well, you can't stay there.

It made no difference since I had to get the car to drive us to lunch anyway. We had clam chowder and salads and freshly squeezed lemonade. Mostly we talked about the food world: how delightful Nigella Lawson's program is, even though you can tell by the way she chops garlic and things "she's not professionally trained"; how you'd never know from the Norman seriousness of Simone Beck's expression (I had brought along my pictures) that she was a wild driver, especially "the way she tooled around the Arc de Triomphe"; how generous the Mondavis are compared to that "other family" who put so many conditions on their educational contributions nobody can accept them.

After lunch she asked if I would drive by the condominium where she and Paul used to live before she moved to her present

home. It was just down the road. As I pulled into the driveway, a stern-faced woman in an official-looking uniform emerged from a little fortressy structure at the entrance to the grounds.

"We'd just like to drive around for a few minutes. She used to live here," I said.

The guard's eyes narrowed, focused on my face in preparation for the inevitable lecture, and then moved on to my passenger. Instantly a softness fluttered across every feature and suffused every syllable of her body language.

"Oh yes, of course, of course. I know who you are. Take your time."

Lined with palm trees and big floppy ferns, the curving roadway led through a sun-splashed green paradise, very much like her current residence. At the end was a little hill with some buildings on top.

"That was our place. Not very big or luxurious, but very comfortable."

I felt like crying. I felt privileged.

"Look at all those new places there. They've built them since. You used to be able to see clear to the water." The water was still there, glinting with silver-blue ruffles, but you could only glimpse it through the spaces between the buildings.

I turned around.

As we approached the guard shack, there were now two people smiling in anticipation.

"Did you find everything all right?"

"Does it look any different from when you lived here?"

Obviously any question they could think of to stop us was fair game. They came over to the car and asked even more. They were thrilled to be talking to Julia Child, to have her answer their very own inane questions, smiling all the way. That voice: they loved every arpeggio, every crinkly note.

They paid no attention to me, except to hope that I'd keep my foot off the accelerator until they had their fill of her. I was used to that role, of course, being a writer. I've always been the one gathering the information, conducting the research, tasting, testing, playing

the scribe. That's how I've found myself spending evenings with Joseph Heller and with Craig Claiborne; having lunch in the Central Park boathouse with Mimi Sheraton and Raymond Sokolov; sitting across from James Beard in his hotel room, amazed that Levis made jeans that big; making bilingual puns with my dining companion, the Baroness de Rothschild; accompanying Bryan Miller and Molly O'Neill on restaurant reviews in San Francisco; spending the afternoon in an empty French Laundry with Thomas Keller; hanging out with M.F.K. Fisher, with Jane and Michael Stern, with Jacques Pepin; writing a regular monthly food column from California for the *New York Times*.

As I drove away from the guard shack, I could see the two women in my rear view mirror staring after us. I knew what they were thinking.

"Who the hell is she?"

A good question. It's the kind of thing that, if you're a writer, you could write a whole book about.

Out of the Kitchen

The Turkey

BECAUSE I'VE SPENT A LARGE PART of my life as a food writer, people are often surprised to learn that when I got married in the mid-1960s, I knew absolutely nothing about cooking. One person who would not be surprised at this revelation is the man I married at the time, although he would, I'm sure, prefer to leave his memories of those early attempted-meals unvisited. The situation was this: we'd gotten married in Connecticut and driven to California, where he was about to start graduate school at Stanford. We'd left behind, in more ways than we ever dreamed, our families, family recipes, and any stray cooking tips that might otherwise have made their way into the bride's kitchen.

Which was fine with me.

I wasn't at all interested in cooking, although I realized that, according to some ancient wisdom, the wife of the graduate student did the meals. I took this as a challenge.

An intelligent person, I reasoned, should be able to churn out one dinner per day, which was the most anyone could reasonably expect, without the bother of learning how to cook. All the measuring and stirring, the watching and the waiting, was a big waste of time, a lot of fuss that women got themselves involved in when they had nothing better to do. Whereas other incipient cooks might have been watching Julia Child on television to hone their skills, my inspiration came from "Beat the Clock." When I discovered *The I Hate to Cook Book*, by Peg Bracken, a kindred spirit if there ever was one, I wept.

In one of my early forays to the grocery store—All-American

Markets on El Camino Real in Palo Alto—I discovered a foil packet printed with the words Tuna Noodle Casserole over a luscious looking picture of same. Being so little experienced in culinary matters, I did not find it impossible to imagine that the powdery contents of this flat square package could, with the addition of a bit of liquid, expand into the three dimensional tuna-noodle casserole depicted on the packet. After all, there were flat sponges that became thick and dense when soaked in water for only an instant. It was worth a try.

No sooner did I get the tuna noodle mix home, however, than I realized that it did, in fact, require the addition of some other ingredients, namely, tuna and noodles. My anger at what I considered false advertising dissipated completely the first time I actually followed the directions and produced the dish. It was so delicious that I decided to make it at least once a week, which left only six other days to worry about. My mother suggested that I crush potato chips over the top, which did add a certain *je ne sais quoi*, especially around the seventh week; however, I tried to resist introducing such little flourishes, which seemed innocent enough but could easily sucker one into the trap of home cooking, a kind of domino effect which would soon find you gussying up each dish with time-consuming extras.

And then one week, to my amazement, the casserole tasted significantly different although I had prepared it exactly the same way. That my husband first detected the nuance was obvious from the not-exactly-delighted look on his face. "Did you," he began haltingly, being ever the soul of tact, "did you, by any chance, forget the tuna?" I was insulted.

I may not have known how to cook, but I did know how to count and, since there were only three ingredients, I didn't see how I could have miscalculated. Nevertheless, I had to admit that tuna was the solution to The Case of the Missing Ingredient. Looking at the bright side, I ascribed this oversight to my growing sense of confidence in the kitchen. So when Thanksgiving came around, I felt ready.

A grad student friend of my husband's, possibly in response to some complaint I hadn't been privy to directly, had given me a

paperback copy of *The Fannie Farmer Cookbook* which I had, to the best of my ability, ignored. It contained complete directions on cooking turkeys including making stuffing and gravy and the other Thanksgiving requirements. Besides knowing how to count, I could also read, which I felt certain was all I needed to know to whip up a traditional Thanksgiving dinner. In fact, all went well until the moment I had to put the stuffed and trussed and prettily paprikaed bird in the oven. The directions said to roast the turkey at 325 for three and a half hours, just enough time before the guests were due to arrive. But when I went to turn on the oven, with which admittedly I hadn't spent much time, I went into an immediate panic. The dial with the numbers was fine: I easily found the 325 position. But the other dial displayed only two options, Broil or Bake; as far as I could see, there were no other dials. To my horror, I realized we had an oven that didn't roast. That's what happens when you wind up in student housing, I thought, but it was no consolation with only three plus hours to go. All those relatives with their previously unwanted cooking tips were back East, so there was no one around to ask about this catastrophe.

Frantically I began rummaging through the apartment for the dictionary—maybe if I looked up the word roast I could find the secret directions—when I caught sight of the telephone. I decided to call Information; I mean, why the hell not?

The operator, although she was a woman, was almost certainly not a feminist. Even though I explained the problem calmly and succinctly—that I had an oven that didn't roast and did she have any suggestions—her response was less than sympathetic. In fact she sounded downright suspicious, as if this was some sort of crank call.

"I'm not authorized to answer that question," she informed me. "I'll have to turn your call over to my supervisor."

I realize now that it's possible that this operator was the only other person on the face of the earth who didn't know what roast meant, but at that time I felt annoyed. I had a sneaky feeling that her supervisor wasn't going to be a big help either, so after a minute or two, I hung up. Then I remembered Miss Thane.

Miss Thane was a schoolteacher who lived in the apartment next

door. She was always very friendly and cheery and aunt-like in her blue print dresses and blue-gray hair. Maybe she had a stove that could roast; I only needed it for three and a half hours. It was worth a try. I knocked on her door.

About twenty years after Miss Thane opened that door and answered my question, I was writing a regular monthly column about food for the *New York Times*, I had published the first of my six cookbooks with Simon & Schuster, I was the restaurant reviewer for *San Francisco Focus* magazine, and I was writing a book about this country's preeminent food writer, M.F.K. Fisher, who had become a dear friend of mine.

I'm sure Miss Thane, who has probably told this same story at many an amused Thanksgiving gathering, would be amazed and perplexed at such a career path. I know at least one ex-husband who probably feels likewise. There must have been something way back somewhere, there must have been seeds that eventually flowered into a passion for food, its history and meanings and unending pleasures; the joy of growing and preparing and sharing food with friends, of seeing it as heritage and comfort and love.

There must have been something.

That's what this book is about.

Beginner's Roast Turkey

INGREDIENTS
 1 turkey, 14 to 16 pounds
 olive oil
 paprika
 salt and pepper

1. Look inside the turkey. God knows why, but sometimes they put a lot of stuff in there that you don't need and don't even want to look at. Throw all that stuff away.

2. Rub olive oil all over the turkey and sprinkle it, inside and out, with salt and pepper. Rub paprika into the skin.

3. Find the setting on the oven that says Bake. It means the same as Roast. Trust me. Set the oven for 325.

4. Put the turkey on a rack in the big pan that's probably been sitting in the oven since you rented the place.

5. Put the turkey in the oven for about an hour or so, which will give you time to go to the hardware store, ask the guy what a baster is, and buy one.

6. Come back and baste the turkey every half hour or so. The whole ordeal takes about 3½ hours, just so you know.

I. Once Upon a Time, in Brooklyn

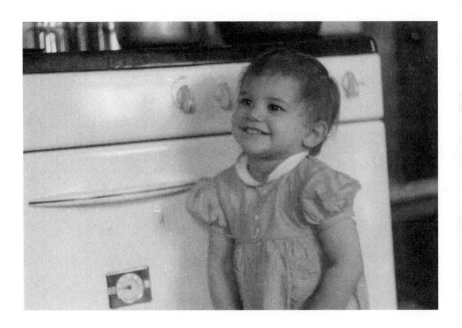

The Strawberry Gumdrop

MY EARLIEST FOOD MEMORY IS a strawberry gumdrop, and a pretty big strawberry gumdrop at that. I don't remember what it looked like or tasted like or even if I actually ate it. I only remember what it meant: it meant I was smart, a clever little girl, only about two years old, but canny enough to outfox her parents.

I had a cold, or something that wouldn't have been very important except that I was an only child at the time, it being at least a year prior to the avalanche of brothers to follow. Actually there were only two brothers, Ferdy and Richie, for quite awhile and then, when we three least expected it, another brother, Matthew, arrived just as we were all graduating, marrying and generally leaving home. So he was raised almost as an only child with all the perks and undivided attention that I was experiencing that day, the day of the strawberry gumdrop.

There was a pill involved. My parents were supposed to give me the pill and I was supposed to swallow it. The fact that I was completely uninterested in participating in this process suggests that I was simply your normal, everyday Terrible Two resisting parental authority at every turn. Suggestions that I hold my nose and just gulp it down only reinforced my suspicions. What did holding my nose have to do with it, I wondered, though I didn't ask.

No advanced brain power was needed to decipher their next subterfuge since every child is born with the preternatural knowledge that some day his or her parent will crush a pill into his or her orange juice and try to act as if nothing is going on. They will simply whistle and do the crossword puzzle and put the dishes in the sink, all the

while keeping one unblinking eye fixed on your every move until you finish the orange juice with the pill crushed in it, which you don't.

Enter the gumdrop.

Although I can't be sure from this distance, I undoubtedly sensed that my behavior that day hadn't been the kind that won pats on the head, or a trip to the swings and the monkey bars in the little park around the corner. So why, I wondered, was I suddenly being offered a big, juicy gumdrop by not one but two parents with the over-eager smiles that would put any child instantly on the alert. They were handing the candy to me, but they were holding on to it at the same time, as if they expected me to sit there like a baby robin ready to snap up whatever was being popped into her mouth. As I moved my head to examine the candy more closely, particularly the part facing them, it automatically revolved the same number of degrees in its own orbit. The part that was facing them, the dark side of the moon as it were, remained in shadow. Obviously there was something to investigate before committing myself to this gumdrop.

My hesitation was all they needed to confirm their as yet unsubstantiated theory that indeed they had a precocious child on their hands. My mother rolled her blue eyes in blatant admiration and my father returned the sentiment.

"She knows," their eyes were saying. "She's too smart for us. We can't fool her. She's figured out that we've hidden the pill in the gumdrop."

Instead of being angry with me for my stubbornness and lack of cooperation, they were congratulating me on my powers of perception. It is possible that, as with so many memories, I wasn't fully aware of these ramifications at the time. But the story was repeated so often as proof of the prodigy-level intelligence of the first-born that I came to remember it vividly in all its flattering detail.

By now I have used food myself to lure, to seduce, to cajole, to comfort and, yes, to distract. Most of the time it works, even on the smartest people. But I've never tried it with gumdrops. They always seemed so obvious.

Double-Strawberry Shortcake

Strawberry shortcake should be easier to make than it is. You can buy those squishy, spongy, cup-shaped things and plop strawberries on top, but that's just a waste of good strawberries. Not only that, but it isn't even strawberry shortcake. So if you really want strawberry shortcake, put the crossword puzzle down, go get all the stuff and come back and do it this way. It'll take awhile; don't say I didn't warn you.

INGREDIENTS

Shortcake

2 cups flour

½ teaspoon salt

1 tablespoon baking powder

3 tablespoons sugar

2 teaspoons grated lemon zest

¼ cup cold sweet butter cut into small pieces,
 plus 2 tablespoons melted

¾ cup heavy cream

Filling

1 20 ounce package frozen strawberries, thawed

2 tablespoons sugar

1 tablespoon lemon juice

1 tablespoon framboise or other liqueur

2 pints fresh strawberries, hulled and halved

1½ cups heavy cream, whipped, or plain yogurt

FOR SHORTCAKE

1. Preheat oven to 450 degrees and grease a cookie sheet.

2. In a bowl, mix flour, salt, baking powder, sugar and lemon zest. Cut in ¼ cup butter piece by piece until mixture resembles cornmeal. Add cream and mix until dough holds together.

3. Turn dough out onto a floured surface, knead lightly a few minutes and roll dough out to ½ inch thickness. With a 3-inch cookie cutter, cut 6 rounds.

4. Place rounds on cookie sheet and brush with melted butter.

5. Bake about 12 minutes or until golden. Let cool and split each round in half horizontally.

FOR FILLING:

1. In processor, puree frozen strawberries with sugar, lemon juice and liqueur. Pour over fresh strawberries and stir to mix.

2. Place a shortcake half on each plate, cover with strawberries and top with other shortcake half. Surround with additional strawberries and garnish with whipped cream or yogurt.

The Power

I WAS THREE WHEN WE MOVED TO 538 East 37th Street in Brook-
lyn, a block away from the borough's famous Holy Cross Cemetery.
The morning after we moved into the house, I stood on the top step
of our stoop looking down the street. I could just see the skinny iron
spikes that surrounded the gravestone-studded grounds like a black
picket fence, ominous and forbidding. I wouldn't go near the place
even if my mother hadn't said, "Stay right in front of the house"
when she finally relented to my persistent begging and let me go
downstairs to play. She gave me my tin pail with the pictures of fish
on it and my red metal shovel, slightly scratched from all the hours
I'd put in in the sandbox near the goldfish pond behind the house in
Wallingford, Connecticut we'd just moved from. I don't know what
she was thinking of since there wasn't a speck of sand in Brooklyn as
far as I could see, except maybe the dirt path down by the cemetery.
But then again, she hadn't been thinking straight ever since my new
baby brother had been born a few months previous. He was nice and
all that, but he was definitely detracting from the undivided atten-
tion to which I'd become accustomed.

"Call me when you want to come in," my mother told me. "I'll
be right here with the baby." As if I didn't know.

It was a pretty nice street with several two-family houses just like
ours, made of pebbly stucco and brown shingles with red brick
stoops in front. It wasn't all that different from Wallingford except
that instead of gravel and grass there was a sidewalk made of big ce-
ment squares between which grew narrow snakes of velvety green
moss. With the aid of my shovel, I could loosen the dirt and pull up
ribbons of moss in long, unbroken lengths. At least it was something

to do. There was no one to play with, but there was a lot of sidewalk out there. I continued with my work, ever wary of the Holy Cross Cemetery looming at the end of the street.

I had accumulated several impressively continuous moss strings when I suddenly became aware of someone watching me. I raised my head slowly and got up. He was exactly my height.

"Hi," he said. "I'm Billy Shehee. Whatcha doin'?"

Freckles sprinkled his nose and chin, his cheeks were rosy and his lips looked shiny, as if he'd been licking a strawberry lollipop. His blue eyes were the same color as the sky behind him and his lashes were so black they looked wet. He was beautiful. We didn't have boys like that back in Wallingford, but then I'd never before been allowed to roam the streets like this. The only boys I'd ever met were the children of my parents' friends, or they were cousins. My new brother, needless to say, didn't count.

I showed him my moss. I even offered him half of it, but he said he had some. He got it out of his driveway between his house and the house next door. It was a secret place, but he'd show it to me sometime, he promised. His best friend was Frankie, he told me; Frankie had a goldfish but it wasn't in a pond. He never heard of Connecticut but he kept trying to pronounce it. I took that as a sign that he cared. He said he actually played in the cemetery sometimes, and when I looked shocked he said he could prove it. "I climbed the big tree and picked a bunch of horse chestnuts," he said. He'd just strung one of them on an old shoelace, but it was home; he'd go get it, he said. And then, he was gone.

I stood there for a few seconds, giddy from my first encounter of this kind; and then I picked up my pail and started to walk home. Only then did I realize I didn't know which house was mine. Somewhere up on the second floor of one of the two-family houses was my mother, undoubtedly shaking the blue plastic rattle over my brother's button nose, tickling his tummy, forgetting about all previously born children in the family. Maybe I'll go play in the cemetery with Billy Shehee, I thought angrily, forgetting he'd already run off.

I dropped my pail, moss and all, and started running down the sidewalk. Nothing looked familiar. Was I even on the right street, I

wondered, on the verge of tears. Suddenly my toe got stuck in a gaping crack in the pavement from which moss had recently been removed and I tumbled over, landing with a thud. I didn't even hear the window open above me as I examined my knees, both of which were covered with needle-thin streaks of blood and a few grains of the only sand in Brooklyn. I heard a window open.

"What are you doing down there? Are you ready to come up?"

I certainly didn't want to admit, after all my peskiness about going out to play, that I'd gotten lost just standing in front of my own house. Nor was I ready to concede that all I wanted was to go back upstairs. But there had to be a way. It's miserable when you're three and you're trying to save face and you don't know how to manipulate the situation.

"Are you hungry?"

To be honest, I can't say with absolute certainty this was the exact moment that I understood the significance of that question. But it was definitely around this time that I learned something about the power of food, especially with respect to mothers. If you say you're hungry, they (mothers) have to say "O.K. Come on upstairs and have your lunch now." They might even say it will be the red soup with the square carrots and alphabet noodles in it, but don't expect miracles. If you hobble into the kitchen, they will also notice your skinned knees and put Mercurochrome on them and cover them with new white Band-Aids. In other words, if you say you're hungry they have to pay attention. New little baby brothers notwithstanding.

Canned Alphabet Soup

Canned soup is easy, fast, tasty, and one of the worst things you can eat. It's full of salt, the vegetables have no nutrition left after what they've been through, the noodles as soggy as wet Kleenex. But if you don't know any better, here's what to do.

1. Buy the least horrible soup you can find.

2. Read the directions. There aren't many of them; that's the point.

3. Add something like Tabasco sauce or a squeeze of lemon. It can't hurt.

The Kitchen

THE KITCHEN IN OUR HOUSE AT 538 East 37th Street was a long rectangle, more like a hallway than a room. Along one of the long walls, a wooden highchair was semi-permanently installed next to the double sink, one side of which was deep enough for the washboard my mother used on a daily basis trying to keep up with the sartorial requirements of the two, then three, of us kids. (Hence the highchair.) Next to the sink, an old fashioned, rickety-looking stove with a side-by-side tiny oven sat on its spindly legs beside the window. In a way, the window was the kitchen's most attractive feature (as in attractive nuisance) because if we hung halfway out we could see the coal truck backing into the alley in its grumbly fashion and watch the glistening black chunks crash their way down the sliding pond (as we called it) into the coal bin in the cellar. Since we lived on the second floor, leaning over the window ledge offered an element of danger, significantly augmenting the excitement. In fact, if we hung out far enough the din was so loud we couldn't hear our mother yelling at us to come away from the window before we killed ourselves.

That spirit of adventure wasn't the window's only romantic quality, however; it also served as a connection to Billy Shehee, the boy next door, who I was in love with even before I knew he could make walkie-talkies out of milk cartons. This he accomplished by tying a long piece of string to two cartons, one of which he gave to me. By burying our faces in the carton and screaming at the top our lungs, we could send secret messages to each other across the alley whenever we wanted, although the system always worked better in the summer when the windows were open.

Across from the sink was a red metal table and four, then five, kitchen chairs covered in shiny red vinyl. Perhaps the landlord or some former tenants knew why there was a narrow foot-long shelf protruding from the wall above the table, but my mother used it for the grape jelly jars that became juice glasses, and my father used it to screw on the small electric fan that whirred away futilely during hot summer meals. A large built-in cabinet held the cereal boxes, the towels, the red-handled flatware, and eventually the complete set of unbreakable melmac dishes that my father bought because they represented some sort of scientific breakthrough in plastics technology. Indeed they had more of a better-living-through-chemistry appeal than any aesthetic value. As in all advanced Brooklyn households, the broomholder was installed behind the kitchen door.

The refrigerator was a big, white, round-shouldered Norge with a pullout bin for potatoes at its base. Its freezer compartment could easily accommodate two ice-cube trays or, when even further scientific breakthroughs came along, one ice-cube tray and a box of Birds Eye frozen peas. As for my mother, her favorite kitchen appliance rested on top of the Norge. It was the boxy brown plastic Zenith radio set on its own crocheted red and white diamond-pattern doily.

Although logic dictates that there were other programs on the air, whenever my mother turned on the radio, it was "Arthur Godfrey Time." He was always chuckling about something in his craggy-voiced way or commenting about matters that held no interest for children waiting for Fig Newtons, or introducing guests who sang too much like opera singers. The only other thing he did with astonishing regularity was talk about Lipton tea, which was the same thing as tea for all I knew. Every once in a while my mother would make herself a cup of Lipton tea and sit down and drink it. As far as any of us can remember, this was the only thing she ever did for herself in all of our childhoods put together. Whatever else it was, Lipton tea was not a joking matter. No one ever pointed out that although the melmac never broke, it eventually became indelibly stained, thanks to Lipton tea.

One day as I was doodling and scribbling and drawing as I always was, I wrote, "If you agree with me, you'll agree with Lipton tea."

My mother, who was usually standing by the highchair removing Pablum from my brother Richie's ears, turned around when I recited the words aloud. She asked me if I made that up all by myself, and when I said yes she made a big fuss about it. She came over to look at the page and said it was smarter than anything they said on the program and that I should copy it over and send it to Arthur Godfrey. Himself. By then Richie was putting the finishing touches on a full head of Pablum and yet Mom was still all excited about my jingle, as she called it. She helped me address the envelope—I couldn't believe that an ordinary, everyday person could actually send a letter to Arthur Godfrey.

I don't know if my mother thought he would write back, but I noticed she did run downstairs every day when the mailman came. Even I listened more attentively to "Arthur Godfrey Time" to hear my jingle, just in case he used it, and to hear him announce to the whole world that it was the work of a seven-year-old girl in Brooklyn.

It seemed like years had gone by when, finally, the mailman slipped a little square envelope, addressed to me, through the slot in the front door. Before we even got up the stairs, Mom noticed the name Arthur Godfrey on the flap. She was almost more excited than I was, but she let me open the letter myself. Inside was a short thank you note signed by Arthur Godfrey. Himself. It was a great moment, a brush with fame and celebrity, a taste of stardom. Before the night was over, the whole family, down to the smallest cousin, knew about it. I conveyed the message across the alley via walkie-talkie.

I'm not sure if Arthur Godfrey really said my jingle was better than anything anybody ever thought up at the Lipton Company, but I remember my mother saying something along those lines. Come to think of it, Arthur Godfrey's reply may have been a form letter, though my mother never mentioned it, not that I would have known about such things. And my jingle may have been the first feeble scratches of a career in food writing; but that isn't the important thing. The fact that I had taken on Arthur Godfrey Himself and, at least in my mother's eyes, beaten him at his own game: That was the important thing.

Tea For Two,
When One of Them Is a Child

INGREDIENTS
 1 teabag (money doesn't grow on trees)
 boiling water
 milk
 sugar

1. Put teabag in child's cup and pour in boiling water until it reaches nowhere near the top.

2. When the liquid turns a tinge browner than clear, remove teabag and put it in grownup's cup.

3. Fill up remaining space in child's cup with the coldest possible milk.

4. Talk about how sugar rots out your teeth if you use too much when you're a kid.

The Broomholder

MY FATHER INVENTED THE BROOMHOLDER. It was a piece of aluminum that curved around a ball bearing, and it came in a little cardboard box with two screws, the whole thing no larger than a bar of Ivory soap. Spare, streamlined, its corners rounded and smooth, it was a tight, elegant design that did what it did and nothing else. With the screws, you attached the broomholder to the wall behind the kitchen door. That was where everybody in Brooklyn kept their brooms during the heyday of the broomholder, which was the late 1940s, early '50s.

Actually Brooklyn was probably the wrong place to try to sell broomholders because most people didn't go in for fancy schmancy. You had a broom, you leaned it against the wall behind the kitchen door. If it slid out and slammed down in the middle of the kitchen floor, so you picked it up and put it back. What was the big deal? You weren't going to go out and spend two, three dollars on a nest for your broom, of all things, only to then have a fight with the landlord about putting screw holes in the wall. Which is why our father's 1941 Chevrolet, which was gradually rusting away, was never kept in the garage. The garage was full of broomholders.

I don't know what the other kids' fathers did, but I did know that my father was the only inventor on our block, which was East 37th Street between Clarendon and Cortelyou. And I knew that inventors were great because we had to memorize their names in school: Eli Whitney, Cyrus McCormick, Robert Fulton and, of course, Thomas Edison. Not only that but my father subscribed to *Popular Science* in which there was a monthly feature, "I'd Like To See Them Make," about things people wanted invented.

And so when people asked me the dreaded, relentless question of childhood, I had my answer, at least for a while: when I grew up, I was going to be an inventor. Fame, immortality, gratitude from the masses would be mine; and as if that weren't enough there was yet another incentive.

My father studied engineering at MIT in an almost all-male class in an almost all-male school. The one female student in his class was constantly surrounded by men carrying her books, doing her homework for her, vying for her attention. That clinched it for me.

And then one day my Aunt Julia gave me a camera. It was called a Brownie Hawkeye, a sleek black box that you looked in from above. It seemed much more professional than the cameras you held up to your eye to look through. It wasn't a kid's camera because they hadn't been invented quite yet. Before long I imagined myself a famous photographer, taking pictures for *Look* and *Life* magazines. I looked forward to someday developing my own photos in the darkroom my father had set up in my grandparents' basement. Even my father was impressed with my change in career goals, though he secretly may have regretted losing an inventor in the family. One night I was in my bedroom at the end of the hallway trying desperately to avoid going to sleep. I could hear the murmur of my parents' voices as they sat having tea at the red metal kitchen table. When I heard my name, I tiptoed over to the doorway.

"Maybe we should get her a good camera," my father was saying. "She seems really interested in photography."

I felt a definite thrill being the topic of their conversation and also at being taken seriously. I was the oldest of the three of us, but still I was only eight. Even from down the hallway, I could hear the hesitation in my mother's voice. Maybe she was just taking a sip of her tea, but I sensed something else. I crept closer to the crack in the almost closed door.

"Oh, you know her, Ferd," she said, lowering her voice slightly because she knew I never went to sleep until I was numb. "She's interested this week, but next week it will be something else."

I felt angry. Here I had gone and done something that got my

father's attention and she was dismissing it as a passing fancy. On the other hand I knew she was right.

In a way, it was a relief. Whatever I decided to do I could change my mind the next week and nobody would be shocked. I could make changing careers a way of life. Besides, I was a girl, wasn't I? And I knew what that meant: it meant that it didn't really make any difference anyway. A girl was going to get married and have babies and take care of the house. A girl was going to cook. So that was how, at a very early age, I made my only truly firm career choice: cooking was the one thing I wasn't going to do until absolutely necessary.

Recipe for Success

Dad ate green grapes
Mom cleared the table;
I began avoiding the dishes
by asking my father
How come?

How come
cantilever bridges, bevel gears,
macadam roads?
How come
Indo-European language groups,
sundials, the Punic Wars?

Intriguing questions were my goal,
Something to get him into H.G. Wells'
Outline of History.
"It may not be accurate," he'd say as he opened it,
"but it's all here."
(And Mom would start doing the pots.)

"Beware the jabberwock," I'd shout, leading him to
Alice and Wonderland, if I was lucky.
(That was good for the knives and forks.)

Rare indeed were inspirations like:
"Into the valley of death rode six-hundred
what, Dad?"
He'd bring to the table
All the World's Poetry and
(everything else went into the dishpan).

Usually I couldn't keep him interested that long,
especially if he had to end a murder
in the living room
between my brothers.
They not only didn't have to do the dishes,
They didn't have to learn anything.

The Cuisine

IN TERMS OF CUISINE, my mother took inspiration from the fact that there were five of us, and we all had to eat every day, three times a day, no matter what. Her culinary style derived from an Irish childhood that included nine children, all of whom had also shown similar thrice-daily tendencies. Thanks to that background, she understood, in its most profound and urgent meanings, exactly what cooking was: it was her job. She made all our meals, day in and day out, morning, noon and night, week after week, year upon year. She never complained. We never complained. We never talked about it. What was the use?

By some sort of Irish osmosis, we knew instinctively, my brothers and I, exactly what food was all about. Food was to eat. You felt hungry. You went into the kitchen. You expressed the fact that you were hungry and received the appropriate response: Go play outside until supper is ready. What do you think this is? A restaurant?

Life isn't a restaurant. That was one of the Irish things we grew up knowing for sure. Even restaurants weren't restaurants, at least the ones we went to. Usually they were a lot like Woolworth's, with a few booths across from the counter, and they kept up the quality of their hot cheese sandwiches so you could think you were actually eating at home.

"They put out a good spread," my mother would say to her sister Mildred across the table, and both of them nodded with equal expertise. "And you can't beat the price," Mildred added, who, though economy minded, was a stickler for quality. "I see they use the real Velveeta," she'd remark approvingly, "and the thin-sliced baloney."

Thanks to these family-wide standards of excellence, my mother knew what she needed to know without wasting time clipping recipes and searching through cookbooks. She did own a cookbook, a thick, thumb-indexed, green tome full of pictures with a pink and brown cast to them that made them look like the tinted portraits in old photo albums. She didn't need any advice on how to boil a cabbage until it practically disintegrated, or to what degree of hardness one should bake a pork chop. This wisdom was inherent in the reality-based, Irish-style cookery which she'd inherited, and which protected her from being bamboozled into the culinary acrobatics of other taste-driven cuisines. She understood the benefits of non-intimidating presentation, never once making us feel that something was too beautiful to eat. A bowl of succotash, she knew, was a bowl of succotash; it wasn't there to look at.

Nor was there any need for the unexpected; quite the contrary. The roast beef, the ham, the chicken—once she'd organized the sequence of meals, it was immutable. And why not? Doesn't the human soul yearn for the phases of the moon, the inexorable cycles of life: the spaghetti, and then the hot dogs, and then the hamburgers? Nor were our taste buds ever assaulted by the shock of an herb. My mother's cookery was a celebration of the natural and the unadorned. (As Archie Bunker was to put it, years later, "What could be more natural than baloney?")

She believed vegetables were essential, usually defrosting two different kinds per meal. We also had potatoes every night, except when we had sweet potatoes, which happened only twice a year. But even when we had sweet potatoes, we had real potatoes right alongside, just in case. After all, sometimes you're not in the mood for exotic potatoes. My mother understood the importance of variety every once in a while, as long as it didn't become a habit.

Like all the other mothers in our neighborhood, my mother went to Bohacks, around the corner, for all her shopping needs. It was part and parcel of her belief in simplicity: you went to one store, you bought everything you needed in that store. If they didn't have it in Bohacks, as she used to say, who could have it? What's to have? Why drive halfway around the world for some crazy mustard that, when

you find it, they charge you an arm and a leg? If you don't have mustard at home, use some catsup for one day. What's the difference? There was one admissible exception to one-stop shopping, however, and that was Ebinger's Bakery. That was special partly because they wrapped everything up in a green box tied with red-striped string, and because they made Blackout Cake, but mostly because Ebinger's wasn't just around the corner. You had to go there on purpose.

Mom's refreshing emphasis on no-frills food meant that she never got snookered into baking. To spend all day slaving over fancy desserts when you could buy a nice box of glazed doughnuts at Bohacks was sheer folly in her view. Because of that basic tenet, I was understandably concerned one day when I came home from school and found the house smelling like Ebinger's Bakery, the air buttery and sticky sweet. The almost edible sense of anticipation made me feel vaguely uncomfortable, as did the gleam in Mom's eye as she hummed around the little kitchen, peeking into the oven at regular intervals. Finally, a potholder in each hand, she reached in and lifted out a smoldering mass of something.

"Ooooh," she sighed, breathing deeply as she glided from stove to table, like Loretta Young twirling through the doorway in her flarey skirt welcoming you to her television show. This was not Mom's style, but her next moves were even stranger. I stopped eating my after-school allotment of animal crackers and watched in amazement. Covering the steaming hot pan with a large plate, she turned it upside down and began shaking and thumping. Then she wriggled the pan off, a pink-gold glow drifting across the soft, smooth ivory of her face. She didn't exactly say "Voilá" the way my aunt Julia always did at Horn and Hardart's automat, but she might as well have. It was a Voilá moment.

"What do you think?" Mom asked. I could tell by her expectant joyous expression that I was supposed to think better things than I was thinking.

"It's pineapple upside-down cake!" she announced, proceeding to reveal its step by step construction, from the laying down of the pineapple rings and maraschino cherries on the bottom of the pan, to the pouring of the batter, to the final flip over. The brown stickiness all

over the top was not called "gunky yuk"; it was called "caramelized brown sugar," my mother corrected. I couldn't help mentioning that it looked right-side-up to me, despite her insistence to the contrary. It was a thing for grownups, a tapestry woven with colors like umber and ochre, garnet and gold, a labyrinth of curves and furrows. I suspected that Arthur Godfrey had something to do with this great departure from the norm. Maybe Dole pineapple had joined Lipton tea on his list of sponsors, or perhaps someone on his program that day suggested that baking a cake for your family was a good thing to do. It was disconcerting to see Mom duped into baking, especially when this activity had such a profound effect on her personality.

"Have some," she'd coax gently, even at lunch time when we'd never before been urged toward any dessert except the Lorna Doones nobody wanted in the first place.

It was delicious and all that but it made me feel concerned, as if Mom had undergone some sort of Invasion of the Body Snatchers way before there was a movie by that name. I just wanted her to stop smiling and go back to her regular self. Thankfully, she never tried anything like that again.

My mother seldom asked me to help in the kitchen, nor did she attempt to teach me to cook. I learned what I learned just by being there, watching and wincing and knowing that some day, if I wasn't careful, I'd have to do the same damn thing.

Irish Potatoes

You don't have to eat potatoes every day, but you could do worse. These are especially good when you're cooking a big roast of something, which you'd also be doing every day if you were really Irish.

INGREDIENTS
> 5 pounds russet potatoes (the oven's on anyway; why stint?)
> salt and pepper
> a roast already cooking in the oven

1. Cut the potatoes into quarters and sprinkle with salt and pepper.

2. Arrange them around the roast about 2 hours before you're planning to take it out.

3. Baste the potatoes occasionally with the pan juices. Don't bother rummaging around the drawers for the baster you got for the turkey. Just use a spoon.

4. If the potatoes stick to the pan, pry them loose and sprinkle them with the sticky stuff. It's the best part.

The Call of the Wild

THE WAY DOGS CAN HEAR WHISTLES that humans can't detect: that was the way kids responded to the tintinnabulation of the Good Humor ice cream truck. The setting was any summer night in Brooklyn. We would all be sitting at the kitchen table finishing dinner. My father would be poking at the tiny electric fan, which generated more heat and noise than anything resembling the cooling breezes he insisted we'd experience once it was adjusted properly. My mother would be cutting small squares from the large square of Anne Page crumb cake.

The jingling began in the distance, probably from East 38th Street, a block away. If I needed any confirmation that these were indeed the sounds of the Good Humor man, I had only to glance at my brothers' widened eyes, brightening noticeably with anticipation. There was something animal about our reactions: the wriggling of the ears, the bunny-like twitching of the nose, the instinctive search for an escape route out of the kitchen. Time was of the essence. If we didn't get down the stairs and into the street at the precise moment, the Good Humor man would drive away forever, or at least until the following night. Because she hadn't heard the bells—it took a full minute longer for the sound to register in adult ears—my mother assumed the smirk-like smiles of her children indicated a positive interest in crumb cake.

"Is this big enough," she'd ask, lifting a portion onto one of the speckled orange melmac plates reserved for dessert.

And then the begging would begin.

"Oh, Ma. Oh, please Ma, can we get ice cream? Please. Pleeeease!"

It was a chorus, its pathetic intonations registering somewhere between hopelessness and outright tragedy. Even so, our parents turned us down with astonishing regularity, citing economics as often as not: seven cents each, times three, was "nothing to sneeze at," as they put it.

And when they said no, I have to believe in retrospect, they knew not what they did. For by keeping us from tumbling down the stairs and gathering with our friends around the Good Humor truck, they were not merely depriving us of an ice pop; they were denying us our sense of community. There at the beginning of East 37th Street, under the maple tree in front of our house, was the spot where the Good Humor man pulled over, not smack in the middle of the street, but not all the way to the curb either. While the truck was parked there, and while we were telling the happy-faced, white-uniformed Good Humor man which things to get us from his magic freezer, and while we were all mingling together, we, the kids, ruled the earth. It was our time and our place.

No grown-ups were directing us about what to order, or warning that we shouldn't pick the hard chocolate coating off the ice cream pop to eat that first, or advising that we should lick, not bite, the raspberry sherbet ice pop otherwise our teeth would freeze and we'd get a headache. Although we may have been given counsel on these matters before we went tearing out of the house, once we were on the street, we could act as if these were our choices, not their commands. These were our rituals of the feast, our ceremonial foods.

In those moments, we inhabited our own Town Square, constituted our own little agora. With no fear of interference we discussed options: Wodja get? Wanna bite? Trayja. We settled disputes: Upon whose stoop would we play stoop ball? We problem-solved: Brian's big brother Jimmy was the only one tall enough to get the Spaldeen out of the maple tree. We designated authority: Brian would be the one to tell Jimmy to do it. Milling around the Good Humor truck, with its dazzling blue and white logo painted on the side, we were the citizens standing before the flag of our country; but our nation was indivisible only while the Good Humor man stayed put. And we could keep him only so long as we were ordering things; he was

friendly, but he wasn't one for idle chatter. So when we saw Hughie Black from the last house on the block running furiously toward us, holding his seven cents between his fingers, gasping for breath, tears spurting from his eyes because he knew he was too late, we did Hughie's shouting for him: "Wait, wait. Stop. He's coming." It worked, but it was just a postponement of the inevitable.

I hated the sound of the freezer door clanking shut and the shiny chrome handle snapping closed for the last time. I felt wistful watching him, the Lone Ranger jumping on his white horse, a parting tug at the chimes above the steering wheel, a wave. I wondered, despite his assurances, if he'd be back the next night. It could rain. It might be a holiday. He might forget to turn onto East 37th Street. It had happened before; it could happen again. This was my first brush with the Uncertainty Principle and it wasn't a pleasant one. But until I was old enough to cross Clarendon Road all by myself and hang out in the candy store, this was as close as I was going to get to culinary independence.

After-Supper Cake

Crumb cake, pound cake, coffee cake—that's what we had after supper. The best ones were Ann Page, from the A&P, but we liked the ones from Bohacks almost as well. In fact, when the Good Humor man was out of season, we loved them. They were nice, simple, homey things that you could put a scoop of Breyer's ice cream on top of if it was your birthday or something.

INGREDIENTS
 ½ cup butter at room temperature
 1½ cups sugar
 pinch of salt
 5 eggs
 2 cups flour
 1 tablespoon lemon zest
 1 teaspoon vanilla
 1 tablespoon fresh lemon juice

1. Preheat oven to 325 degrees. Grease and flour a 9-inch tube pan with a removable bottom.

2. In a large mixing bowl, cream butter, sugar, and salt.

3. Add eggs one at a time, beating well after each addition, stirring in a bit of the flour after the third egg. Add remaining flour and zest, mixing until well combined. Add vanilla and lemon juice and blend well.

4. Pour batter into prepared pan and bake one hour. Remove from oven, cool in pan on a wire rack for about 15 minutes before inverting pan. Serve with ice cream if it's your birthday or something.

The Candy Store

BERNADETTE KELLY WOULD HAVE BEEN MY FRIEND, anyway, probably. She went to the same school as I did, she played with the same kids, she lived right around the corner on Clarendon Road, between East 37th Street and Brooklyn Ave. But the fact that her house was situated directly across the street from the candy store made her friendship particularly valuable, especially in the early years, while we waited to get old enough to cross Clarendon Road. During those eons, we perched ourselves on her front stoop to observe the enviable comings and goings of slightly larger versions of ourselves whose only achievement was reaching an age that won them permission to travel unaccompanied from one side of the street to the other.

After school and all summer long, they flaunted their relative maturity, flocking into the candy story and buying up all the red licorice hats and Bonomo's Turkish Taffy that we could only dream of. We kept our eyes on the dark doorway, tortured by fears that by the time we were old enough, there would be nothing left. When they emerged, some of the kids were chewing bubble gum and squinting at the tiny comic strips it came wrapped in, some were playing wax harmonicas or biting them in half to sip the thick cherry syrup inside, and the rest of them were wearing big red wax lips that covered their faces from nose to chin. They looked ridiculous and Bernadette and I could hardly wait to do the same thing.

I could never figure out how they could spend so much time in there. When my mother took us to the candy store—when anybody's mother took anybody to the candy store—we were instructed

to order our ice cream cones with chocolate sprinkles (usually *without* chocolate sprinkles) and to "hurry up about it." Dawdling was specifically excluded from the contract, as was any hope of enlarging the scope of parental largesse into the penny candy area. Explorations into the uncharted mysteries of that treat-filled paradise would have to wait until I got old enough. And then, one day, I did.

The red fire alarm box on the corner loomed over my mother as she stood in front of it watching me negotiate my first solo trip across Clarendon Road. I waved to her from the other side, then turned bravely toward the row of dark red brick shops in the middle of which nestled the candy store. I passed the hardware store where they sold nails and masking tape to men; Bohacks grocery store where everything my mother wanted was always on the top shelf so that Mr. Dolan had to grab it with the pincers at the end of a long wand he kept next to his floor-to-ceiling rolling ladder; the butcher shop with the sawdust on the floor and men in red-smeared white aprons and the smell of something going on in there that made you look, every time. Further down was the deli where the display case was so high that Mr. Greenberg couldn't see me and whenever I asked for something he'd shout "What was that, sonny?" reinforcing my suspicion that my voice was too low for a girl; and finally the drug store, dark and foreboding, lined with jars and potions, presided over by a wizard with a monocle who was always measuring things into bottles in the back.

Like all candy stores in Brooklyn, ours had a weather-beaten newsstand in front, its faded red slats peeling to splinters, piled high with copies of the *Brooklyn Eagle*, the *Journal American*, the *Daily News*. A grimy, brown-and green-striped awning jutted out from the time-blackened bricks. It was perfect all right, the crown jewel of Clarendon Road.

When I stepped inside the first time sans a parent, the sense of freedom made me giddy. No voice was hovering overhead chanting "Gum? Didn't you hear what the dentist said?" or "Put that back; you've had enough chocolate for one day." When I reached for a jawbreaker the size of a ping-pong ball, no vocal accompaniment rang out, no chorus of warnings and litany of consequences. Embold-

ened, I approached the alcove fitted with laddered glass shelves on which sat boxes filled with penny candies.

The air was delicious with cinnamon and spearmint wafting off the tiny red hearts and sugar-silvered leaves. The scent of licorice and peanut butter, lime and orange fluttered toward me, a fantasy of un-censored sweetness, a new, rule-free universe in which I could breathe in butterscotch and caramel and strawberry. The dime I brought with me, my week's allowance for helping with the dishes, entitled me to choices, ten decisions if I remained in the penny can-dy area, fewer if I aspired to such riches as Clark Bars and Chuckles, Necco Wafers and Chiclets over in the five-cent-bar realm. A cherry coke would still leave me change enough for a two-pack of Mary Janes, so chewy and nutty I didn't care about their pulling the molars right out of my mouth some day, especially since no one was there to remind me. Later there might be questions, judgments made, hands thrown up in the air. But for the moment anyway, I was in charge. I was beginning to see that the candy store wasn't just snacks and sug-ary nonessentials. It was the dessert course, writ large: you could stop eating all the things you didn't want in the first place and start col-lecting your reward. The candy store was the treat and nothing but the treat.

The delights of the candy store were tailored to children and, more important, they were ludicrous for adults. The paper strips em-bedded with raised hills of pastel-colored sugar, they were edible to-pography for young lips and teeth, a playground for the mouth; primitive as papyrus, inscrutable to the elders. Nor would any adult be tempted by thumb-sized wax bottles filled with grape-flavored syrup: biting off the top, throwing your head back, sucking out the liquid were just not grown-up things to do. And though parents ate licorice, they didn't eat it in the form of black tubes coiled into Sher-lock Holmes pipes with flame-colored sugar dots in the bowl. Our postprandial cigarettes were not always chocolate; sometimes they were glistening columns of white sugar with pink tips. Bernadette and I took them over to her house to "smoke" on her stoop because sometimes Judy Bargman's father, who was very handsome, would be coming home from work and would go "out of his way" to scold

us about how cigarettes would stunt our growth. When he went out of his way, we knew we were getting somewhere.

Whenever Bernadette or I saved up a few pennies, we ran across Clarendon Road to the candy store. Sometimes we indulged in delayed gratification by stopping at the racks and thumbing through comic books (*Superboy, Plastic Man*) or peering enviously at the zippered pencil cases and the big boxes of tiered Crayolas that nobody's parents ever bought them even though they were the only source of colors like Flesh, Gold, and Silver, not to mention Burnt Sienna. Sometimes we shared an egg cream or a lime rickey or a mell-o-roll. We stayed in the candy store as long as we could, knowing that eventually Billy Shehee would wander in with Frankie Clifford and Brian Ganley; and Pat Thorne would mope her way over with or without the Cusack triplets, Jean, Jane and Joan. Within those walls, we escaped the identities assigned to us and coalesced into a society of peers. The land of the candy store was our land. It was our amusement park, our clubhouse, our bar and grill. It was our hardware store and Bohacks, our butcher shop and deli and drugstore. We were still kids; we didn't need a whole row of stores to be happy.

The Music

Something was wrong.

I may have been only eight or nine, but the minute I stepped into my grandparents' house, I sensed it instantly.

My grandmother—DeeTee I called her, a result of my trying, at too early an age, to pronounce her real name, Leonides—my grandmother was not in the kitchen. She wasn't hauling a chicken out of her cauldron-sized, white stock pot or chopping the heads off a cod that she and Gramps had just brought back from the Fulton Fish Market. She wasn't frying smelts with a handful of chopped garlic, or sprinkling cracker meal between the leaves of artichokes, anointing them with olive oil and simmering them with freshly shelled peas till everything melted into the same musky sweetness. Nor was she in the dining room piling a batch of her toast-brown honey-soaked fritters into the blue and ivory Wedgwood bowl on the sideboard.

I noticed, beyond the massive mahogany dinner table, that the French doors to the living room, which were always securely locked whenever grandchildren were imminent, looked slightly ajar. My grandfather had long ago varnished the amber-red, cherrywood doors and polished them to a mirror finish. So I could see my puzzled expression reflected in the wood as I pushed gently on the crystal doorknob. There on the piano bench, her hands poised above the keys, sat DeeTee, still in her flowered apron and hairnet. She lowered her hands, and sound thundered into the room, an ominous torrent of low notes that suddenly softened and paused, as if searching for respite. Her fingers danced on the keys, racing up to the friendlier-sounding soprano notes and then reversing course into the dark

mood of the baritone zone. It was frighteningly beautiful; not just the music but also the image of DeeTee, transformed from my pink-faced grandmother with worried eyes focused on her grandchildren's unfinished dinner plates into an impassioned concert pianist, a master of her instrument. I stood there, immobilized by the powerfully beautiful rumble of sound and by this bewildering discovery. And then, without warning, she stopped.

"*Ay, ay, ay, ay,*" she cried, curling her fingers into fists and addressing them angrily in Spanish in a scolding tone she seldom used. And then she saw me.

"*Ay Dios, niña.* You are here since when?" There was such sadness in her cinnamon brown eyes. "You can see, *Dios mio*, I cannot play anymore. My hands. Arthritis."

I'd always noticed that her knuckles were swollen and that all her fingers seemed to curve in different directions. But she never complained or shook them, like she was doing then. She was always rolling out dough, pounding and slicing, carving and chopping. She never did anything but cook; she never sat down; and she certainly never ate anything, though she tasted and grimaced quite often as she tended to all her works-in-progress around the kitchen. Even with arthritis, she was able to do everything she wanted to do. Or so I'd thought, until that day.

As soon as I got home, I told my parents I wanted to take piano lessons.

"But we don't have a piano," my mother pointed out with her customary stranglehold on reality.

I could practice at DeeTee's, I argued; I could stop on my way home from school every day. My father said he'd ask DeeTee and Gramps about it but that I shouldn't get my hopes up. Meanwhile I asked the people down the street for the name of their daughter's piano teacher, and they offered to let me take my lessons on their piano. They said I could practice there also, but I wanted to go to Dee-Tee's and, as it happened, she seemed just as enthusiastic as I.

Knowing DeeTee's strict rule against children in the living room, I half expected that she'd have Gramps move the piano onto the front porch. But then, we weren't allowed in there either, nor were

we supposed to hang out in the dining room. He couldn't very well move the piano into unrestricted areas like the kitchen or his workshop and, as for the basement, I couldn't imagine DeeTee's gleaming, black piano in the company of furnaces and hot water heaters and laundry tubs. So I guess DeeTee had no choice but to permit me entry into the living room, although she always did so with the accompanying words *"ten cuidado,"* which I knew meant "be careful," which I knew meant "don't touch a thing."

Still, it was difficult to resist playing with the tiny glass deer and elephant, or the white bone china swans with bone china flowers on their backs, or the curvy, black satin lampshade with gold fringes. I had to pet the stuffed head of the tiger-skin rug stretched out under the oval-shaped ebony table, but when I ran my fingers over its teeth and its tongue came out in my hands, I reformed.

What I hadn't expected was the food and how my piano lessons soon affected the eating habits of the entire family. When I arrived after school, DeeTee assumed I'd be famished. She snatched me into her arms as if to keep me from collapsing from my bout with deprivation and sat me down on a kitchen chair. She'd just made fruit salad full of crisp purple grapes, chunks of buttery pear, peeled orange segments; or how about apple sauce, still warm; maybe some rice pudding freckled with nutmeg; or a few of her twirly pastries she called *ajuelas*, glistening with colored sprinkles?

Sometimes she motioned me over to the white closet in the kitchen alcove in which she kept her "Spanish things." An assemblage of wooden boxes, squat bottles and square tins held the food she knew from Gibraltar, where she and Gramps had come from almost a half-century before. She seemed pleased that I loved the *turrón*, a granite-hard block of nougat studded with almonds. Even with her tender, gnarled hands, she had no trouble slamming one of her big cleavers through the *turrón* with the force of a lumberjack. What she called guava jelly wasn't anything like the Welch's grape jelly we put on peanut butter sandwiches at home. It was a flat golden-brown bar that she sliced into thick rectangles. They tasted a little like burnt sugar, but their texture was more like soft gumdrops or the candies we called Chuckles, though I didn't tell her that, nor would she have

wanted to hear it. There was a narrow, cylindrical jar packed with some kind of lima bean look-alikes, plump and corn colored. The fun of eating them was biting down with just the right amount of pressure so the thick skin popped off but the bean didn't get squished in the process. You moved it around in your mouth until its delicious saltiness disappeared. Only then was it ready for biting into, at which point it offered the soft crunch of a cashew nut, if you paid attention. With a little practice, even a child could do it.

And there was saffron. Although I never tasted its crinkly red strands right from the jar, I breathed in its beckoning aroma as I practiced the piano two rooms away. Its perfume traveled like a wandering melody from the *arroz con pollo* DeeTee was cooking on the stove into the living room and directly over to the piano. The smell of saffron and my first taste of Verdi were one. Practicing my Hannons, those insufferable repetitive five-finger exercises that sounded like a motor left running, was made more bearable by the gypsy fragrance of saffron slinking off the peas omelet browning in the oven or escaping the fricassee of chicken and peppers bubbling together in an iron pot. Eventually I played Chopin waltzes to DeeTee's thyme-scented, fish and potato consommé; I made Mozart sounds to her Spanish-style minestrone. By the time I mastered Suppe's "Poet and Peasant," the piece she'd been playing that day I found her at the piano, I'd learned to love eggplant, cooked any way at all. I'd also, by then, become DeeTee's accomplice in her never-ending mission to feed the hungry, whether or not they were.

We went to Gramps and DeeTee's for dinner every Sunday, but she was convinced that, for the rest of the week, we existed on the fringes of starvation. Her previous solution had been to try to feed us enough on Sunday to last the whole week. But when I started coming there every day, she realized that, equipped with my Roadmaster bike with the big wire basket lashed to the handlebars, I could be her delivery system. With my help, she could at least alleviate the famine we were undoubtedly suffering in silence at our house.

So once or twice a week, into a brown canvas bag she would pack her blue-rimmed white pots full of her day's work: lamb stew, thick cheese-and-pepper pies, black beans and rice and, sometimes, very

small bowls of a black, shiny potion with tentacles sticking out of it. Whatever it was, no one would even look at it but my father, who did so with almost sacramental reverence, spearing the wriggly, rubbery inhabitants as we watched with true concern for his sanity.

I don't know what DeeTee thought about my musical prowess, but I knew she was proud of me for my part in helping to save all our lives. Maybe because she never felt too comfortable speaking English, we never talked much, a bit about school or how my brothers were doing. Her message was in the brown canvas bag and on the mahogany dining room table, in the Wedgwood bowl and all over the kitchen. It said I love you, you're too skinny, come back soon. It said I can never do enough for you. It said this is my heritage, this is your heritage; remembering this food will some day change your life. It will be your music. And your song.

Gibraltarian Artichokes

Not that DeeTee ever used a recipe, but after years of experimenting and discussing the nuances with various family members, I think this preparation comes pretty close to the fantastic artichokes she prepared serenely in the kitchen despite the cacophony in the living room.

INGREDIENTS
- 4 artichokes
- two lemons
- 2 garlic cloves, chopped
- 2 tablespoons parsley
- bread crumbs
- salt and pepper
- 4 tablespoons olive oil
- 2 cups peas, fresh or frozen

1. Remove the tough outer leaves of the artichokes and cut off about an inch of the tops. Slice off the bottoms so they can stand on the base.

2. Spread the leaves open slightly and immerse the artichokes in water into which you have squeezed half a lemon.

3. Place in a pot large enough to hold the artichokes standing. Sprinkle them with garlic, parsley, breadcrumbs, salt and pepper, working the ingredients between the leaves. Add the peas. Squeeze remaining lemons over the top and drizzle olive oil over all.

4. Fill the pot with water just till it reaches the tops of the artichokes. Cook just below the simmer 30 to 45 minutes. Drain in a colander and serve.

The Black Food

OUR REGULAR EXCURSION to DeeTee and Gramps' house for dinner
every Sunday was a ritual we looked forward to all week. Although
occasionally underappreciated at home, we were the centers of attrac-
tion for our grandparents, who couldn't wait to bask in the wit, bril-
liance and scintillating presence of their only grandchildren. As for
DeeTee, she wanted us to start eating all the things she made as soon
as we walked in the door. Not that we minded, except for the one day
she made the black stuff.

We always knew she was unusual, even for a grandmother. She
would bring a big platter to the table piled up with thin flat disks
that made the room smell warm and smoky and expectant, as if a
ceremony had begun. But when we asked what it was, it would be
eggplant and we would, therefore, remain baffled. Or she would give
us a plate full of leaves and show us how to pull them between our
teeth to get the "meat" off. Or cut a wedge of a thick pie, studded
with green and gold, which she called *"huevos."* We didn't under-
stand her food partly because we didn't understand her language. So
even when she told us what the food was—*ajuelas, sandía, grana-
das*—we didn't know what was coming. But the day we had the
black food would have lasting repercussions. When she placed be-
fore us a bubbling hot pot of mud-brown liquid, we were already
sufficiently horrified; but we were soon to be further traumatized by
an unfortunate translation.

Reaching into the morass with serving spoon and fork, she lifted
out several dark lumps of something and placed them on our father's
plate. Instead of cringing, he sighed an unmistakable and to us un-
believable appreciation. More things came out of the small cauldron,

worse things: rubbery squiggles, spiders, miniature dragons. Whatever it was was still alive, I thought, watching my father brighten visibly with each addition, as if he couldn't believe his good fortune.

It was one of those moments that demonstrates the irreconcilable differences between grownups and children, that convinces the younger generation that their parents are a breed apart, that they are role models of everything rejectable. It was also the moment I realized my father couldn't have been the smartest person in the world after all.

"Would you like some *calamare en su tinta?*" DeeTee asked, speaking both languages in one sentence as she often did.

That was the other problem: hurting her. You never wanted to hurt DeeTee. She was so good to everyone; she cooked all Saturday and Sunday morning just for your visit. She lived in an apron. The stove was buried under pots still simmering, the oven was full, the kitchen table smothered under serving platters to be filled with a never-ending succession of roasted vegetables, baked rice dishes, chicken fricassee, fresh fruit salad, stewed prunes: anything there was a chance you might want. The minute we arrived, she sat us kids down to big bowls of hot chicken soup teeming with tiny, star-shaped pastina noodles and we immediately began to fight over who would get the bowl with the chicken heart in it. I used to wonder why she put the heart in at all since she knew the fracas it always led to; but she knew exactly what she was doing. By getting us to focus on the heart as the object of our desire, she soon had us arguing and bargaining and finally making deals about who got the heart that day and whose turn it would be next time. Her real accomplishment, however, was getting us to eat the soup in the first place. With the chicken heart as bait, she was employing the kind of merchandising savvy worthy of those sophisticated advertising campaigns which move consumers to concentrate on which brand to choose, not whether or not they want the product to begin with. Obviously if she'd put her tactics to work for Procter and Gamble or somebody, she could have sold a lot of mouth wash. But she was only interested in getting her three grandchildren to eat, and the day she served the black food was no exception.

Being the oldest, I felt responsible to reply with diplomacy and tact to her offer of "*calamare en su tinta.*" I began by asking her what it was.

"*Calamare…cómo se dice en inglés.…* It's a kind of fish. You want to try?"

Well, no, actually I didn't. But she had that pleading, dewy-eyed, vulnerable look on her face that only an ogre could ignore.

"Go on," Dad urged, spearing another wriggling, tar-colored denizen of his dinner plate. When he held it up and I saw how truly grotesque it was, I was pretty sure I wasn't going to be able to do DeeTee any favors. But then he went on to clarify her explanation, which had at least been sufficiently vague to offer a certain lure of the unknown which Dad's anatomically correct explanation entirely demolished.

"It's called squid," he said with an almost ghoulish enthusiasm, "and each one has all these delicious tentacles. The other part is like a long tube called ink sacs which makes the sauce for the squid. It's actually a kind of miniature octopus called devilfish."

Octopus? Ink sacs? Tentacles? Devilfish? Was Dad kidding? My brothers obviously thought so: Ferdy had bared his upper teeth and was silently mouthing "I vant to suck your blood" to Richie who had, if one were to judge from his facial expression, already turned into a werewolf.

I peeked over at DeeTee who, to my amazement, didn't look hurt. In fact a tiny smile nudged up the corners of her thin cherry lips as she picked up her ivory Wedgewood platter and walked toward us.

"Here. I give you nice piece of chicken, yes? Some carrots, very sweet. *Arroz*, a little spoonful, yes?"

Yes, we agreed. Yes, anything as long as we didn't have to eat the black stuff.

Of course that was her plan, I finally figured out, another of her masterful merchandising techniques. After that, she seemed to make squid almost every time we came down. It worked like magic. In order to avoid it, we would happily eat everything else. Once, we even tried the prunes.

The Breadbox

"Is it bigger than a bread box?"

On the '50s television quiz show "What's My Line?", that was the standard question about the size of the mystery object. A meaningless question I thought, reflecting on the breadboxes in our family and their varied sizes and shapes, to say nothing of aesthetic qualities. The one in our house was a bulky, white rectangular chest that looked like a little cousin of our Norge refrigerator. They both had sturdy, rounded shoulders and a solidity that suggested the eternal. Civilizations might come and go, but that breadbox was sure to be there on the kitchen counter reliably stocked with Silvercup bread, Thomas' English muffins and either crumb cake or powdered donuts. Sometimes Mom bought Wonder Bread or Tip Top, and it was always the nice soft white sliced bread we loved. To make sure it was fresh, she counted the lines printed on the bottom of the wrapper, a secret code only she could decipher. I liked the slices right out of the bag, *au naturale*, with nothing on them.

"Not even butter?" Mom invariably asked, incredulous that I would forsake such an offer.

I could never understand why grownups had to have butter. Butter ruined bread, obliterated its possibilities. Once buttered, bread was useless for those children's rituals which transformed it into food we could relate to on our own terms. Meticulous handwork was required for the first of these rituals, the removal of the crust. It wasn't really crust, the way Italian bread had crust; it was just a golden brown rim around each slice that had to be carefully removed in one long continuous strip with no breaks or tears. When we were

finished we each pasted our own crust on the kitchen table in front of us. Whoever had the longest strip won, not that there was any prize except the grudging admiration of the losers.

Freed from its brown binding, the soft tuft of inner bread was placed on the tongue where it melted like a fluff of cotton candy. It was like do-it-yourself Communion without all the nerve-wracking holiness or the frantic tongue work if it stuck to the roof of your mouth. The alternative was even better, though it involved a chance to learn about delayed gratification: the tuft was placed not on the tongue but on the table. With clenched fists, we mashed it flat then rolled it into a tight little ball, the smaller the better. Density rather than diameter was the goal. When you bit into it, you got no air, just a pure, compact marble of solid bread. This style was not permitted at dinner (too disgusting, Mom said) but we could get away with it for between-meal snacks, treats.

Men had nothing to do with breadboxes. In fact, judging from our father's behavior, men couldn't see breadboxes even if they were sitting right next to them. If they wanted something from a bread-box, they would ask. The breadbox was the province of women. They made the decisions about what went into it, from the omnipresent utilitarian daily bread to the occasional bribes, surprises, and rewards. It was the jewelry box of the kitchen, the hat from which the magician could pull out nice surprises for everyone, if she felt like it. It was territory.

Each of my grandmothers had her own territory as well. Their breadboxes were as different from each other as the grandmothers who ruled over them. At DeeTee's, for example, the breadbox rested on a blue, snowflake doily on top of the cabinet where she kept her sculptured bottles of green-gold Spanish olive oil, her blue-stenciled tin boxes of English digestive biscuits, and her flat cakes of almond paste. Her dainty breadbox, with garlands of lavender-blue petunias painted on its lid, opened like an executive roll-top desk. My brothers and I were not supposed to attack it like three little *"sinverguen-zas,"* Grandpa's affectionate way of calling us pests. The bread inside was more important than our bread at home. It wasn't sliced and it didn't come in waxy, white bags printed with blue and red balloons.

It stayed in the breadbox, like a wrapped present, until dinner was served.

This giant Italian bread with deep clefts had golden brown ridges jutting out from one crusty blunt end to the other. I could hardly wait to taste the warm, wide slices, but I loved the ceremony even better. DeeTee set the loaf on a board in front of Gramps, who grasped the ivory handle of his glinting serrated knife. He sawed the bread the way he sawed wood in his workroom downstairs: precise, perfect cuts with practically no sawdust to sweep up afterward. When his carpentry was complete, DeeTee put the bread in a silver basket and covered it with an ivory-colored linen cloth embroidered with a curly "F" for Ferrary. Then it traveled in its gleaming carriage around the oval table, children first because that's the way DeeTee wanted it. If we left off the linen cloth, we'd be called *sinverguenzas* again, so we usually did. After dinner, the two remaining slices— somehow there were always two—were removed and bedded down in the breadbox for the night.

By contrast, Grandma Reilly's breadbox was a mammoth contraption, somehow bigger inside than out. It was like Central Control and she operated it at breakneck speed, lifting the heavy lid with one hand, reaching for the slices with the other, getting both hands out of the way just in time. This was the same giant-sized breadbox she had when Mom was growing up, she told me, when she had nine children battling through the kitchen doorway three times a day. From the outside, Grandma Reilly's squared-off metal case was neither delicate nor inspiring, but the bread inside was utterly exotic.

Her bread wasn't from the A&P or Bohacks. You couldn't buy it in any store or even at Ebingers bakery. It was delivered to her door by a Merlinesque creature with no name other than The Dugans Man. He parked his magical truck at the curb, jumped out, skipped up all ten steps of the front stoop in one Superman single bound. He set down his box of baked goods, snapped open its two flat lids and began pointing out the choices for the day: poppyseed rolls and icing-thick bear claws, cookies covered with chocolate sprinkles. Grandma Reilly nodded at the coffee ring and the bread and, for not-so-rare birthdays—there were dozens of cousins—the chocolate

seven-layer cake. Instead of giving them to her from his case, he ran down the stairs to his truck and returned with fresh loaves and boxes and bags. Sometimes he told her she "would be wise" to order something in advance so he could reserve it for her for the next time. But she never did.

"These guys will tell you anything," she mumbled to Mom and Mildred after he was gone, and Mom and Mildred agreed. They were both experts on what they called chiselers, who were salesmen in general, and on con artists, who were people who owned stores.

He piled his special, chauffeur-driven loaves into a big, sort of ugly case which was probably the biggest box of bread in Brooklyn. But no one would call that a breadbox. Not in a million years.

Pummeled Bread

INGREDIENTS
 8 slices supermarket white bread, crusts removed

1. Wash hands thoroughly, especially if you've been playing in the sandbox all morning.

2. After removing crusts, set bread slices in front of you in a row.

3. Clench fists tightly and, with knuckles facing each other, begin to pummel the slices. You will probably find it easier to alternate fists rather than smashing both fists down simultaneously.

4. When slices are completely flat, open fists and, gathering up one slice at a time, roll it into a tight ball like a piece of clay.

5. Finally place each ball in palm of hand and squish. Balls may be served as is or with chocolate milk.

Serves 2 as a main course, 4 as an hors d'oeuvre.

The Cook

In the matter of cooking and all it entailed—trudging through Bohacks, dragging food home in the wire-wheeled pull cart; the peeling, chopping and skinning; the stove time; the filling of platters and bowls; the serving—Aunt Julia was my role model. She didn't do any of it.

She was a bachelorette—her word—with her own apartment. She had red hair and a green bathing suit; in an era of sensible black cars, hers was turquoise blue. She wore iridescent nail polish and Hazel Bishop no-smear lipstick. She put henna in her hair or maybe they did it for her at the beauty parlor. She went to the beauty parlor for no reason, even if she wasn't going to a wedding.

"When I was your age," she told me, "Pop—your grandfather, Gramps—figured he could cut hair as good as anybody. So he put a bowl over my head and cut around it. Ohmygod, I almost died. I wore a kerchief over my head for a month till it grew back. I didn't think I'd ever get over it. Ohmygod, when I think of it. Poor Pop. He meant well."

Aunt Julia would say Ohmygod just like that. It wasn't swearing or anything, but you didn't hear other women in the family saying Ohmygod, just like that. Or going to the beauty parlor with no weddings on the horizon. Or smoking. Julia smoked Chesterfields and sometimes, when she used her shiny black cigarette holder, she looked exactly like a movie star.

On the weekends, quite often she took me to the movies, usually to the Avenue D Theater next door to Van Dohlen's. She bought a box of Raisinettes for me and Jujubes for herself, but she said I could

have as many Jujubes as I wanted. We traded boxes for a few minutes until my teeth started sticking together and a vision of Dr. Shein and his giant drill kept me from going back for more. Plus I knew what was coming, so I didn't want to spoil my appetite.

We always sat up in the loges. When the matron turned her flashlight on the other kids who had snuck up there and told them to go down to the regular seats or she'd throw them out altogether, I felt privileged. At intermission, if they gave away sugar bowls or cups and saucers, Julia would let me keep them even if they sparkled like diamonds or had gold on their rims. Julia never minded staying for the cartoons again even if we'd already seen them at the beginning. As we walked, blinking, through the lobby, she asked, as if she didn't know, "Would you like to go to Van Dohlen's?"

Unlike the candy store around the corner from my house, Van Dohlen's was an ice cream parlor. Black marble countertops gleamed like patent leather across from the shelves of vase-shaped glasses for ice cream sundaes and long oval bowls curled at the ends for banana splits. Light twinkled from crystal chandeliers and glanced off the mirror-lined walls. As we slipped into one of the plush-cushioned booths across from the soda fountain and waited for menus, we were princesses. Servants attended us, bringing goblets of water, silver spoons, perfect creamy globes of vanilla ice cream lacquered in chocolate, crowned with puffs of whipped cream lit by a long-stemmed cherry. Unlike at the candy store, it took forever to eat ice cream at Van Dohlen's. But then, we had forever.

Some weekends, usually in summer, Julia took me swimming, but never to Coney Island or Farragut Pool, the gigantic tree-lined public pool in our neighborhood where all the kids went until August, when you couldn't go anymore or you'd get polio. No, we went to the Hotel St. George, polio or no polio, where the pool was as big as the ocean and looked even bigger because of the floor-to-ceiling mirrors on all sides. They had dressing rooms at the Hotel St. George, not lockers, and they gave you towels so you didn't have to bring one of the threadbare, embarrassing ones from home that had been relegated to beach and pool use only. Julia emerged in her emerald green strapless bathing suit, shiny as satin, and I shuffled out in

my stupid-looking flowered suit with the ruffled skirt and straps that tied at the back of my neck. Julia tried to teach me to float, we spent time holding on to the edge and kicking our feet, and Julia even jumped off the diving board once or twice. But the important thing, as with going to the movies, was not what we were doing then, but what we were going to do afterward.

It had a funny name for a restaurant, Horn & Hardart, more like a department store than a place to eat. Nor were there menus or waiters. Strangest of all, a woman seemed to be in charge of the goings on. She sat in a round booth at the edge of the enormous dining room waiting for people to give her money. She never looked up, just took the money and threw down a loud clatter of nickels. She didn't say "Next" but you knew that's what she was thinking with that "sour puss," as Julia called it. So people scooped up their nickels and moved on.

One side of the restaurant—Julia called it an automat—was a wall of little glass doors through which you peeked to see what was inside. I searched for the compartment with the Salisbury Steak. Julia would put the right number of nickels in its slot and open the door. I'd reach in and pull out the white plate with the golden-brown oval mound of meat sizzling in its center.

"It's just chopped meat," Mom would say later, reminding me that I didn't even like hamburgers. It may have been chopped meat, but it was certainly not a hamburger. At Horn & Hardart, it was Salisbury Steak, almond-shaped, juicy, an adventure. Another door, more nickels and "Voilá," as Julia would put it: a pile of green beans scattered like pick-up sticks under a melting gold nugget of butter, magical. String beans?, Mom would call them later with an incredulous question mark at the end because of their not being a big favorite under ordinary circumstances. Blueberry pie was my choice for dessert but if they didn't have it, I would take rhubarb, whatever that was. I would take anything for the thrill of the nickels and the doors, the little white plates moving over their thresholds like actors making their entrances, the fun and the fantasy. Or maybe it was having the opportunity to make the choices in the first place. At any rate, it

only happened with Julia, who obviously knew something secret about eating and its pleasures.

While she remained a bachelorette, Julia successfully avoided the perils of those kitchen-centered responsibilities that marriage seemed to require. But eventually, when she succumbed to one of her many marriage proposals, she managed to do so in a way that didn't contradict her philosophy that food was wonderful, cooking might be satisfying, but eating was the point. I discovered how she accomplished this miraculous achievement the night she invited our family to dinner, shortly after her marriage.

We all sat in her living room eating cashews—she served cashews, not peanuts—and chatting about her new blond furniture, and wondering if we were ever going to get anything to eat since Julia never ventured anywhere near the kitchen. Finally her husband, Al, appeared in the doorway, sheathed in a white apron, smiling proudly and carrying a glistening honey-brown turkey the size of their new RCA television.

"Al's the cook in the family," Julia smiled. "Come. Let's eat."

Salisbury Steak

Baked beans, macaroni and cheese, applesauce—everything was great at the Automat, but Salisbury Steak was significant. It meant you'd been to Horn & Hardart. Nobody's mother made them Salisbury Steak at home, and if they said she did you knew they were trying to show how great they were. Or else they were lying. This isn't how they made it—Mr. Horn and Mr. Hardart probably never told anybody—but this is how they shaped it. Just ask anybody.

INGREDIENTS
- 1½ pounds ground beef
- 1 teaspoon salt
- ½ teaspoon freshly ground black pepper
- 1 egg, beaten lightly
- ½ cup ricotta
- 2 tablespoons grated Parmesan cheese
- 1 clove garlic, minced
- ½ cup basil, tightly packed

1. In large bowl, mix ground meat with salt, pepper, and egg. Divide into 6 portions. Mix remaining ingredients and divide into 6 portions also.

2. Form each portion of meat around a portion of basil mixture, making sure to shape each into an oval, like an oversized almond.

3. Preheat grill, broiler or skillet and cook each steak to desired taste—5 minutes per side for rare, 7 for medium, 8 for well done.

The Country

It HAPPENED BEFORE I WAS BORN and before my father was born. It happened in Gibraltar, where I'd never been, but I could see the scene as clearly as if I'd been standing in the plaza, trusting in the wisdom of the line of ancient olive trees looking on in silence. The man with the machete wasn't my grandfather, whose choice of weapon was yet to be determined. The man had a dark beard and his crow-feather eyebrows gleamed with sweat as he paced the square, one eye on my grandfather, the other on the wagonload of watermelons piled between them. Gramps' description always included a rooftop full of chattering Gibraltar monkeys. Strictly speaking, they were tailless apes, he invariably corrected himself; but I liked envisioning them with long, coiled, snake-like tails. They seemed more monkey-like.

"I was the champion," Gramps explained as modestly as he could manage, "so this man had a special interest in vanquishing me that day."

It was market day in Gibraltar and by noon the aromas of guava and mango and honeydew mingled in a lush bouquet that you could taste through your skin. And although people, including children, were almost trembling with anticipation over their basketsful of chubby fava beans and warm plump peas and tomatoes, nobody would leave. They were waiting for the battle to begin.

The bearded man made the first move, stretching his body across the pyramid of watermelons, grasping the bulging sides of the one at the very top. He set it down on a wood table as thick as a chopping block, raised his arms high over his head and slammed the blade of

the machete smack through the center of the melon. He hacked off several chunks of fruit and presented them to three stern looking gentlemen at the edge of the crowd. These were the judges. As they tasted, their faces softened with smiles and one of them yielded a low moan, none of which was good news for Gramps. In order to win, he had to select a melon that was even sweeter and more flavorful. Curling his hand into a fist, he thumped the side of a few melons, leaning close to them as if he were listening for someone to say, "Come in."

"You want a watermelon to sound hollow," he would later advise my brothers and me, in a tone that suggested he was imparting an eternal verity we'd never have known if it weren't for him. Which was true.

Finally he made his selection but instead of chopping up the melon on the table, he held it high over his head for a minute, getting his balance. By then everyone was staring at him, bewildered and silent, "even the monkeys," he assured us. Positioning his fingers for just the right thrust—his engineering expertise coming into play— he hurled the watermelon to the ground. It seemed to explode into a million pieces. He retrieved several of the biggest chunks for the judges. One taste and this distinguished panel of tasters became giddy with delight over the obviously superior qualities of Gramps' watermelon. They rose up from their judges' platform and clambered over to the bright red shards glistening in the plaza, determined to get another mouthful. By then they had several monkeys to compete with, but the decision was in: Gramps was the winner and still champion.

"Actually," he confessed, "all the watermelons that day looked excellent. But using a knife gives the fruit a subtle metallic taste that mutes its sweetness. The only way to win was to eliminate the knife. Anyway," he added wistfully, "that was the last time because by the next year, DeeTee and I had left Gibraltar for Manhattan, where they didn't have any watermelon contests."

Gramps was usually inspired to tell this story in the country, where watermelon was always an important family ritual. "The country" was what we called the fifty-acre farm that Gramps and

DeeTee had bought somewhere outside Brooklyn. It came complete with a barn, a well, and a farmhouse plus the ruins of a moss-covered chimney, which generated goose bumps and ghost stories during the summers we spent in the country with our grandparents. The country was somewhere in upstate New York, near Newburgh. Not really near Newburgh; not near anything, in fact, except the Ogdens who lived on their own fifty acres next door, to use a Brooklyn expression. (Even Newburgh was not near anything, achieving momentary notoriety only because it was where Jack Kerouac ended up his first night on the road.) Mrs. Ogden wore a long braid and Mr. Ogden wore a pitchfork, and when they looked out at you from their fields they might have been posing for Grant Woods' *American Gothic*, a copy of which hung in their back porch.

The Ogdens grew corn but I don't think they ever tasted their own creation. If they did, they would have had to throw their heads back and let their eyes roll around and sigh enthusiastically over the deep sweetness, and I'm sure the Ogdens would never do such a thing. Of course we had corn in Brooklyn, but it didn't have that hay and wet-grass smell, and it was covered with yellow strings not golden threads, and the kernels didn't glow from inside and look like they were about to burst off the cob. This was a different vegetable, a kind of sun-basted fruit, though butter had a lot to do with it. This corn was always dripping with too much butter because DeeTee never said "Okay, you kids, that's enough" about the butter. About anything.

The peas tasted better too, especially when DeeTee scraped her thumb down the pod and handed them over: four or five roly-poly green pearls. The way I loved olives and filberts and grapes, that's the way I loved those peas, for their single-mindedness of purpose, their intensity. And the string beans, well, they were yellow for one thing, full of summer, just like the peaches and the fat black plums and the watermelon. Still it wasn't the taste that got me excited that day in the country when Gramps said "Which of you kids would like to go to the Bull Market in Newburgh and help me pick out a watermelon?"

He was a short guy, Gramps, with a bald head, a Fuller-brush,

bristly gray mustache that made him look proper and distinguished, and a little pot belly that made him look like Gramps. Did he mean he was going to pick up watermelons and smash them to the floor in the middle of the Bull Market? There was only one way to find out.

"Me!" I said, not wanting to miss the opportunity. Two other "Me's" also sang out just as loudly, so Gramps told the three of us to jump in the car.

But first we stopped at the bakery because that's where DeeTee wanted to go first. In the country, DeeTee never baked her *buñuelos* or the honey-slathered curly crispies she made in Brooklyn. Maybe the stove, a green and white porcelain contraption set on bowed iron legs, was too old or fussy for the delicate calibrations of DeeTee's pastry. In the country, she bought sugar cookies with a red cherry in the middle, and the airy circle of cloud called angel food cake with no icing that she covered with strawberries from the Bowman's farm. The bread was almost as fluffy as the cake and, although I loved it as much as Wonder Bread, DeeTee always muttered "This isn't Ebingers" as it emerged, slightly squished, from the slicer.

We stopped at a few farms and by the time Gramps parked the black '51 Chrysler Windsor in front of the Bull Market next to a horse, a hay wagon, and a flat bed truck with a yellow tractor on it, the car smelled edible. Gramps took DeeTee's arm and they proceeded down the wide, sloping ramp that led to the Bull Market's swinging doors. It used to be a slaughterhouse, Mr. Ogden once told me, and the animals would be herded down the ramp to an arena-style room full of butchers. Even if the story wasn't true, as Gramps suggested, it made going to the Bull Market a lot more exciting than going to the A&P. And in fact you never knew what to expect as the doors swung open because instead of regular shelves and aisles, the Bull Market was like a barnyard where farmers set up stands and bushel baskets spilling over with lettuces and apricots, carrots and asparagus. Gramps walked us over to the mountain of watermelons heaped high in the middle of the room like a centerpiece. The moment had come.

My brothers and I held our breath as Gramps thumped the sides of several specimens.

"Do you happen to have a knife?" Gramps asked the nearest straw-hatted farmer, who wasn't really paying as much attention as he soon would be, once Gramps started flinging watermelons in the air. I wondered who'd scoop up the miscellaneous chunks of fruit, there being no monkeys in the vicinity. Gramps didn't seem concerned. With the knife, he made an incision in the rind of a tiger-striped, fat-bellied melon and then carved a circle the size of a quarter. We weren't the only ones looking on in rapt attention as Gramps removed the four-inch long tapered cone he'd cut from the side. He held it up to the light, examining the red triangle of melon and then he bit off the tip.

"Ah, *dulce. Dulce*," he sighed, as if he were satisfied, though we knew he was just preparing to lob that melon into the middle of the Bull Market. Just then DeeTee caught his eye and nodded, and the next thing we knew Gramps was gesturing to the farmer that he'd take that one. Something about the way DeeTee tilted her head must have made him change his mind.

A few onlookers came over and asked him watermelon questions as if they could tell he was the world champion.

"When you want to see if a watermelon is good," he instructed with a wink in our direction, "you cut a plug in the side and taste it. That's the only way."

"Thanks, much obliged," they responded, as if he'd actually told them the family watermelon secret.

Little did they know.

Gramps picked out lots of sweet watermelons that summer—and every single summer of our childhood. He never once slammed a watermelon to the ground as people watched in astonishment and monkeys waited their turn. Yet I've seen him do it a thousand times, proudly following his every move from behind the ancient olive trees.

Corn

Corn was once as exotic and intimidating as arugula. Cookbooks advised boiling it for a half hour or so, while some included a separate section called "To Eat." Mrs. Rorer's Cook Book *instructs: "Score every row of grains with a sharp knife...and with the teeth press out the center of the grain leaving the hull on the cob." These days, cooking corn is a lot like not cooking at all, which has a certain appeal. Quite simply, you can "walk down the garden path to cut your corn," according to Andre Simon* (A Concise Encyclopedia of Gastronomy)*, "but you must run back." At that point, you insert it into some boiling water for a minute or two, or you can grill it, shucked and brushed with a bit of oil, on a preheated grill about 6 minutes, turning frequently.*

II. Betty Crocker Homemaker of Tomorrow?

The New Food

IN THE EARLY 1950s, I EXPERIENCED my first food-related epiphany. With my initial glimpse of the steaming hot, silver bright phenomenon called Swanson's Frozen TV Dinner, I realized that eating a meal could be a voyage of discovery. The simple but elegant aluminum rectangle, about the size of a writing tablet, was divided into compartments: for mashed potatoes topped with a semi-melted pat of butter; for the sleek slices of turkey glued with caramel-colored gravy onto the stuffing beneath; and for peas which, thanks to the tray's metal barriers, would never roll over into the potatoes.

It was the modern way to eat.

There simply was no gastronomical precedent that compared to the thrill of peeling back the shimmery foil while breathing in an escaping whoosh of mixed aromas. The anticipation was unbearable though the meal looked exactly as pictured on the box. Unlike other family meals, TV dinners meant a choice of entrees. That the salad was a bit soggy, the brownie imbued with the essence of meat loaf in no way detracted from the mystique of this techno-culinary advancement.

It was perfect for children. You knew exactly how much of each thing you had to eat before you got to dessert; your work was cut out for you. For the first time in history, dessert was served simultaneously with the main course, and all of it was removed from direct parental control. Plus you could sneak your fork across into the dessert compartment prematurely if no one was looking.

And no one *was* looking because they were watching "The Cavalcade of Stars," or "Milton Berle," or, on Sundays, "Dean Martin and Jerry Lewis."

I knew about TV dinners and the changing mores they represented only because of Brian Ganley's family across the street. The Ganleys lived in a big brick and stone house with a garage underneath and a million steps leading from the street up to their front door. Brian was my age and his older brother, Jimmy, walked us to school every day. I was proud of this association with the Ganleys, who were popular because of their stoop and famous for being the first people on East 37th Street to get a television set. It was a Philco with a peephole screen and a bright flashing antenna on the roof. Almost every day after school Brian invited me in to watch "Howdy Doody." The Ganleys were friendly, nice people, but I couldn't help feeling a twinge of jealousy as I left each afternoon. Not only could they sit there continuing to watch television all night; they could do so while eating TV dinners.

I longed for those privileges. I used all my powers to make my parents feel guilty and terrible for not buying a television. I enlisted the aid of Ferdy and Richie to join in the whining although they'd never seen Brian Ganley's television.

The problem wasn't that my father had no interest in television. The problem was that, thanks to his engineering background, he was entirely too informed about the state of the art. He was waiting for color, he explained; they were experimenting; they were making advancements; there was no sense rushing out and buying a black and white when any day now.... We should be patient. Every month, we watched in horror as he flipped through his subscriptions to *Popular Mechanics* and *Popular Science* searching for "Build-Your-Own-Television-Set" blueprints.

After awhile, however, even he couldn't wait any longer. Once my brothers had been exposed to television's seductions, they launched whining campaigns of their own. By the time we got our set, I was dazzled as much by the thought of seeing the programs as by the vision of all the frozen TV dinners we'd be eating as we watched. Like the Ganleys, we would henceforth dwell in the land of the cool.

Soon after we got our set, however, it became obvious that we were going to be eating old-fashioned kitchen-bound dinners for a

long time to come. This setback was due entirely to my father, and it had nothing to do with his concerns about our eating habits.

Somewhere in the far reaches of his engineering education, he'd learned about Hallicrafters, "a fine company, a great name," as my father put it. Other parents bought ordinary television sets like Dumont, RCA, Emerson; but these were not "precision instruments" like the products from Hallicrafters. Obviously they must have made something at Hallicrafters before they made the television set my father bought, but even a child could see that televisions weren't their area of expertise.

Nevertheless when my father wrestled the hulky thing up the stairs and opened the box, it looked beautiful. He was impressed with the handsome design and excellent cabinetry work: "a fine piece of furniture in the bargain," he noted with delight.

The three of us snuggled down on the Oriental rug in the front room, awestricken as my father carefully positioned the set in the corner. My mother unfurled a new lace doily across the top and on it placed the green plastic Lazy Susan usually brought forth only for company, though there was a noticeable absence of peanuts in the little trays. And then my father stepped behind the television and with a bit of flourish, for he had a sense of history, plugged it in. Reaching around to the front, he turned one of the knobs and then stood back, his eyes—all our eyes—riveted to the screen.

"Has to warm up," he explained after a few minutes.

No one moved.

My father bent down, touched his ear to the side of the set. He squeezed his eyebrows together and held up his hand to signal us to be quiet, though we were barely breathing at that point.

"It's coming, all right. There's a hum."

He was smiling his encouraging smile, the one he used emerging from under the hood of our '41 Chevy whenever it chugged to a stop in some godforsaken middle of nowhere. My mother was already removing the Lazy Susan and the doily. Instinctively she seemed to know he'd soon be crouching down behind the set, removing tubes, holding them up to the light, setting them down on top of the television.

"Don't you kids touch these. They have to go back in exactly the same order."

We would never touch them. They were innards, mysterious, frightening, possibly diseased. We got off the floor and slumped down on the couch. Unlike the Ganley's Philco, our screen wasn't tiny. We could watch the Hallicrafters from anywhere in the room because no matter where we sat, there was no picture.

As for the hum, there was a hum. There was always a hum. We listened to it for hours over the coming weeks as we gathered in the front room, one of us holding a mirror in front of the screen, someone manning the dials, my father stationed semi-permanently behind the set jiggling wires and peeking at the mirror to see if anything had changed. Not that it didn't work, my father was quick to point out; the set was definitely "on." It was simply that the picture, when there was one, was a mass of flickering shadows and halos.

"Ghosts," he announced cheerfully, implying that this was just what he'd been hoping for.

"Looks like it's coming in a little clearer now," he'd declare optimistically, disappearing once again behind the eternal Hallicrafters horizon, except for his voice:

"How is it now, Loretta?" he'd ask my mother.

"Hmmm. Well, it's still a little hard to make out," she'd report encouragingly about the fuzzy vibrations we were all staring at in despair.

"Must be a little snow," my father would say.

"Snow" was an official word from the television instruction book which meant that we weren't going to be seeing "Howdy Doody" at five o'clock that night either, unless we sneaked out across the street to the Ganleys.

Whenever my father did get a picture, it would be caught between two worlds, sliced across the center so that people's faces smiled out from below the line, while their feet tapped the tops of their heads. It was better than nothing; my brothers and I were more than willing to settle. We were glad to watch the "Magic Cottage" in this half-and-half motif; it was part of the magic.

"Could be the antenna," my father sometimes suggested, which

at least broke up the hopeless vigil in the living room long enough for everyone to get a Snickers bar while he followed the wires through the house. It was never the antenna; the next thing was a call to Ed's TV and Radio Repair.

"It's a Hallicrafters," we'd hear him enunciating on the phone. "Hal-li-craf-ters. Oh, sure, I'd be happy to: H-A-L-L-I-C-R-A-F-T-E-R-S. That's right. Yes, they do make televisions, as a matter of fact. It's a good name, excellent company."

When he got off the phone, we could barely stand to look at his pained expression as he told us the terrible news:

"Sorry kids. They're going to have to take it down to the shop."

We knew what that meant: it meant a humiliating retreat to our pre-modern, old-fashioned, non-frozen-dinner lifestyle. We were forlorn. Up and down East 37th Street and Clarendon Road, on out to Flatbush Avenue and King's Highway, all over Brooklyn, television was changing America's eating habits. But not if you had a Hallicrafters.

Forkless TV Dinner

Fortunately there's nothing worth watching on television, obviating the need for TV dinners. But if you rent a movie some night, you might try the following; it's especially good for foreign films because you can eat it without looking, thus allowing you to read the subtitles.

Ingredients

1 long baguette
1 tablespoon olive oil
2 cups chopped tomatoes
1 clove garlic, minced
1 cup calamata olives,
 pitted and chopped
2 tablespoons capers,
 drained and rinsed
1 small red onion, diced
2 7-ounce cans tuna,
 drained and flaked

handful of arugula
 or watercress
3 tablespoons parsley,
 chopped
3 tablespoons red wine
 vinegar
¼ cup extra-virgin olive oil
salt and freshly ground
 black pepper

1. Slice off top third of baguette lengthwise. Hollow out center, saving crumbs, and brush insides of baguette with oil.

2. In large bowl, combine 2 cups of crumbs with all remaining ingredients. Add salt and pepper.

3. Fill baguette bottom with mixture. Cover with top and press down.

4. Cut into two or four sections, depending on how many are watching the film, and wrap each section in plastic wrap. It's actually big enough for four.

5. Refrigerate 2 or 3 hours before serving. Let stand at room temperature 1 hour before serving. Eat it over a plate, just in case.

The Harvest

"Chestnuts" was a boys' game.

When the first chestnuts of the season began popping out of the broad-shouldered limbs of the chestnut tree at the end of the block, the boys were there under it. Like squinting dwarves, they stood far below even the lowest of the overarching muscled branches, charting each lumpy ball as it progressed from fuzzy pale green to lustrous mahogany. They checked back daily, stampeding down the street the minute they got home from St. Theresa's, their plaid school bags still in hand, buckles jingling. They were led by Frankie Clifford, self-appointed leader of East 37th Street's hunter-gatherers.

Visitors to Holy Name Cemetery might have wondered how the small crowd of runt-sized boys ever hoped to gain possession of the little nuggets, since the tree loomed unreachably on the other side of the cemetery's sharp-spiked iron picket fence. Permission, they knew, would not be granted for a bunch of mostly nine-year-olds to walk off with nuts intended to nourish the beloved departed, albeit symbolically. They were reassured in this view by the presence of uniformed guards who patrolled the gates, peering out from behind the black bars as if they were on the outside and the boys were on the in.

And then one day the tree looked as if it had been decorated with hundreds of shiny brown ornaments and we knew it was harvest time in Brooklyn. Fortunately the guards kept their eyes glued to every move made by Huey Black, a milk-complexioned, hazel-eyed boy who'd just moved to Brooklyn from Scotland, who never raised his sing-song, brogue-lilted voice, but who struck the suspicious

guards as the ringleader of the group. This misplaced vigilance virtu-
ally assured a plentiful harvest as Frankie sent Huey to the cemetery
gates around the corner and the guards never let Huey out of their
sight.

Brian gave Frankie a boost up onto Billy Shehee's shoulders and
then handed Frankie the broomstick they used for stickball. Poised
above the pointy black spikes, he swung the broom-bat back and
forth through the branches, knocking down chestnuts until he was
out of breath. From across the street we, the girls, were supposed to
"stay out of the way of the guys," as Frankie put it. Naturally we
weren't wishing that Frankie would fall down onto the spikes or any-
thing horrible like that, but we weren't against a few scratches to
teach "the guys" a lesson. Frankie jumped off Brian's shoulders and
slid the broom bat along the ground, sweeping up the chestnuts that
had fallen on the cemetery side of the fence. Because of their prox-
imity to the dead and the other world, these inside chestnuts,
through some sort of reverse logic, were equated with eternity and
everlasting life. In the game of chestnuts, it was a big help if your
chestnut was immortal. Nevertheless Brian and Billy scrambled over
the bumpy carpet of chestnuts stuffing as many as possible into their
pockets, mixing the mortals with the immortals; they never thought
to bring a bag, not to mention two bags.

On the steps of Frankie's bright orange brick stoop, the boys div-
ied up the crop, making sure to give us, the girls, the gnarled speci-
mens with the dull sheen that rattled in their shells. They began
hammering big fat nails into the chestnuts and threading shoelaces
through the holes, tying knots at the end. One of the boys would
dangle his chestnut in the air holding it perfectly still while another
boy tried to smash it with his own dangling chestnut. The holder of
the vanquished chestnut looked as destroyed as the crumbling lump
at the end of his shoelace, especially if it was one of his really good
chestnuts and not one of his spares.

Despite the visible effects on the egos on the stoop, skill or
strength seemed to play no part in the winning of these combats.
The major determinant of chestnut survival seemed to be the posi-
tion of the hole and how much damage was done to the chestnut's

flesh when the nail was hammered into it. At least that's what Dad said when he went through all his drill bits to find the right size so he could bore a perfect, clean pathway in precisely the right place, all of which had to do with something he called the center of gravity. By the time he finished neatly threading the chestnut with a rust-colored shoelace from one of his wing-tipped cordovans, I'd decided I would never subject his careful craftsmanship to the harrows of battle.

"No, I'm sorry," I told Billy Shehee, even though I had a crush on him, when he challenged my chestnut to a duel. He was even more disappointed when I told him that my chestnut had a center of gravity and I wasn't going to let it get smashed to smithereens. By the end of the week, when the boys had nothing but empty shoestrings, Joan and Bernadette and I decided to wear our own chestnuts around our necks like crown jewels. The season for chestnuts was over, but not at our house.

"You're not supposed to eat those chestnuts," Dad would remember to warn us before the week was out. "The kind you eat, it's a whole different species."

"Yes, ummm, and they're so delicious," I'd say, my mouth remembering the warm, nutty crumble, the holiday taste.

"Yes they are. Which reminds me..."

And the next night or the night after that, we'd have chestnuts. Not with dinner and not right after dinner, but after awhile when we were, as Mom would say "becoming pests." Usually it was after a few hours of trying to watch television on the Hallicrafters as Dad adjusted the dials and turned the set in different directions, finally closing the curtains so the light from the front window wouldn't interfere with the picture, which wasn't really there. That's when we'd be permitted a few pieces of candy—a stick of chocolate licorice, a few Charms or candy kisses—or we could opt for a five-cent bar: a Three Musketeers, a package of Chuckles, a box of Black Crows. But the presence of chestnuts changed all that.

Sitting on the floor, my father would spill out the bag of chestnuts onto the low round stone table that looked like it had originally been used by cave men. Holding a chestnut firmly against the table

in his left hand, he'd pull the knife cleanly across its slippery curved top. As we sat on the floor around the table, watching this surgery in silence, he'd examine the unscathed chestnut and ask inevitably, "Is this the best knife we have, Loretta?"

Then he'd go to his toolbox and get a sharp-bladed tool he used for engineering situations and start carving X's with the precision of a diamond cutter. When he finished the chestnuts, he'd have us all gather around the fireplace for the roasting part. He didn't actually sing "Chestnuts roasting on an open fire…" but I could tell he was thinking about it. He reached into the fireplace behind the logs. We'd hear a click and the fireplace would fill with blue and orange and yellow light playing like flames over the logs. The fact that we had no chimney and therefore couldn't make a real fire didn't deter Dad. He devised a wheel of different-colored film that turned slowly in front of a light bulb. It felt cozy, especially on a cold winter night in chestnut season. But you couldn't roast chestnuts on a light bulb, so Dad got out the electric waffle iron, replaced the waffle plates with flat metal disks and covered them with X'd chestnuts.

Soon I could smell them, a woodsy, sugary smell, a hint of the fire and ash and burning crackle that Dad wanted to give us. We could hardly wait for Dad to decide to test the first one as he let it dance in his hands till it cooled slightly or until his hands got inured to the burning heat. Then he'd squeeze it until the shell splintered and he could break off a piece of the smoky, hot chestnut and put it in his mouth.

"Don't burn yourself," he'd say, handing us each a shelled chestnut. I would begin by blowing on it, breathing in its smoldering body heat, pinching its fleshy little cheeks. The first bite could mean pain; I knew that, remembered it was worth it for the resulting complex of sensations: silky, grainy, crumbly. Too soon it was over and I was waiting, interminably, for the next one, the delay a big part of the gratification. There was Dad, testing, peeling, handing over his chestnuts roasted by the open electric waffle iron, the only food he ever prepared and cooked and served. That in itself made chestnuts qualify as a rare treat, even a communion. But I don't think he saw it as cooking. I think for him it meant leisure and downtime. It meant

carving and whittling and playing with knives; building a campfire in the woods, bringing back the hunt. It meant technology and ingenuity, triumphing over obstacles. These were the chestnuts you could eat, but they were still a boys' game.

Chestnuts Roasting in a Microwave

Not much romance here, but it works: take four chestnuts at a time, carve the proverbial "X" on top, pop them in the microwave at high setting for 3 minutes. They will have split open perfectly, leaving none of that webby, tenacious inside skin clinging to the flesh. If they haven't, put them back in for another minute. Peel immediately, as the shell tends to shrink back down on the nut if left to its own devices. You can even freeze these for later use.

The Nook

ALTHOUGH BOTH MY BROTHERS AND I loved going to lunch at Grandma Reilly's, my little brother, Richie, found it especially advantageous. Not that his meal of choice was any different—the only thing he ate was peanut butter sandwiches. Nor could the brand and type deviate: Skippy Creamy, never Crunchy. But he knew that when he ate his peanut butter sandwich there, it would be free of the little surprises he often discovered in the sandwiches he brought to school from home. He would not have to worry at Grandma Reilly's about taking a nice, big bite of sandwich only to find himself chewing on a rolled-up wad of lined paper torn from my homework Memo Pad.

He never appreciated these unexpected messages no matter how cheery their content or how solicitous of his welfare. And yet whenever I made his sandwich for him in the morning—I offered to help, my mother didn't even have to ask—I would scribble a sprightly greeting like "Hi, Richie. Hope you're having a good day." We didn't have Happy Faces in those days or I would certainly have included a nice big one and possibly even colored it a jolly sunny yellow. Occasionally I scribbled a joke of the Why Did the Chicken Cross the Road variety, something I knew he'd know the answer to which might brighten his mood. Then I planted it in a thick plot of peanut butter and spread more peanut butter over it so that no one could distinguish this sandwich from one which contained no special meanings. I rolled the note up carefully with the writing on the inside partly so the ink wouldn't smear into the peanut butter but mostly so the words would be legible when he pulled the slightly

soggy morsel from his mouth in the lunch room at St. Theresa's, where my brothers and I attended grade school.

Sometimes I suspected he didn't even read the notes, even though I usually bothered to include two or three for diversity. Generally speaking he had a bad attitude about these attempts of mine to use food as a system of communication. Nor was he impressed with the originality of the delivery system.

Despite all these special considerations on my part, Richie would usually be in a nasty mood as the three of us walked home after school. Ferdy was three years younger than me and Rich three years younger than him. Ferd and I tried not to tease him too much, but it was hard. With his red hair and freckles, he was a cute little kid in a kind of Huckleberry Finn kind of way and when he was mad he sort of glowed. I'd noticed how often, in the world of cooking, there would be no reaction to the food presented, no acknowledgment of the work and effort that had gone into the making of the meal. That didn't happen with Richie, whose response was spirited, if not furious. From this perspective, I felt well rewarded. Although my mother scolded me sternly, I occasionally detected a laughing glint in the deep blue of her eyes as she did so. She thinks it's funny, I thought. Maybe she even thinks there's something crazy about the set-up where ladies make the sandwiches and boys of all ages simply eat them, never expecting their pleasure to be mitigated by wads of paper or anything else for that matter. Serves them right, maybe she was thinking. The lot of them. But she only said things like "Okay, you kids. Calm down." If we were lucky, she'd add "Anyway, tomorrow we're having lunch at Grandma Reilly's."

We loved going there. It wasn't so much the cuisine that attracted us—except for Richie, who looked forward to message-free sandwiches—but the chance to see our cousin Kenny. He lived at Grandma Reilly's with his parents, Uncle Fred and Aunt Mildred, my mother's sister, who'd moved in after Grandpa Reilly died. In that big rambling house, down the street from the school, Grandma's nine children, including Mildred and my mother, had grown up. It had rooms everywhere, even in the cellar on the other side of the coal bin, where Kenny had his own private lair which he called his

clubhouse. There he kept his baseball cards and ukulele, the dead frog and the jars of lightning bugs he didn't want Mildred to know about, and his own deck of cards. Kenny was younger than me but older than Ferdy; he was kind of the missing link in the family. Not only did he fill that age gap, he possessed exactly those qualities absent in our threesome. He wouldn't hesitate to sneak into the pantry and smuggle out a bag of Wise Potato Chips or a box of Uneeda Biscuits and bring them down to the clubhouse. He said we could have as many as we wanted, the implication being that he could always get more. He was allowed to not eat the crusts of his bread, he never brought his plate over to the sink after lunch, and he left his books in school so he didn't have to do his homework. He was great.

The four of us ate lunch in the nook off the kitchen. It was a cozy little alcove painted sky blue with an oilcloth-covered table in the middle, a bench on either side and a window at the end. The benches were like built-in storage bins, their seats attached by hinges to the wall. When Kenny got tired of eating his salami sandwich, he'd wait until Mildred wasn't looking, pull the seat up and throw in the rest of his sandwich.

"I'm ready for dessert now," he'd announce, but when it would be Fig Newtons, he'd be sorry. He'd have to take a few bites anyway until Mildred turned back to the conversation in the kitchen with my mother and Grandma Reilly. Then he'd pop up, raise the seat and the Fig Newton would go the way of the salami.

And when there was the milk strike in Brooklyn, the benches held special promise. We were too young to understand the particulars of the strike, but the result was powdered milk. At home we gagged on it but we had to drink it anyway because of our teeth and bones and everything. But at Grandma Reilly's, Kenny's protests brought results, though they were not without their Pyrrhic qualities. Mildred bought a bottle of real milk—"It must have cost you an arm and a leg, Mil," my mother said, by which she meant Kenny was becoming a spoiled brat—and mixed it half and half with the powdered. The combination was vile, much more horrible even than the blue version. Jars of Ovaltine and Bosco were brought forth from the cupboard accompanied by sympathetic offers to make us chocolate

milk and a desperate interpretation of hot cocoa. Nothing helped. Longingly we eyed the benches as possible dumping grounds, but even Kenny sensed that they weren't appropriate for liquid waste.

The nook gave us all the privacy we needed to make our plans. These were the kinds of schemes we'd never be conjuring up if it weren't for Kenny's leadership. They were brilliant: we could set every alarm clock in the house, all of which were upstairs, to go off at half-hour intervals starting at 1 P.M., when we'd be safely back at school. We could distract everyone while Kenny checked the supplies of chocolate-covered peppermints in the living room sideboard, where they were kept for company. We could watch the delivery man struggle up the stairs with the block of ice and hope that it took him so long to get it into the icebox that the ice cream would start to melt and we could offer to eat it all.

We only got to have lunch at Grandma Reilly's a few days a week. Most of the time we brought our lunch and ate in the St. Theresa's lunchroom. For most of us, it was always the usual fare: a sandwich, a Macintosh apple, a Lorna Doone: no surprises. Except, of course, for Richie, who never knew what to expect.

A Rose by Any Other Name

It's embarrassing to still like peanut butter sandwiches when you're supposed to be all grown up. Fortunately hummus and pita bread satisfies some of those PB&J urges, plus it's much more sophisticated. You can admit you like it in front of the most discriminating diner.

INGREDIENTS

 1 cup dry garbanzo beans or 1 can cooked
 ½ pound tahini
 ½ cup chopped parsley
 juice of a lemon
 juice of half a lime
 ⅓ cup olive oil
 2 (or more) cloves garlic, minced
 pinch cumin
 salt to taste

1. Soak dry garbanzos overnight. Discard water, cover with fresh water and bring to a boil. Cook until tender, about 30 minutes. Reserve water.

2. In blender or food processor, blend cooked garbanzos with all other ingredients. Adjust seasoning to taste. Add some of the cooking water to thin, if necessary. Serve with pita. This also freezes well.

The Sacrifice

"AND WHERE DO YOU EAT?" Joan Doyle asked Father Bumpstead, the priest who had come to St. Theresa's for our annual, three-day retreat. We were sitting on the fold-up metal chairs in the auditorium, rows and rows of us, our eyes glued to Father Bumpstead's every move, our hands clasped quietly in our laps, our minds wandering. Even though we were only sixth and seventh graders, he'd been telling us, we weren't too young to renounce worldly things, to consecrate ourselves to Christ and do all the other annual things that came up during retreats. He hoped we appreciated the generosity of the nuns, he went on, in absolving us from homework for three days so we could devote ourselves to prayer and fasting. Best of all, he continued, he'd be there, day and night, should we need spiritual guidance. It was the day-and-night remark that prompted Joan Doyle's question. His answer shocked us back into a state of undivided attention.

"I eat in the convent," he replied with a detectable grin, "with the nuns."

No one, I could tell from the widened eyes of my classmates, had expected this reply. The nuns, with their crinkled, walnut-shell faces and their fascination with self-denial, didn't eat. We were sure of it. They never even mentioned eating except for repeating one of the incomprehensible rules in our catechism to "fast and abstain on the days appointed." For a couple of years, we didn't even know this had anything to do with food. The way the nuns talked about it, food was something to give up. If you didn't eat your Tootsie Roll at recess, for example, you could offer it up to God and maybe get Him

to do you a favor; things like that. Possibly God was supposed to feel sorry for you, a little kid starving to death just so maybe He'd let the Dodgers win the pennant for a change. We were supposed to give up candy for Lent, not eat meat on Friday, keep in mind that gluttony was one of the seven capital sins. For the Sisters of Mercy, the act of not-eating was practically a sacrament. Once a week, they passed a box around during lunch and told us if we put in our lollipops or Power House Candy Bars, we could save the pagan babies; it was a sacrifice, but a small price to pay to convert everybody to the One True Church.

In fact, the nuns surrounded lunch with so many rituals, it was hardly worth the effort. They separated us, boys on one side of the corridor, girls on the other. We then were told to line up by size; unless someone had grown significantly overnight, we knew our places by heart. We were usually too hungry to argue, not that arguing was an option at St. Theresa's.

"No talking in transit, girls," Sister Mary Leone reiterated multiple times as she walked us down the three flights to the lunchroom. At the lunch tables, we stood behind our chairs and were permitted to speak to each other until Sister Mary Leone's frog clicker signaled that it was time for grace before meals. After grace, as a further sign of respect, we were to stand silently and count to three before moving our chairs.

So maybe Father Bumpstead was mistaken when he talked about eating with the nuns. And yet he was a Jesuit; so that was impossible. Or maybe he was referring to taking Communion with them. The nuns did receive Communion; they had to: it was the law. Although Communion looked like a round flat wafer of bread, we knew it was more than that, thanks to transubstantiation. As the nuns explained it to us, transubstantiation meant that bread and wine actually turned into the body and blood of Christ, although you couldn't tell by looking at it. Why would you want to eat that? was one of the questions not even Joan Doyle, often labeled brazen, dared to ask. Besides the nuns weren't in the business of giving answers. They specialized in rules, which may have explained why Communion was their all-time favorite sacrament: You had to fast from midnight

including being careful when you brushed your teeth not to swallow any toothpaste. You couldn't have orange juice in the morning. You had to kneel down with your head back and stick your tongue out at the priest reverently but far enough so he could place the Host, as the wafer was called, firmly on your tongue. If he missed, and the Host fell on the floor, it was your fault and you might as well kill yourself before Sister Mary Leone reached your pew. With the Host on your tongue, you closed your mouth, bowed your head, and waited for the Host to dissolve. Usually, however, the Host had other plans, clinging like a magnet to the roof of your mouth and daring you to pry it loose. Using only your tongue—those were the rules— you had to coax the tenacious little disk down your throat without choking, coughing or looking like you were being strangled, all of which were almost sins. Also it couldn't touch your teeth or you'd be automatically excommunicated.

During the three-day retreat, Father Bumpstead served us Communion every day. Despite his claim to be eating with the nuns, he never looked hungry. Perhaps he carried around some extra hosts to snack on in his room; Jesuits had special dispensations for things like that. Joan and I were more than willing to give him our Tootsie Rolls and forget about saving pagans for the rest of the week. On the other hand, he seemed very well fed if not a bit chubbier by week's end. Maybe because he was a priest and everything, the Sisters of Mercy decided to give up fasting during the retreat. It was a sacrifice; but it was only once a year.

The Egg Cream

JOAN DIDN'T SAY ANYTHING WHEN I showed her the floor plan. I'd just learned the phrase myself—floor plan—and I felt very worldly armed with this new concept and its exotic connotations. I assumed Joan didn't completely understand. Then again, how could she?

"This is the Ranch Style," I explained, unfolding the colorful brochure populated with two-children families aiming their cartoon-character grins at the model homes depicted, "and this is the Split Level. The little space where the line breaks means it's a doorway," I continued, despite Joan's growing sullenness, "and this bunch of lines is a staircase."

We were sitting on her stoop ignoring Bernie Powers and Mike and Joe Coppolla playing Running Bases between the manhole covers in the middle of East 38th Street. I was beginning to feel almost angry with Joan for her lack of reaction, especially since it was in such sharp contrast to my initial response to these floor plans.

My parents had prepared us by saying they were going up to Connecticut to look at some new houses just in case my father's company, American Machine and Foundry, asked him to transfer to the Stamford "plant," as they called it. But when they covered the kitchen table with these folders and began describing animatedly the relative merits of the various models, my heart filled with tears. These little rectangular squares were master bedrooms and dining areas, outdoor patios and half-baths; they weren't just pencil lines on graph paper, or educational places we might be driving to for the following summer's vacation. They were other kids' neighborhoods;

they were beyond the borders of Brooklyn. As far as we were concerned, they were Mars.

My parents probably had expected sobbing and complaining from the three of us and a certain reluctance to join in the enthusiasm of possibly moving to our own new home in Connecticut. But they didn't seem prepared for outright rebellion and our complete willingness to let them go up there without us if they thought it was so great. We'll pay the landlord ourselves, we told them; we'll get jobs. Mom swept the folders together like a deck of cards and Dad put them on top of the refrigerator under the radio.

AMF was not cooperating. During the next week I kept finding those brochures tucked under the doily under my mother's jewelry box on her vanity; or stacked up against the wedding picture on my father's dresser so that my mother's veiled face and my father's pompadored head poked up over the sheaf of Ranch Styles and Split Levels; or scattered across the apricot satin comforter on my parents' bed as if they'd been looking at them all night, or first thing in the morning, or both. You couldn't help overhearing things: These houses had no bulky metal radiators steaming and choking in the corner of every room; they had "baseboard heating." They had no brick stoops to play jacks on, or people downstairs cooking sauerkraut, or paved streets to play stickball in the middle of until cars came and you ran to the curb, which these places didn't have either. They didn't have a Scissors Man with a rickety old wagon and a rickety old horse clip-clopping down the street with his screaming grinders and silent sharpening stones, primitive and mysterious. They didn't have the Glenwood Dry Goods Store that sold striped polo shirts and striped dishrags and striped knee socks, everything matching. They didn't have Coney Island and the Fun House, the Steeplechase and Roller Coaster, the Cyclone and Ferris Wheel; they didn't have cotton candy or Nathan's hot dogs or Nedicks orange drink. The words "We wuz robbed" meant nothing to them: they didn't have the Dodgers. They didn't have anything up there in Connecticut if you asked me and Ferdy and Richie.

AMF wasn't interested in our opinion, however, and so the brochures made their way to the kitchen table, and we were soon

fighting over which room would be whose in houses that were not yet built on unpaved streets we'd never seen in towns we couldn't find on the map.

"The name of the place is Springdale. Isn't that the most ridiculous name you've ever heard?" I was still trying to get Joan's attention, but now she was gazing blankly at the sidewalk where the chalk marks we'd drawn for potsy yesterday had mostly washed away in the rain. "And there aren't even any sidewalks," I was about to add when I noticed that her whole face had a peculiar crumpled look, her mouth especially.

"Joan," I said with impatient concern. "Do you have to go to the bathroom?"

Almost instantly an earsplitting, air-raid siren wail blared out from somewhere inside Joan. The Coppolla brothers dropped their Spauldeen and stared over at us, immobilized on their respective manhole covers.

"I don't want you to move away," Joan sputtered and sobbed. "Don't leave me. You're my best friend." When she turned her face toward me, it was a completely different color than normal, like a pink grapefruit instead of her usual pale lemon. She looked a little like "I Love Lucy," the way her lips were stretched into a wide clown mouth. I tried to blink that image out of my mind.

"It's not definite yet," I said weakly, patting her shoulder, which was sweaty and trembling. "My father's company hasn't decided. It has something to do with radar."

Joan didn't show any more interest in radar than she had in floor plans. I felt a mild disappointment because my father had explained a bit to me about radar and I wanted to show off this knowledge, including the warning that it was, as he put it, "top secret."

"All of a sudden, everybody's moving," Joan whimpered, her voice scratchy, painful to listen to. "First the triplets, Jean, Jane and Joan, go off to Honesdale, Pennsylvania. And Dolores moves to Valley Stream. And then John Scalzo…"

John had hair as black as India ink that squiggled into a curl in the middle of his forehead, above his jewel-blue eyes. We both had a crush on him and we were both hoping he'd write after he moved to

Westchester. And he did write, but it was to Gail Williams, one of the twins. And then the Williams moved to Baldwin.

"Even Larry Eason."

"Larry Eason? Who told you? He never said."

"Well, his mother and sisters aren't moving," Joan added in a tantalizing tone. "Mrs. Lawler told my mother. He's probably going to be sent to reform school. He's been stealing too many things."

I tried to cheer Joan up by saying that going to reform school wasn't really the same as moving because you came back after the reforming, or so I'd heard; but Joan wasn't looking at any bright sides.

"Oh, and remember Pat Thorne's moving too," she added glumly, "right after school gets out."

"Yes. Port Jefferson, I think."

"Yeah, see? Everybody, like I said. And nobody ever comes back."

Not only did Joan's mother always tuck a white handkerchief into the pocket of Joan's white school uniform blouse every day, but she also made sure it had the right day of the week sewed on it. So there was Joan blowing her nose into "Monday" while I sat there with no handkerchief at all. And even if I'd remembered to take one, it probably would have said "Saturday" or whatever day was on top of the pile. On the other hand, I wasn't crying.

"You know," Joan squeaked between sniffles and blows, "you seem like you actually want to move."

I felt my forehead crimp up. Now I was the one concentrating on the washed-away potsy chalk marks, watching them blur into the lines on the blueprints that Mr. Koenig spread out on his office table the previous Saturday in Springdale. If they took the third house on the left, he was explaining to my parents, they could have it in a few weeks; but since it was already finished, they wouldn't have any choice about options, like what side the garage would go on and whether they wanted picture windows in the dinette. Consequently he could make them a better price, seventeen five instead of the regular eighteen. When we got back in the car, Mom was the first to speak.

"These guys will tell you anything," she said, looking skeptical but disturbingly pleased.

"You kids must be thirsty," Dad said, surveying his pouting triumvirate in the back seat. "How about a lemonade?"

Dad didn't know we didn't drink lemonade. Cherry cokes, cream sodas, egg creams; never lemonade. But we knew what he meant.

"If I'm not mistaken, there's a candy store in town."

It was called Bill & Fred's. Flanked by the barbershop and the tailors, it was nice and dark. Plump cigars filled the cedarwood cigar boxes open on the high counter next to the packs of SenSen and fuzzy white pipe cleaners. The penny candy case was down on the right side, further than normal, but more or less in the right place relative to the comic books. Five chrome stools stood waiting in front of the soda fountain behind which stood a man in a plaid shirt who looked like Humpty Dumpty.

"Hi. And welcome. I'm Bill," he said.

Mom and Dad ordered lime rickeys, Ferdy ordered chocolate soda and I deliberately asked for an egg cream. It was a test. An egg cream was Brooklyn; it wasn't a recipe or a skill or a thing you learned. And even though Bill squirted syrup and seltzer into a glass and handed me something that tasted like an egg cream, it wasn't an egg cream. It couldn't have been. Another man came over to take care of Richie's request for a vanilla ice cream cone. He was skinny with a narrow face shaped like an upside down pear, a goatee for the stem. Flitting back and forth behind the counter, the two looked like Abbott and Costello.

"Hi, I'm Fred," said Abbott, nodding five times, one for each of us, stopping at Richie. He then asked a question that departed from standard candy store procedure. Not: "Do you want that on a plain cone or a sugar cone." But: "Do you want a scoop or a pre-frozen?"

Without blinking, Richie ordered the pre-frozen, as if he'd been ordering pre-frozens all his life. I knew he didn't know what a pre-frozen was because I didn't know and I was older. Here was a person who ate nothing but catsup and all of a sudden he's ordering pre-frozens.

"I heard of it. I heard of it," he replied defensively in answer to the unspoken but palpable skepticism with which Ferdy and I were besieging him. When Fred handed him a cone-like contraption

wrapped in paper, Ferdy and I kept saying how stupid looking it was until Dad, who never got impatient, got impatient.

Through all this, Bill and Fred never stopped smiling, unlike Mr. Sollie in our candy store, whose gorilla-like grumbles when he thanked you for paying were worse than no gratitude at all. They probably wouldn't be so friendly when we came in without our parents. At least I hoped not.

Dad made an unprecedented offer: We could each buy a comic book to read on the ride back home; it would be his treat. We didn't dare look at Mom in the wake of such extravagance, but when I peeked out of the corner of my eye, her face was calm. Maybe she hadn't heard.

We drove by the house one more time before heading back to Brooklyn. They could plant floribunda roses under the bedroom window and rosemary on either side of the front steps, they were saying to each other. I tried not to listen.

When we got home Mom gave us each our allowance like she did every Saturday except that she'd already done so that morning. It wasn't the sort of thing that would slip her mind.

"You kids were very good today," she said. "You deserve a little bonus."

I didn't mind having the extra fifty cents, but it meant that things weren't yet back to normal. On the other hand, with the two quarters in my blouse pocket, I could afford to make Joan an offer.

"You look thirsty," I said. "Let's go get an egg cream."

Egg Cream

There are no eggs or cream in the egg cream—inscrutable, those Brooklynites. There's no set recipe for it either. The only constant is Fox's U-Bet chocolate syrup which, according to company owner David Fox, is made with genuine Brooklyn water. If ya aint got U-Bet, ya aint got egg cream.

INGREDIENTS
 2 tablespoons Fox's U-Bet
 ¾ cup milk
 ¼ cup seltzer

1. Spoon the syrup into a chilled glass and stir in milk.

2. Stir in the fizziest seltzer you can find. Drink immediately. If you find yourself wondering why all the fuss over egg creams, you obviously aren't from Brooklyn.

The New World Symphony

Forty-four Old Colony Road.

What an address I thought, compared to 538 East 37th Street. In Brooklyn, you could find people if you wanted to, just by knowing their address. You could plot the numbers on graph paper, visualize the relationship of their location to yours. You could estimate how long it would take to get to a place, taking lefts and rights along squares and rectangles. In Connecticut, with an address like 44 Old Colony Road, you could be anywhere. More to the point, you could be nowhere.

Somehow the Neptune Moving and Storage Company found Old Colony Road that warm, sun-dusted Saturday at the end of June, three days after St. Theresa's closed for the summer. For forever, as far as I was concerned. The van stretched along the street at the bottom of the sloping front lawn, as green and thick with grass as the middle of Prospect Park. Despite the steep hill and the dew-wet grass, the moving men were quickly transferring everything into the house. Too quickly, if you asked me.

I sat on the lawn, my arms wrapped around my knees, sniffling and listening to the grunts of the leather-faced moving men lugging backbreaking cartons up the path I was sitting in the middle of. One of them, the hall bookcase on his back, suggested it might be helpful if I could cry over toward the driveway.

"I don't want to move," I mumbled, tears gathering in droplets on the tip of each nostril.

"O.K., Girlie. Stay put. We'll manage."

If I got out of his way, I thought, maybe he'd listen to reason.

"I mean I don't want to move away from Brooklyn," I whined, looking up at him as if he were my last refuge. "I'd like to get in that van when you leave and go right back. Would that be all right with you?"

"Sure," he said, with a very nice smile.

Once we had that settled, I felt better. I could watch the commotion calmly, my only concern being how I was going to tell Mom about going back with the Neptune men. Oh and where did I think I was going to live. It would be just like Mom to bring up things like that. I have lots of friends, more friends than you even know about, I'd tell her enigmatically as I hopped into the back of the van. It was right about then that I saw the piano.

I followed the moving men into the house and watched them set it down against the wall in the living room, between the doorway to the kitchen and the entrance to the dinette. It fit perfectly.

DeeTee had told me I could have her piano when we moved. It was the only bright side about moving. I never believed it would happen. DeeTee loved that piano so much. In her house it had a room of its own. She let no one near it except me when I went there to practice every day.

"How?...where?..."

"The moving men stopped by DeeTee's to pick up the piano after they left our house," Mom explained.

It looked more beautiful than ever, blacker and sleeker, dazzling. I lifted up the seat of the piano bench. All my music was still in there, and so was hers. A big splat of tears landed on the sheet music for "Poet and Peasant." I brushed it away with my finger and closed the bench. DeeTee's piano had moved from Brooklyn to Springdale; there was no turning back now. While I wondered how to explain this to the nice Neptune man, they all snuck away without a word.

Over the next few weeks, I wrote a letter every day to my three best friends, Joan, Betty, and Therese, complaining about whatever happened. This was becoming increasingly difficult as our parents went out of their way to make us like the place. They bought me a new bed, which was a big improvement over the convertible sofa I slept on in Brooklyn, and a new dresser that was so blond and

modern I took pictures of it to send Joan, Betty, and Therese. My mother didn't object when I pasted my Elvis Presley pictures on the bedroom ceiling and no scolding finger appeared in response to my clothes being left on the floor even when I pointed them out. My brothers got bunk beds, we all got new bikes.

"It was a little far to Bill & Fred's candy store," Dad admitted when he opened the garage door to reveal the three new Roadmasters two-wheelers.

The red metal kitchen table was carted away with the arrival of a shiny wooden dining room set including brown and gold upholstered chairs. On our new RCA Victor television, we could actually watch programs instead of just watching Dad change the tubes and move the antenna around. This advancement was one of the reasons my mother finally consented to get TV dinners every once in awhile which she could store easily in the new Coldspot, the polar-bear-sized refrigerator that replaced our old Norge. In the Norge, the freezer compartment was a tiny box holding two ice cube trays, or one ice cube tray and three or four snowballs we tried to save for summer. The Coldspot had a huge freezer drawer half the size of the refrigerator with room for Mrs. Paul's frozen fish sticks, and for everything frozen made by Birds Eye, Swanson's, and Libby's.

Springdale was a strange place. It wasn't a city like Brooklyn where Mom wheeled her fold-up shopping cart to Bohacks every day and came back with bags of peas to shell, greenbeans to top and tail, potatoes and carrots to peel. And it wasn't the country like the little town near Newburgh where our grandparents had the converted farmhouse we visited in the summer. True, the nights were similar to the country, glittering with lightning bugs and the wide sprinkling of stars that had no competition from streetlights or lampposts. But unlike the country, there were no cornfields or farm stands or chicken growers. In Springdale, Mom drove to the supermarket in her new two-tone Dodge Coronet and came back with rock hard squares of ice-locked vegetables, boxes of instant mashed potatoes, packages of Mrs. Grasses Noodle Soup. A few times, Mom made her slow-cooked Boston baked beans, spicy and thick with the dark sugary taste of molasses, the salty chewiness of

bacon. But then she discovered that Boston baked beans came in cans with all the work already done. Like the other stuff, it was exciting to eat, part magic, part science. But they left something out; you could taste it.

Every day when we went to the post office—they didn't deliver mail to the door on Old Colony Road—we bought milk in a little shop next door called Cumberland Farms. They didn't deliver milk to the door either in Springdale.

This was also the summer of the electric egg cooker, a piece of technology my father discovered that was supposed to give Mom a little more sleep in the morning. Instead of getting up to make Dad his hard-boiled egg, she could put the egg in the cooker the night before, leaving Dad with the task of switching on the device right after his shave. This flick of the wrist didn't exactly make Dad a chef, but it was more like cooking than anything he usually did. He was soon advocating a healthy breakfast for the entire family, by which he meant a hard-boiled egg. I was his only convert, mostly because I liked the idea of having my father to myself for a while. Usually he'd be reading the *Stamford Advocate* and I'd be rearranging my flowered writing paper in the red leather zipper case my Aunt Julia had given me as a going away present, the egg cooker sputtering in the background. Sometimes we'd want to tell each other things or make some comment to show how smart we were, but usually we were too busy with our work.

"What's that smell?" he'd sometimes ask, looking around, sniffing.

"It's my writing paper," I'd answer, pulling out a pale blue sheet, bordered in the roses that perfumed it.

"Oh, nice. Very pretty." And then "The eggs! I almost forgot. They must be done by now."

The primitive device had no chimes or bells; you knew its work was done when the noise stopped. Sometimes my father would take charge, removing the eggs, tapping their shells all over until they became a cobweb of tiny cracks.

"Be careful. It's very hot," he'd say, juggling the eggs as he did the chestnuts. Although the shell was totally shattered, it clung to the

egg as if it were cemented on. When I finally got it off, my egg was a series of crevices and potholes, like the surface of the moon.

Despite all the extra sleep she was supposed to be getting thanks to the egg cooker, my mother would often be up anyway, possibly awakened by the device's death-rattle performance. Whenever she took charge, she'd bring the eggs over to the sink and, in two seconds, hand them back, shorn of their shells and smooth as pearls.

"Toast?" she'd ask and my father would answer, "That would hit the spot, Loretta."

"What about you?"

I'd shake my head. I hadn't even wanted the hard-boiled egg.

For a while we went to Brooklyn every Sunday, stopping first at Gramps and DeeTee's. As we walked up the steps into the kitchen, DeeTee would already be ladling her chicken soup into three bowls, hoping to restore her grandchildren from rickets and scurvy and the other ill effects of living so far from her cooking. I wondered how the piano room looked; if there was a big, lonely space along the wall. The cherry wood doors were shut tight as they'd always been; from the outside, everything looked the same. DeeTee always said *"De nada"* ("It's nothing") when I thanked her for the piano. If she seemed sadder, it was because she missed us all so much; that's what everyone thought. Except me.

At Grandma Reilly's, we mulled around with the usual cascade of cousins until Mildred struggled in from the kitchen with a platter of giant baked ham crisscrossed with cloves, trimmed in browned, golden rounds of pineapple. Then Grandma Reilly set down the pot roast and a bowl of her Irish specialty, the crispy-brown, sizzling potatoes with the buttery flesh. In seconds, two dozen cousins, aunts and uncles surrounded the table, wondering about grace, if we should say it, who would begin.

Until later that summer when she also moved away, I got to visit Joan.

"No Ebingers!" she shrieked in disbelief when I told her that among our Connecticut deprivations was the absence of the bakery that made Blackout Cake and the chocolate and vanilla cookies, Black and Whites. She was only slightly less incredulous that Spring-

dale had no movie theaters like the Avenue D, which showed ten cartoons with the Saturday serials. I knew I wouldn't get much sympathy if I told her that what we had instead was the Norwalk Drive-In Movie Theater and that almost every week our parents piled us into the Dodge Coronet for a double-feature. If it was not Dollar-a-Carload Night, I became an instant only child sitting in front with my parents as my brothers crouched down in the back. Even if the sound from the metal box Dad hung on the car window was scratchy, we didn't complain because we knew at intermission he'd take us to the snack bar. They had everything at the snack bar: hot dogs and hamburgers, relish, orange sodas with crushed ice, plastic straws, Dixie cups with flat, wooden spoons, French fries to share. We'd run back to the car just in time for the second movie, balance the flimsy cardboard food trays on our laps and, as Mom suggested, try to eat more than we spilled. If we didn't fall asleep before the end of the movie, it was unusual.

As for Ebingers, we didn't miss it as much once our parents started driving us to Carvel for dessert. Carvel was a square glass building with a man inside waiting at a sliding window. When you gave him your order, he positioned an empty ice cream cone under a spigot. By carefully revolving the cone, he got a thick stream of custardy ice cream to form a perfect pyramid of swirls on the cone. It had to be high enough to take your breath away and yet not topple over when he handed it to you. Especially not *after* he handed it to you.

"Wow," Richie would always say, which wasn't an inappropriate response. But since Carvel was part of our parents' conspiracy to get us to like Springdale, I tried not to look too enthusiastic.

Whenever I played the piano, I could imagine myself back in Brooklyn, listening to DeeTee in the kitchen frying *plátanos* and stirring tiny, star-shaped pastina into her chicken soup. With the piano right in the house, I knew I wouldn't have to balance DeeTee's food-filled, brown canvas bag on the handlebars of my bike and drive home afterwards. Like it or not, I was home.

Fried Plátanos

INGREDIENTS
1½ tablespoons vegetable oil
2 yellow plantains, peeled and cut into ½" thick
slices on the diagonal

1. In a large skillet, heat oil over medium-high
heat.

2. Add plantain slices; do not crowd. Cook until
golden brown, about 4 minutes each side,
turning once.

3. Drain on paper towels and serve.

The Food of America

EVERY SUMMER OUR PARENTS PLANNED a vacation with educational overtones. From the Thousand Islands to Watkins Glen, from West Point and Niagara Falls to Saratoga Springs, we spent every day learning about our state. In canoes, on horseback, in buses and even on the *Maid of the Mist* we listened to Dad's encomiums about how New York the state, like New York the city, was a summer festival. To enjoy this splendor and sylvan majesty, Dad reminded us often as he clicked his Leica in every direction, we never had to stray far from home. In fact, in the '41 Chevy, we never could stray very far before Dad had to pull the sputtering car over to the side of the road while Mom tried to make believe she wasn't worried we'd be stranded out in the middle of nowhere. We knew we were in trouble when Mom brought out the bag of candy that, if she told us once she told us a thousand times, was supposed to last the whole trip. If she handed it over to us in the back seat with no mention of portion control, we knew we'd entered a state of emergency.

All this changed in Connecticut when Dad bought a Nash Rambler Station Wagon. With this sleek red and black beauty at their disposal, our parents planned the vacation of the century. That summer, they announced, we would drive to Disneyland, visiting all the major parks and monuments along the way. They were serious.

Before we knew it, we'd driven through the Pennsylvania Dutch country, past Amish barns with hex signs painted on them; we'd visited the Ford plant in Dearborn, Michigan; we'd spent hours in the Museum of Science and Industry in Chicago. The Rambler rumbled over the scrubby Badlands and into the craggy Black Hills presided

over incongruously by the four white-faced, blank-eyed chief executives. We got to Yellowstone in time to see Old Faithful do its wild leap into the purple sky and, in Salt Lake City, we sat in the water, unsinkable as innertubes. We went to San Francisco and Disneyland, the Painted Desert, the Grand Canyon. We drove across the Texas panhandle. We were somewhere in Texas, on our way home, before the education part really kicked in.

It was getting late and we hadn't found any place that my parents thought looked good enough to stop for dinner. Maybe we were lost: there was that kind of quiet going on in the car. We weren't on a highway or anything. The road was narrow and scrappy, lined with fields of what looked like dried straw. We hadn't passed a gas station for miles when finally we spotted a homey looking cottage with lights twinkling behind red and white checked curtains and a sign outside that included a painting of a chicken. As we got closer, it became less and less charming. By the time Dad pulled into the beer-can-lined parking lot, it looked more like a ramshackle wooden shack with a couple of bare light bulbs hanging from the ceiling. On a square piece of wood nailed to a stick by the front door were scrawled the enigmatic words, "Chicken in The Basket."

"What do you think, Loretta?" Dad asked in a low voice that conveyed a total absence of hope. Mom shrugged and sighed simultaneously, never a good sign. "Do you think they mean chicken that's cooked or do they just sell chickens?"

None of us spoke fluent Texan. As had become customary in such preprandial scouting expeditions, Dad got out of the car to give the place a closer look. As he set foot on the sagging wooden steps, they creaked and moaned, an unpromising greeting immediately supplanted by the squeaking hinges of the front door. Undiscouraged or possibly motivated by starvation, Dad proceeded inside. Seconds later, he reappeared, waving us out of the car. The restaurant—or the haunted house as Richie had dubbed it—was one big room. People in cowboy hats sat at old wooden tables eating from red plastic baskets. Dad asked for menus.

"Chicken in The Basket. That's the menu, folks. With fries. Without. Take your pick."

Dad looked crestfallen, as if he'd failed us, from the dubious hygiene to the odd-sounding meal, to the fact that it was so late we probably couldn't find anyplace else. I thought he was going to cry.

"Can we each get our own basket?" Richie asked hopefully, attracted by the prospect of not having to share with Ferdy for once.

"Can we? Can we?" Ferdy and I chimed in, not to be outdone by our little brother.

"Oh," Dad said, the sorrow in his eyes melting into gratitude for our enthusiasm. "Oh, sure."

"With fries," Ferdy and I said. "And catsup," added Richie for whom all meals had to involve either catsup or peanut butter or both.

"Wait a minute," Mom cautioned, who was in charge of the finances. "What if you don't like it?"

"We'll like it."

Hadn't we been watching Hopalong Cassidy movies practically since birth? And Buster Crabb, Tex Ritter, Roy Rogers. The waiter was wearing cowboy boots; in fact everybody was wearing cowboy boots. How could we not like it?

"Five," Dad said with a weak smile that suggested he'd half forgiven himself for subjecting us to this unorthodox eating situation. Mom didn't say anything but we all knew she'd have plenty to say later about such extravagance. Silently we vowed to finish every crumb, for Dad's sake. Everyone in the restaurant seemed to be looking in our direction. Through the curtain-framed window, our red and black Rambler glowed under the peach yellow moonlight, also claiming the attention of the diners. Dad took the opportunity to ask us which was our favorite sight we'd seen so far on the trip. He listed a few possibilities from the previous four days—Hoover Dam, the Petrified Forest, Grand Canyon—adding "but don't forget all the places from last week." Ferdy was ready with his choice.

"When we had the flat in San Antonio," he chirped.

"Oh," Dad responded both intrigued by the choice and concerned that he'd neglected to emphasize sufficiently the educational aspects of this vacation. He persevered.

"What did you like about that?" He was hoping for a mention of our walk through San Antonio's riverside paths and how they meandered under the city itself through fields of summer flowers, past tufts of cactus, and around the dramatic outdoor auditorium and theater.

"I liked when the screws were rattling inside the hubcaps and the tire almost fell off and we got to eat in the Sears cafeteria."

It was hard to argue with Ferdy's choice on the basis of dramatic appeal. Thanks to the incompetence of the Sears Automotive Services of San Antonio, who installed a new tire with such a light touch that the bolts started coming undone as we drove down the highway, we'd achieved our closest proximity to disaster.

"Yeah," Rich chimed in, "and the peanut butter sandwich was great."

As compensation for our near-death experience the Sears manager invited us to have lunch, free of charge, in the company dining facilities. Although Mom was charmed by the favorable economics of the offer, which obviated the need to enter lunch expenses on the Triple A Trip-Tic Budget Page, she remained miffed at Sears for practically killing the family.

"I liked the breakfast club at the Black Hills," I offered, sensing Dad wasn't enchanted with the particulars of the boys' choice. Some radio program, like "Don MacNeil's Breakfast Club," was being broadcast from the mountaintop restaurant nestled amongst the pine trees forming a prickly ruffled green collar under the chins of the presidential quartet. While we ate our French toast, a man with a microphone asked people where they were born and then launched into a few bars of some song that said how great the place was. "Brooklyn" was about the only response that triggered nothing in his repertoire.

Meanwhile Dad didn't seem to be getting the kind of answers he'd been hoping for. Mom said her choice was San Francisco because of how cool and delicious the air was when we drove over the Golden Gate Bridge. Plus, she added, they made such good chow mein in San Francisco even though it was so far from New York. It was clear that food was on everybody's mind.

By that time the waiter was back, his arms lined with baskets from palm to shoulder.

"Who's got the chicken?" he asked, waiting until we all chuckled. Someone had to say "We all have the chicken" before he set anything down. "That's Texas humor for you," Mom would say in later retellings, but at that moment we were too famished for cynicism.

The aromas from the napkin-covered baskets conjured up visions of the outdoor grill in the country with Gramps tending charcoal-flecked chicken breasts and smoldering, unshucked ears of corn roasting in the coals. Dad's request for forks reignited the restaurant clientele's amused interest in us. The waiter answered Dad's question with a question that served as an answer.

"Forks?" he repeated, as if the word itself was only dimly familiar, the implication being that we were the barbarians in the room.

Forklessly I proceeded, unsurprised that the bronzed, sizzling hunk of chicken burned my fingers but too hungry to care. The skin was as crisp as potato chips, the flesh juicy and buttery and sweet. Soon, essence of chicken slathered my face and cheeks, wandered down my arms. I didn't care. I was in love with that chicken. This wasn't just eating; it was more like transubstantiation, where ordinary things like chicken take on aspects of the divine. There was also something wild going on, as if this was how people ate before the invention of manners and other obstructions to pure pleasure. Judging from the silence at the table, everyone felt likewise.

When we left Texas the next morning, we headed north toward home. Mom and Dad took turns driving so we could make good time. There were no more natural wonders or educational experiences on the itinerary. "Chicken in The Basket" had been the last.

Chicken in the Basket

INGREDIENTS

½ cup honey
3 tablespoons lemon juice
3 pounds chicken wings
½ cup flour
½ cup yellow cornmeal
1 teaspoon salt
¼ teaspoon cayenne pepper
1 cup vegetable shortening
red baskets

1. In a large bowl, combine honey and lemon juice. Marinate chicken wings in this mixture 3 hours.

2. Remove chicken from marinade. In a plastic bag, combine flour, cornmeal, salt and cayenne. Shake wings in bag to coat with mixture. Chill 30 minutes in fridge.

3. In a large skillet, heat shortening until surface ripples. Fry wings in one layer, turning until golden and tender on all sides, about 15 minutes.

4. Drain on paper towels. Place in red baskets, one per person.

The Betty Crocker
Homemaker of Tomorrow

PAMELA MANNING WAS ONE OF THE SMARTEST girls in our class and yet she liked to cook. It was absolutely embarrassing. At Sacred Heart Academy, when you signed up for the College Program, you took Latin, French, science, and the other academic subjects you'd need to get into a good Catholic college; preferably a good Catholic girls' college. You didn't take home ec, sewing, cooking and other time-wasters. You spent your time doing interlinear translations of Caesar's Gallic Wars and tried to ignore Pamela walking into study hall with a batch of fudge. When she bragged about how she made it from scratch and how her family loved it so much that she had to make a whole extra tray, her voice reeked domesticity, like something they'd say in an Aunt Jemima commercial or on "Ozzie and Harriet."

Pamela didn't seem to notice that the nuns would look at her as if she was frittering away her mind and then quiz her more closely on her declensions to make sure she hadn't sacrificed valuable home-work time. Sister Frances Teresa would remind us that *"Petimus alti-ori,"* our school motto, meant "We seek the higher things." It was obvious from her timing and her tone of voice that making fudge was not one of those things. The nuns were also a little suspicious of those who showed an interest in cooking because of its association with sex. If an Academy girl had cooking on her mind, she was prob-ably thinking more about marriage than going into the convent.

However on one occasion every year, cooking skills were actively solicited, and much fuss was made over Pamela Manning's talents, which suddenly seemed to qualify her for possible canonization. Just

before Thanksgiving, Sacred Heart Academy would host Mission Night, an event to help raise money for the Society for the Propagation of the Faith, a fancier version of our grammar school efforts to save the pagans. Mr. Crimmins, the janitor, would clear the lunchroom of all tables and chairs and each class would set up booths. "Throw a Ball, Win a Cake" was the sign posted over the appropriately named Cake Booth. This was clearly Pamela's territory, and her chocolate fudge cakes, frosted cupcakes with colored sprinkles, peanut butter cookies and walnut brownies attracted ball throwers throughout the evening. Other booths, like the Fish Pond, the Candy Booth, the Trading Post, were supposed to offer various prizes and awards, but thanks to a general lack of imagination shared by both students and nuns, most prizes were cakes in one form or another.

"Don't have your mothers do all the work," Sister Rose cautioned in her instructions to bring in as many prizes as possible, necessitating my annual visit to my mother's old green cookbook. Although I never once saw Mom consult that cookbook, its spine was broken, its pages stuffed with clipped recipes and scribbled notes. The pictures were black and white except for a few pages in the middle depicting mothers in aprons smiling proudly behind "chafing dish meals," chiffon cakes and cocktail sandwiches in garish shades of pink and green, slightly out of register.

If Pamela Manning could make things from scratch all by herself, then why shouldn't I be able to, I reasoned. I was glad Mom was around, however, because of the incident with the chicken legs for the CYO picnic a few months before. Strictly speaking, that was my first solo cooking experience and I was already trying to forget it. At the CYO meeting, the boys were told to bring potato chips and cokes for the picnic—"unless your mothers would like to make lemonade"—while the girls were supposed to bring the food—"your mothers can help you, of course." I didn't think it was fair, but you didn't argue with Father McMurray unless you wanted to be excommunicated or barred from the picnic or both. I told Mom I'd take care of it. I bought a dozen chicken legs, put them on the tray of Mom's new rotisserie and turned it on. When the bell rang, I started

taking the chicken legs out and packing them into the picnic basket. At that moment, Mom walked into the kitchen.

"Are these done?" she asked, poking her finger into the pale spongy flesh.

"I'm sure they are," I answered confidently, somewhat annoyed that she was intruding. "The bell rang."

I'd heard Mom say that the beauty of these new broiler ovens was that they rang when the food was ready.

"Yes, but how long did you set the timer for?"

"Set the timer? What timer?"

That was the thing about cooking. There was always some little trapdoor or unflagged detour to waylay the uninitiated.

I kept this caution firmly in mind leafing through the green cookbook, looking for cakes for Mission Night. Even the shortest recipes used confusing words like sift and fold and included directions for separating eggs without mentioning what you were supposed to separate them from.

I didn't want to ask Mom for a suggestion lest I hear those fateful words "Pineapple Upside-Down Cake." If she mentioned it as a possibility I thought I'd say something like "But Mom; kids like icing." I held my breath as I thumbed through the green cookbook when she said, smiling, "I have an idea. How about a mix?"

Although I knew Pamela Manning wouldn't be caught dead using cake mix, I quickly answered in the affirmative to avoid visions of pineapples dancing in Mom's head.

We went to the Springdale Market together. The shelves spilled over with different brands of mixes picturing cakes slathered in beautifully gooey frosting that you could practically lick off the package.

"Let's get Duncan Hines," I suggested, remembering the commercials demonstrating how much higher their cakes were than the squat alternatives. As proof, a ruler was usually brought forth and the announcer would point disdainfully at a deflated-looking Brand X and its unappetizing shortness. This inferiority extended even to the frosting, which was lower and pasty looking, not glistening and swirling balletically over the top and sides. Duncan Hines was more

expensive than any of the other brands, though the advertising had certainly made clear why that should be. The price differential did not escape Mom's eagle eyes.

"You're just paying for the name," she explained, dismissing all claims to superiority and distinctiveness. "They're all the same."

In fact, all the mixes were made in the same factory, she continued, and they dumped them into different boxes and charged whatever they could get. You had to keep your wits about you when you bought anything in this world and cake mixes were no exception.

"These guys will tell you anything," she cautioned. I wasn't entirely convinced as we passed over the line-up of proud-chested Duncan Hines angel foods and yellow cakes on our way to the Brand X section.

"Let's get one that already has the eggs added in," Mom suggested. "Why go to the extra work if you don't have to?"

A dark, chocolatey, double-layered cake thick with frosting seemed the perfect choice, if only for its name. The irony of introducing into the sanctimoniousness of Mission Night a cake called "Devils Food" was highly motivating.

In the kitchen, Mom climbed on the folding stool searching for cake pans on the barely reachable top shelf. I located the mixing bowl and cleared a space between the breadbox and the broiler oven. I didn't find any eggs in the box after all—yet another cooking enigma—but I didn't dare tell Mom. "Just add water," the directions said, so I took out the eggbeater and churned away. It was supposed to be easy but we still had to put the batter in the pans, put the pans in the oven and wait about a thousand years. Then we had to make the frosting mix, spread it on the layers, put the whole thing together.

The entire process was both disconcerting and oddly familiar. It reminded me of an uncomfortable experience I had back in Brooklyn when I was, well, a little girl. Like all little girls, I had my allotment of dolls and a doll carriage to wheel them around in, not that I'd be caught dead doing it. The kids on the block, like Billie and Frankie, would never have stopped teasing me nor could I see any sense in it. One day when they weren't around and in partial fulfillment of my girlie duties, I hauled my all-but-abandoned doll

carriage down the two flights of stairs in our house and wheeled a few of my dust-covered dolls up and down East 37th Street. I was doing it because I was a girl; it was expected of us so we went through with it even though it was stupid and meaningless. I completed a few rounds with eyes lowered hoping, ostrich-like, no one could see. I then returned my doll paraphernalia to its place behind the snow shovels on the landing and vowed never to do that again.

"It looks pretty," Mom said, as I finished a few swirls on the top of the cake.

"Yeah. Thanks for your help, Mom." I felt guilty for roping her into this; we were both victims.

After Mission Night, there was no further mention of cooking and matters of domestic servitude until the last month of school when Sister Frances Teresa told us we would be taking a written exam called "The Betty Crocker Search for the American Homemaker of Tomorrow Knowledge and Aptitude Test." It was a multiple-choice, true-false test, nothing to study for and nothing, thank God, to cook. Nor did we have any choice about taking the test; it was required. Aside from the hour we devoted in Religion class to "Casti Connubii," the papal encyclical on marriage, the Betty Crocker test was the nuns' only concession that not everyone would become a Carmelite. In the context of Sacred Heart Academy, these two activities constituted sex education.

In one sense, I didn't mind the test idea. I looked forward every month to the *Readers Digest* test to increase your word power. On Sundays I scribbled the answers to the *New York Times* quiz on the week's news events. When Dad made up his exams for the night course he was teaching at Bridgeport Engineering Institute on some engineering subject called "Strength of Materials," I begged him to let me answer the multiple-choice questions, most of which I got right despite my complete ignorance of the subject. When I took the Betty Crocker test, I was pleased to discover that I knew much more about strength of materials than I did about cooking.

On Awards Day, Sister Frances Teresa stood on the stage in the front of the auditorium and rattled off the names of the girls who'd won the Catholic Daughters of America Poetry Contest, the I Speak

for Democracy contest, and various other honors and competitions. Pamela Manning was half out of her seat, one of her neatly saddle-shoed feet poised in the aisle, when Sister Frances Teresa got to the Betty Crocker Homemaker of Tomorrow Winner. All eyes were following the sway of Pamela's tightly curled pageboy haircut as she rose up, shook her head incredulously and sat back down.

"Come on up now. Don't be shy," Sister coaxed, holding a gold sealed certificate in one hand and a glittering beribboned medal in the other.

She seemed unaware that Pamela had possibly fainted in her moment of glory. In fact she wasn't even looking in Pamela's direction nor, I suddenly realized, was she saying Pamela's name. The name she was saying was all too familiar. Because Sister Frances Teresa did not generally go in for practical jokes, I had to concede that she was serious about this announcement; but when she referred to me in uncharacteristically endearing tones as "our own little Betty Crocker," I knew there was only one way to shut her up. I walked down the center aisle to the stage, sensing giggling on all sides.

"You certainly surprised us all," Sister prattled on, pinning the shiny medal, with its carving of a hearth, on the pocket of my blue uniform.

As I stumbled back to my seat, I could see my friends Peggy Anne Daly and Gertrude Schmied flashing their eyes at me, their cheeks puffed with stifled guffaws.

"Some people are just good at taking tests," I explained to them later in a futile effort to stop their incessant teasing. "Some people are just smart," I added finally. I didn't care if they called me "stuck up"—anything was better than "our own little Betty."

After I buried the medal under my socks, I felt somewhat relieved. But I was haunted by the dilemma it raised. If you're so smart, I kept asking myself, how come you know so much about cooking?

Pam's Fudge

Pam never gave anybody any recipes, but her fudge, even if you were mad at her, was great. And so is this one. Maybe better. You don't have to cook it or anything.

INGREDIENTS
- 1 cup condensed milk
- 1 12-ounce package chocolate chips
- ½ cup chopped walnuts
- pinch salt

1. Butter an 8-inch square pan and line with wax paper.

2. In a double boiler, heat chips until melted. Remove from heat.

3. Pour in milk and mix quickly, adding nuts and salt.

4. Pour into pan and refrigerate until set.

III. Higher Education

The Blintz

My suspicions about Mrs. Hadelman began the day I met her. Minnie Hadelman lived in a two-story, brick and stone, Tudor-style house about a block away from Southern Connecticut State College in New Haven. She had lived there for a half century, with kids who were now married and had kids of their own and with a husband, her beloved Morris, who had died a few years before. It was her kids who suggested she rent out one or two of the bedrooms to college students so she'd have a little company with very little intrusion in her life. I was the first one to knock at her door.

It was opened slowly and hesitantly by a gnome of a person, about four feet eight inches tall, her broad thick body covered with a blue checked apron. Maybe it was because I was only eighteen, but to me Mrs. Minnie Hadelman appeared ancient, an impression reinforced by her clunky leather clogs that looked primitive if not Neanderthal. Except for a bright glow beyond the staircase, the house seemed dark and cave-like when Mom and I stepped into the tiny vestibule. I could tell by the way Mrs. Hadelman's black-pearl eyes rolled over my face that she wasn't sure renting out a room was such a good idea. Her vigilant-bulldog expression softened considerably when Mom, with her gentle blue eyes, explained that I was a new student at the college, that she was my mother, that we hated to disturb her, but that if it wasn't too much bother, we'd like to see the room. The door squeaked open wide enough for us to squeeze through, single file. She wished Mom was the one renting the room; you could tell.

Mrs. Hadelman led us up the stairs and showed us the two avail-

able rooms, one of which was twice the size of the other and had a large window overlooking the shrub-covered back yard.

"Is only fifteen dollars a veek," Mrs. Hadelman called out, circus-barker style, as if suddenly remembering the phraseology her kids re-hearsed with her for attracting potential customers.

"And for the smaller room?" Mom asked, ever on guard against the sneaky workings of salesmanship, even in the innocent-looking elderly.

"Is the same," she answered.

If no one took the smaller room, I would have my own private suite up there, complete with a bathroom with a stall shower down the hall. As Mom paid her, Mrs. Hadelman seemed to unlock her face and, though she didn't exactly smile, she was obviously relieved to be finished with the uncomfortable business of displaying her house to strangers. She seemed even more at ease when I told her I wouldn't be moving in until classes started the following week. Sud-denly she looked like a grandmother, even a great-grandmother, as she gestured toward the light at the rear of the house and said, with a half smile, "I'm making today blintzes."

I had no idea what she was talking about.

By the time I returned, luggage in hand, I'd re-envisioned my quarters on the second floor as a two-room penthouse loft with picture windows opening onto the surrounding countryside, the smaller room, still unrented in my fantasy, transmogrified into my pine-paneled library, the spacious master bedroom devoted to rest and leisure. Consequently I was less than delighted to come upon Elizabeth Brancato unpacking suitcases and hanging her clothes in my library.

"Thanks for the recommendation," she said, her wide Orphan Annie eyes sparkling with enthusiasm. "I'd just about given up when you gave me Mrs. Hadelman's number."

"So I have only myself to blame" is what I felt like saying, catch-ing myself in time. Instead I mumbled something about how nice it was that we knew each from eighth grade at St. Mary's. Actually we hadn't seen each other for four years, since she'd gone on to high school at Mother of God Academy while I'd gone to Sacred Heart.

"Did she tell you her rules?" Liz whispered, pointing down toward the floor, below which we could hear the clatter of pots and pans. At that precise moment, the word "Girls" drifted up the staircase.

"The place is bugged," we agreed, giggling.

Mrs. Hadelman was waiting at the bottom of the stairs. No food in the rooms, no kitchen privileges, no loud music, no boys. Those were the rules? The minute we were out the door, our giggling resumed: she calls those rules? If Mrs. Hadelman thought these were rules, she'd obviously never been anyplace like Sacred Heart or Mother of God. I wondered if Liz shared my suspicions about Mrs. Hadelman, but I decided not to bring them up quite yet.

At first I didn't mind eating at Southern Connecticut's cafeteria. The swamps of creamed corn and waterlogged green beans tasted comfortably familiar, and eating at the "caf" was collegiate. The gravy-drowned melange universally referred to as mystery meat completed our initiation into the halls of academe. Once we'd fully appreciated its value in confirming our college-student sense of identity, the cafeteria menu lost some, if not all, of its enchantment. It was Mrs. Hadelman who came to our rescue.

"You know vere iz Valey Avenue?" she directed, referring to New Haven's main drag, Whalley Avenue, about a half mile away. "Vell, there you vill find Chuck's Diner."

Encouraged by our gratitude, she continued with her suggestions.

"You know vat iz blintzes?"

We both shook our heads in the negative.

"Chust as vell. At Chuck's iz not so goot the blintzes. Better you should try the chicken soup. It vudn't kill you."

Chuck's certainly looked more promising than the "caf." A shiny, chrome and yellow diner-shaped building, it was filled with yellow formica-topped tables and chocolate-brown, leather-covered booths along one wall. As soon as we sat down, a bowl of pickles cut in thick, juicy-looking chunks magically appeared.

We ordered grilled cheese sandwiches, envisioning squares of Velveeta and congruent butter-browned squares of toasted Wonder

Bread dissolving into each other. Cautiously we tested the pickles. They weren't anything like the candy-sweet, little gherkins we were used to. They were much more attention-getting with lots of little spurts of flavor and a squishy chewiness that kept us reaching into the bowl until our fingertips met only residual pickle juice at the bottom. We felt chastised when the waitress whisked away the empty bowl, so when she replaced it with another, we restrained ourselves until she was safely across the room.

"Kosher dills," she said they were called when she came back with the third not-quite-as-full bowl. Liz and I discussed the meaning of the word kosher, agreeing that it meant "blessed by a rabbi." Considering how many bowls of pickles floated on and off tables, their rabbi had his hands full. Our conversation about the concept of kosher and its implications was curtailed by the arrival of two amazing sandwiches: thick slabs of golden, butter-yellow bread stuffed with molten Swiss cheese, enticingly stringy. We ate until we were panting, only managing to finish half our sandwiches. They were just too wonderful to leave so we decided to bring them back to Mrs. Hadelman's and ask her if we could keep them in her refrigerator until the next day.

"They bake their own challah," was her first comment as she led us into her brightly lit kitchen at the back of the house. "You vudn't vant to vaste such sanviches."

Liz and I looked at each other. Challah? We shrugged our shoulders. Whatever it was, if Mrs. Hadelman thought there was some of it on our sandwiches, we weren't going to disillusion her. At least she wasn't angry about our bringing food into the house.

As she cleared part of a shelf in her refrigerator, I noticed the counter lined with cookie sheets covered with molasses-brown, sticky-looking lumps of something that looked like Chinese egg rolls. The kitchen smelled festive and tantalizing, as if holiday baking was in progress. Actually, it was almost always like that; a deep sniff at any time of day or night would suggest that Mrs. Hadelman was in the midst of some oven-oriented task. It was like living in a restaurant, but nobody ever came to eat. Mrs. Hadelman was a cooking addict; she couldn't help herself. That was the only explanation.

"Rugulah," she said, shedding no light on the nature of whatever it was she was giving us to eat. Nuts and raisins cradled in something crispy and cookie-like, definitely not a Chinese egg roll.

Her daughter, Shirley, didn't have time to cook, she explained, but her grandchildren loved everything—"my knishes, my latkes, even my stuffed derma, vud you beleef?" Her flour-dusted hands leapt between dough balls and rolling pins and cookie sheets as she explained that she cooked and froze her repertoire all during the week until Shirley came by on Friday afternoon and transported it all to her own house. When Mrs. Hadelman informed us that day that we could have our morning coffee in her kitchen from then on if we liked, she looked wistful, as if finally acknowledging that someone was living in her house. And we could even make ourselves eggs or something once in a while, she added, as long as she wasn't using the stove, an unlikely event.

I could hardly wait until Liz and I got upstairs so I could reveal my growing suspicions about Mrs. Hadelman. The time had definitely come. I tried to increase the suspense by whispering that I was about to tell her something shocking, or something that might be shocking, if I were right, which I wasn't totally positive about.

"Come on. Stop stalling. Tell me," she begged.

"Okay, okay," I conceded, and then watched Liz's jaw unhinge as I revealed my secret theory: Mrs. Hadelman might possibly be Jewish.

"What makes you think so?" Liz gasped.

"The food for one thing; did you ever hear of any of that food? Stuffed derma? What is that?"

"God only knows," Liz said, shaking her head slowly from side to side.

"And also the kitchen, not wanting us in there. It has something to do with things being blessed by rabbis, you know, that kosher stuff."

"Wow!" Liz said, catching my excitement. Neither of us had even been close to a Jewish person in our lives, never mind live in the same house with one. It was not only exotic, it was daring. No longer would we be dwelling in our insulated enclaves ringed with rosary beads and founded on rocks which the gates of hell would not

prevail against. Gone was that comforting if boring predictability, the relentless certainties, the underlying, inescapable syllogisms clamped to our brains. We were surrounded by things radiant with mystery: the couch in the living room with its gold-braided cushions and intricate brocade; the velvety wallpaper with its raised maroon curlicues, like secret messages; the creaky beds we slept in, the peeling wooden padlocked hope chest in the corner of my room. These were no longer background music, scarcely worthy of notice. They were Jewish; everything was Jewish.

We couldn't wait to get down to the kitchen in the morning where we were definitely planning to have our coffee, if only to experience the titillations of esoterica. How could we have missed the soap, a translucent square with some cabbalistic blue writing embedded within, or the little candles in their little, bumpy glass holders.

"Ah, goot morning, girls," Mrs. Hadelman called to us from the dining room, a Jewish hairnet covering her head. She was packing some Jewish goodies into a Jewish cardboard box. The kitchen smelled like a Jewish apple orchard.

We'd brought our own cups so as not to disturb the universe and we even had our own jar of instant Maxwell House. But we didn't know what to do about boiling the water. If we used her kettle, would it be a sacrilege? Did they even have sacrileges in their religion? We stood there immobilized by our ignorance and by our respect for inscrutability. We were Martians; we would not trespass.

"I already make the coffee. Iz hot. And you haf here some strudel I make for my grandchildren today. They can't luf me enough ven I make for them strudel."

My first taste of Mrs. Hadelman's apple strudel was practically a conversion experience in the biblical sense. The nuns had always warned that if you go to a non-Catholic college you run the risk of losing your faith. Eventually that's what happened, but it would have happened at that very moment if I'd had to choose between the promise of eternal life and Mrs. Hadelman's strudel. Nothing the Pope had to offer could compare to the tender collision between crinkly slips of pastry and tiny dissolving chunks of apple, between flesh and fruit and nectar, holiest of communions.

"Thanks, Mrs. Hadelman" we both said hoarsely, when we could speak.

A few days later, a short, slender old man in a brimmed hat came to the door. He was the rabbi, Liz and I could tell instantly, because he had a beard and everything he wore was black. He'd come to re-bless everything in the house, we suspected, to make sure it was still kosher now that we'd been on the premises for a while. We wondered if we should remove our coffee cups from the cupboard, if the re-kosherizing wouldn't take if there were some foreign substances in the air. From listening to Mrs. Hadelman talk to Shirley, we'd learned that we were gentiles. So our cups were probably gentiles. We still worried about sacrilege.

His name was Mr. Rich and he wasn't a rabbi after all. Though he looked antediluvian, he was Minnie Hadelman's boyfriend, her suitor, of all things. They played some kind of Jewish card game at the dining room table and then afterwards they moved into the kitchen where Mrs. Hadelman made tea and served some of her unbelievable cookies—not too many, we hoped, since we might be the beneficiaries of leftovers. We were sure they would never move on into the bedroom—they were so old—but we listened anyway. Catholic old people would never, but we still didn't know everything there was to know about other religions. Besides, one night, when we'd gathered around Mrs. H's television to watch President Kennedy scare us to death about the Cuban missile crisis, Mrs. Hadelman started talking about how handsome President Roosevelt was.

"I alvays said," she confided, rolling her eyes dreamily, "that to hef spent vun night vith det man vud have been virth everything."

Liz and I were speechless. We couldn't believe our ears. Did she mean she would have spent the night discussing politics and the state of the world? What else could she possibly have meant? It was too embarrassing to ask for clarification.

One winter morning, a Saturday when I was alone because Liz had gone home for the weekend, I went down to the kitchen and found Mrs. Hadelman making pancakes. Since she was such a great cook, I imagined she was very frustrated at the failures she was producing. Instead of getting nice and thick, these emerged from the

pan smooth as skin and paper-thin. She piled them on a nearby plate and kept trying. Finally she brought them over to the sink, I assumed to scrape them into the garbage. Instead, she spooned some white fluff on them, rolled them up and tucked the edges in.

"You know vat iz blintzes?" she asked, bringing over a tray of the little plump cylinders. "You vait."

She melted some butter in a pan, slid one of them in for a few minutes and slipped it onto a plate. The way it looked—speckled with nut-brown glaze still sizzling with butter—if she hadn't handed me a fork, I would have scooped it up with my tongue. Inside the lace-thin pancake wrapper was a creamy pillow of something, at once tart and sweet. Talking with my mouth full became an absolute necessity because the urge to thank her and the urge to continue eating were of equal intensity.

"You like it?"

My praise, effusive though it was, was not a ploy to inspire an encore, though I would gladly have accepted the gesture.

"Goot," she said, returning to her batter and frying pan. "My grandchildren, they don't know vat to do vith me ven I bring to them blintzes. My daughter, she's too busy. She knows how to cook nothing. I tell her 'Don't bother, Shirley; vat else do I have to do all day?'"

I couldn't keep my eyes off her movements, the way her hands knew what to do, pouring the precise amount of batter, swirling it to cover the pan, the knowledge deep in her bones, easy as breathing. Suddenly she was my grandmother imagined back to life, DeeTee at her stove long ago in Brooklyn, humming some ancient rhythm soon to be lost forever to the new generations.

Minnie-like Blintzes

INGREDIENTS

Pancakes:
 3 eggs
 pinch salt
 1 cup milk
 1 cup flour
 butter or vegetable oil for frying

Filling:
 2 cups not-too-creamy cottage cheese mixed with
 a pinch of salt and as much sugar as you want.
 You could also add blueberries or something,
 but Minnie never did.

1. In medium bowl, beat eggs with salt. Add
 milk and flour and beat until smooth.

2. In a six-inch frying pan, heat butter or oil.

3. Pour in about 2 tablespoons batter, tilting pan
 to coat bottom.

4. Cook on one side until firm; do not let brown.

5. Turn pancake onto large cookie sheets or
 plates and continue until all batter is used.

6. Spoon one tablespoon filling on end of blintz
 and roll up, making sure filling is even.

7. In large frying pan, heat butter or shortening
 and fry blintzes until golden brown.

Makes about 16 blintzes

The Tea Ceremonies

My friends Tom and Dennis had invited me over to share a bowl of ice cubes. It was getting toward the end of the month and they had to divert their food budget to the rent; ice cubes were their customary fare during this period. I loved the idea of chewing on ice cubes when we discussed, as we inevitably did, the significance of Ezra Pound, T.S. Eliot and, for some reason which nobody could recall, Karl Shapiro. Eating real food under these aesthetic circumstances seemed crass and corporeal. So it wasn't the menu that led me to refuse their invitation. I had a previous appointment with James Joyce.

Tom and Dennis understood completely. Every year around this time we became obsessed with Joyce, it being only a few weeks till Bloomsday. We all wanted, in a fervent but vague sort of way, to do something to commemorate that fateful June 16 in 1904 which so profoundly affected English majors, which all of us were. No one was more passionate about this anniversary than our friend, Jim Childs.

Jim's annual goal was to organize a twenty-four hour "*Ulysses* read," sunrise to sunset, with several people "passing the book," as he put it. This tendency to pun at the slightest provocation was one of Jim's more obvious attempts to identify with Joyce. His name was also Jim, a coincidence that strengthened his link with Joyce, at least in his estimation. He had a scraggly little mustache, and his little round disc eyeglasses were identical to Joyce's. The fact that he didn't seem to be going blind like Joyce was somewhat of a disappointment to him, but he squinted a lot to make up for it. Guys who wanted to

be hip wore ascots in imitation of Brooks Brothers ads in *Playboy*, but they couldn't compete with Jim, who always draped, slightly askew, an old, fringed wool plaid scarf around his neck, a piece of apparel so uncollegiate, it was cool.

With the possible exception of this scarf, the most important thing about Jim was his poetry, which he wrote, not like the rest of us, but like he meant it. He persevered. He revised things, stuck in lots of objective correlatives and obscure mythological allusions from Sanskrit and *The Golden Bough*. He wrote poetry as if he were going to do it as a glorious career, not just until he graduated. He used metaphors about the pomegranates that Nikos Kazantzakis had already used as metaphors. The fact that neither of them was really talking about pomegranates made them peers in my admiring eyes. Jim wrote smart things about doors that were so indecipherable they could only be works of genius. One of his poems, which ended with the line "The wild giraffe is a door," was so poignant, Jim himself was moved to tears when he read it aloud one evening. Before I could completely blink away my baffled expression, he was asking me if the image "worked."

"Oh yes. It works," I answered hastily, "I can see it."

"See what?"

"The door."

"The door?" He sounded as if he had never heard the word in his life. I tried to keep my voice from cracking.

"Well, I can feel the door in this poem. Not as a slab of wood, but as a, well, more like a passageway. Door, meaning 'the way through'. Or possibly transcendence. More metaphysical. Like Eliot's 'table'— you know, the one the patient's etherized upon—is sort of like your door, wouldn't you say?"

He wouldn't. He knew better. He knew about Ghiberti's big bronze doors and put them into another poem. A whole decade would pass before I stood before those doors in Florence and understood what all the fuss was about.

Unlike Joyce with his white wine in the cafés of Trieste, Jim drank tea in his New Haven kitchen under a hanging tin lamp. He took it black—milk had too much dimension—and he never seemed to eat

anything, not even ice cubes. We never mentioned the subject of food except for mutton kidneys, Plumtree's Potted Meats, sheep's trotters and some of Leopold Bloom's other Dublin favorites, which we discussed for their symbolic rather than gustatory qualities. Jim's interests were too ethereal to bother with mundane considerations like eating.

"I'll just have a cup of tea," I'd say if the subject came up, sucking in my stomach to minimize the rumbling. I'd rather starve than have him watch me putting food in my mouth, chewing and swallowing. It seemed so animal, so unliterary. Around Jim, delayed gratification was positively poetic.

Jim was married to Terry, tall and gray-eyed, with peach-white cheeks. Like the rest of us, she considered Jim brilliant, funny, and destined for literary immortality, so much so that she worked a full-time job in the post office to support them. She bubbled with energy even after completing her four-to-midnight shift while none of the rest of us had completed anything but a few heroic couplets.

When Jim and I finished planning the Bloomsday reading, we were both exhausted and I was famished.

"Why don't you two go to the movies," Terry suggested, probably because she was tired of listening to us mumbling interminably about Icarus and Penelope. "You guys need to get away from all this intellectual garbage for a while."

Jim liked the idea immediately and asked if I were interested in one of the films playing at Yale's campus theatre. I didn't care what we saw as long as I could get some popcorn, not that I would mention it.

We took the Whalley Avenue bus and were in downtown New Haven with an hour to spare. We descended into the rathskeller at Krupp's where the cockroaches didn't bother you if you only ordered tea and no food. This arrangement was fine with the Krupp's cognoscenti, who came there because it used to be charming when they had an accordion player in the afternoons. To them it might have been a shadow of its former glory, but to me it was only a shadow, dark and beery and with bugs. I felt a minor tug of fondness for the

place only after Jim mentioned they were planning to tear it down to build a parking garage.

I didn't tell Jim I'd never heard of Jean Cocteau, who was either the great director or the great producer of the film he was enthusiastically buying tickets for. I was too preoccupied with the popcorn I was about to order, which was going to be warm, crunchy, and salty. It was going to be the biggest size I could buy even if Jim said he didn't want any, which is probably what he would say. As we stepped inside the Yale Film Society Theater, I was struck by the noticeable absence of a candy counter. I took a few deep sniffs, knowing that my nose would lead me to sustenance. Surely a big university like Yale would have popcorn in its movie theater. When Jim handed me his handkerchief, I realized my sniffing activities had become a bit too audible. I tried to be subtle.

"Do you by any chance smell popcorn?"

"Popcorn? At the Yale Film Society? I shouldn't think so."

For a while the movie—or the film, as Jim referred to it—took my mind off my hunger. It was an odd parade of puppetlike creatures in hard blacks and whites, suffering unimaginably. Jim was wringing his scarf, shifting his angle throughout. When it was over, he said it was a very disturbing film, didn't I think? By then I was almost blind with hunger, which helped me look appropriately miserable.

"Yeah," I answered weakly, trying to figure out how to suggest we get something to eat. Then I remembered our friends.

"Why don't we stop by and tell Dennis and Tom about the Bloomsday plans?"

By then, even ice cubes sounded appetizing.

Granita

If Dennis and Tom had only known about granita—and had been able to afford orange juice—they might not have felt so deprived.

INGREDIENTS

4 cups freshly squeezed orange juice, grapefruit juice, any juice for that matter.

1 cup sugar

1. Mix ingredients together thoroughly. Pour into glass baking pan large enough so liquid comes only ½ inch up the sides.

2. Freeze until solid. Mush it up with a fork until it looks like crushed ice and then refreeze.

3. To serve, re-mush with a fork and serve in chilled wineglasses, not that Dennis or Tom would have had such things.

Collegiate Popcorn

When you're a kid, you want plain popcorn, nothing fancy. But when you're in college, you want to show people that you know a thing or two. This is the way.

INGREDIENTS
popcorn
olive oil spray
½ cup grated Parmesan cheese
freshly ground pepper or red pepper flakes

1. Make popcorn.

2. Put it in a wide bowl and spray it with olive oil spray, tossing to coat evenly.

3. Sprinkle Parmesan over popcorn and toss again to distribute evenly. Do likewise with a few grindings of the pepper mill or a teaspoon of red pepper flakes.

The Mango Fork

I WAS PRETTY NAÏVE WHEN I GOT MARRIED on February 15, 1964, but I knew a little trick called the mango fork. I could hardly wait to introduce my new husband to this ingenuity. I'd learned about mango forks the summer before, thanks to a little episode I'd never told him about. It would be my secret, however, until we got to Guadalajara, our honeymoon destination. After our wedding night, which included dinner at Sardis, tickets to *Man of La Mancha*, and not much else, we took turns driving our shiny red Chevy II due south. We'd stuffed it to the roof with everything we owned, mostly books, clothes, and a Gerber carving set from the one person who didn't give us money as a wedding gift. We wouldn't be returning to Connecticut anytime soon; after our week in Mexico, we would continue on to California, to Stanford University, where my new husband would begin graduate school.

I'd spent the previous summer in Guadalajara studying Spanish and living with a wealthy family hosting five American girls in their spare rooms, all of them opening out onto the pool. The Gonzaleses thought of us as rich Americans, though none of us lived in the luxury we enjoyed in their home, with its live-in cooks, servants and gardeners. As students in the university language program in Guadalajara, we were housed with a family so we could become fluent in Spanish and learn something about the culture. The Gonzales family—two boys and a girl about our age—had different ideas. The parents had instructed their kids, Luis, Guillermo, and Gloria, to speak only English with us to improve their language skills. They had their cooks prepare hamburgers, steaks, and French fries partly so that

we'd be comfortable with the food but also to reinforce an American identity they were trying to cultivate. One weekend they drove us high into the mountains called Mil Cumbres—a thousand peaks— and set up an elaborate picnic, roasting hot dogs on the grill and serving them with catsup and mustard. They warned us against eating *churros* and *plátanos* and *jugo de piña* from the street carts, explaining the consequences in dark, medicinal-sounding Spanish words. We ignored these warnings with abandon.

"The street food is so real," we would tell ourselves, hoping that its authenticity would provide immunity from *la turista,* or Montezuma's revenge, as it was sometimes called. It didn't take long before we learned from the Gonzaleses the Mexican idiom for "I told you so."

The marketplace was also off the Gonzales list of approved sites, so we never told them of our almost daily visits there. Called Mercado Libertad, Liberty Market was irresistible. Its design was sweeping and modern, a multi-level structure with steps leading to expansive decks and balconies constructed of mustard-yellow bricks. On the street level, booths and counters spilled over with silvery fish, plump oranges, limes, papayas and melon, quivery slabs of meat. It was like a living creature, breathing and dancing, screaming and laughing; it had a thousand smells and voices and colors; it had births and deaths. It also had a million flies, which is what kept me from sampling its otherwise tempting array of luscious looking *guayabas, zapotes, ciruelas.* I often went to Liberty Market with John Karatzis, a student from Wesleyan, who immersed himself in everything Mexican from the architecture of the pyramids to the music of the mariachis. John was a fearless eater.

"Let's eat a pineapple," he suggested one day as we wandered among the pottery makers and silversmiths on one of the sun-speckled balconies.

"Sure," I replied, letting the spirit of adventure subsume my concerns about the insect population. Still I was relieved when John discovered he'd forgotten his Swiss Army knife.

"Sorry," he apologized. "We'll have to go to a café to order our pineapple."

Down the street, we found a little café, filled with indoor palm trees, called Copa de Leche.

"That can't be a pineapple," I said when they delivered a plate covered with long, yellow strips the size of bananas. "Where are the rings?"

The only pineapple I'd ever seen emerged from cans in triangular chunks or in rings like the ones glued onto hams and pineapple upside-down cakes. This was before the era of pineapple pieces stamped out in "cosmic fun shapes" like stars and half moons. John's disquisition on the anatomy of a pineapple and his accompanying napkin illustrations of how to carve the fruit vertically around its core left me somewhat less suspicious of the mysterious elongated strips. Cautiously I bit off a piece. It wasn't sticky sweet and soggy like Dole; its flavor was gradual, a whisper rather than a marching band. Each bite added new notes, floral, then tropical, then blaring. John ordered a glass of pineapple juice and the revelations continued. If this was pineapple, what was in those blue and yellow cans?

"John, this is amazing. It's like, well, like forbidden fruit, like knowledge Dole didn't want us to have. We had to come to Mexico to learn the truth about pineapples."

"Alas," John said, mock-philosophically, "eating away from home is the beginning of wisdom. But, *así es la vida*," he added, alluding to one of the plays we were supposed to be reading in our summer lit class. "That's life."

Waking up at the Gonzales home in the morning in Guadalajara was like waking up in the morning in the Newburgh country house when we were kids: a soft, non-stop murmur of Spanish floating through the halls from the kitchen. Because my classes were late, I was always the last one to go in for breakfast, so I had the cook to myself. All I ever wanted was a mango, but she never just handed me one. With a sharp knife, she cut four clean incisions into the skin from tip to stem, then peeled the fruit like a banana. The first time one of the cooks served me the mango on a plate, Señora Gonzales glared at her and shot out some staccato words about *americanos* and the correct way to serve us mangos. Obviously the señora was unaware that most Americans had never even seen a mango, never

mind the paraphernalia for its proper consumption. As I breathed in my mango's intriguing perfume, wondering how to proceed, the cook whisked it away, plate and all. Moments later, the beautiful melon-orange fruit reappeared, securely mounted on a silver-handled mango fork, its three tapered prongs penetrating deep into the pit to hold the fruit in place. The cook handed me the contraption and I ate the mango like a lollipop.

My first taste of mango—its mouthfilling sweetness, its teasing acid tang, even its flat oval pit with the last comehithery threads of fruit clinging to it—made me a mango addict. From then on, had the señora not been presiding, I would have eaten my morning mango right through the skin.

Like all the homes in Guadalajara's affluent neighborhood called Jardines del Bosque, the Gonzales residence was surrounded by high stone walls with broken glass cemented along the top and a chained iron gate at its entrance. I rang the bell, hoping that the Gonzaleses had received my letter about visiting them on my honeymoon. One of the maids peeked through the grate, eyed Stuart and me suspiciously and immediately went back into the house. This was standard procedure I remembered from when I lived there. In a moment she returned, a beautiful dark-haired young woman by her side.

"Gloria!" I called out, my voice smothered in her welcoming embrace. Since no one else was home, the three of us went to see the Orozco murals at the orphanage, an activity that had remained on the Gonzales' approved list. *"Estás en tu casa,"* Gloria said back at the house, graciously offering us just about everything on the premises except mangos served on mango forks. There seemed no tactful way to bring up this oversight and I could think of only one alternative: Liberty Market.

At first it looked almost the same, lively with stalls featuring yellow glazed tequila copas, the long fringed shawls called *rebozos*, and water jugs painted with blue fronds and wild-eyed birds. Considering our meager wedding gift budget, we tried to resist these treasures. But when a uniformed man, possibly a soldier, walked by carrying a bucket of dusty skulls, we could refrain no longer. No, he wasn't selling them, he explained; he was disposing of them since

they were impeding excavation on a construction site nearby. While I pursued my mango hunt, Stuart dug up a skull with the aid of his omnipresent Swiss Army knife. On the way back, he discovered a small tortilla factory, a noisy gear-and-pulley machine that ground out hundreds of perfectly round, flawless tortillas. This was a new addition to Liberty Market, one that would have been applauded on *norteamericano* terrain, where the mechanization of just about any activity is considered progress.

"They don't like these tortillas," Stuart reported of the men's reactions, "because they don't have the taste of the woman's hands."

A small price to pay, we would say in our country, where advanced techniques for producing tomatoes and strawberries and pineapples had already triumphed over flavor considerations. As for the taste of the woman's hands, I was skeptical: was this a matter of keeping women in their place, or honoring a feminine quality technology could not replicate. We touched on these issues lightly: this was our honeymoon, not a foray into the women's movement. Not yet.

Mangos they had at Liberty Market, sensuous and beckoning under flocks of unappetizing fruit flies. We opted instead for a voluptuous, golden orange mango made of onyx from the town of Puebla. We couldn't eat it, but we'd have it forever.

Besides it was 1964 and we were on our way to California, where they'd surely have mangos and mango forks and everything else that dreams were made of.

Mango Fruit Salad with Mango Sauce

Despite my hopes for California, I never saw a mango fork again. It's still relatively easy to eat a mango, especially if you cut it up into a luscious, tropical mélange like the following.

INGREDIENTS
Sauce:
 1 mango, peeled and cut off pit
 juice of a lemon
 ¼ cup honey
 1 tablespoon tequila

Salad:
 1 mango, peeled and cut off pit into nice size
 chunks
 1 papaya, peeled, seeded and cut into chunks
 1 pineapple, peeled, cored and cut into chunks
 1 banana, peeled and sliced on diagonal into
 ½-inch pieces
 ⅓ cup almonds, coarsely chopped

1. In a food processor or blender, puree all sauce ingredients.

2. In a large bowl, toss fruit with sauce and sprinkle with chopped almonds.

The Voice of the Turtlenecks

COQUILLES SAINT-JACQUES, RIS DE VEAU, Soufflé Grand Marnier. Escargots, Béarnaise, l'orange. Eating in San Francisco was like learning another language. Fortunately we had a teacher who'd been practicing these words for three years before we arrived. His name was Gordon; he was Stuart's brother and he knew San Francisco restaurants as if he went to a different one every night, which he did.

The fact that Stuart and I were poverty-stricken graduate students never deterred Gordon from suggesting we all dine together at Ernie's or The Blue Fox or La Bourgogne, the city's most sumptuous and expensive restaurants. Our weekly fifteen-dollar food budget included five dollars for two cartons of cigarettes, one Kents and one Marlboros; one dollar for three pounds of hamburger meat from American Markets; a few dollars for a gallon of hearty Burgundy, which Stuart called "crime of the vine"; a pound of Folgers coffee, various staples and, thanks to a recently arrived recipe from Stuart's mother, a package of frankfurters and a can of sauerkraut.

"This is easy and tasty," Stuart's mother had scribbled in the margin as an extra added inducement, unaware that "edible" was my only criteria, though "quick" vied for importance.

Having been one of the guests at the near disastrous turkey dinner (see Introduction), Gordon often countered our dinner invitations with one of his own, saying something like "I'm almost positive it's my turn anyway."

He introduced us to brunch at the Alta Mira in Sausalito, instructing us to order the requisite Ramos Gin Fizz. He took us to Ghirardelli Square and Fisherman's Wharf, warning that to eat there,

anywhere, was considered *outré* by San Franciscans, especially by newcomers attempting to establish residency. Being a handsome, twenty-seven-year-old bachelor living in a Nob Hill apartment overlooking Grace Cathedral, owning both a Doberman and a Buick Riviera, Gordon held a *de rigueur* key to the San Francisco Playboy Club, where women with their breasts pushed to the limit had puffy cotton tails and long bunny ears attached to their half-naked bodies. They wriggled through the crowd serving Chivas on the rocks to impeccably dressed, affluent looking men practicing a kind of *noblesse oblige* nonchalance. The men obviously viewed the bunnies, in their shiny plasticity, as elements of the décor, a category in which they placed all the other women in the room and everywhere else for that matter. In San Francisco, at least in the Playboy Club at the height of its powers, all women were equal.

In his mission to introduce us to San Francisco's multiple personality, Gordon also made sure we had Irish coffee at the Buena Vista, where the cable car turned around doing its little circle dance at the San Francisco waterfront. One night after dinner he took us for a drink at the Top of the Mark, where those who had not yet renounced kith and kin to move to this twinkling jewel of a water-lapped town underwent their final conversion. Every Sunday that we came to San Francisco, he walked us over to Swenson's Ice Cream Parlor where, no matter their other flavors, we had to order Rocky Road. It was pure San Francisco.

Gordon's favorite restaurant didn't have a name, only a subtitle: "a place for Charles and his friends." It didn't have a listed phone number—you had to know it—and there was no sign on the building. When you knocked, a square panel of the carved wooden door opened inward, eyes peering out, awaiting passwords. The door was then opened and the fanfare ensued, a welcome appropriate to princes and pashas, complete with deep bows for the men, hand kissing for the women, a chorus of *monsieurs, madames* and *magnifiques.* "Very continental," my mother would have said. The setting was regal, aglitter with silver and candlelight, palatial yet sensual. My first taste of the food—a little *"amuse bouche"* they called it mysteriously—was a ravishment. Stealth was its method, coaxing a

preliminary unconscious nibble as it lay in wait, then in surprise ambush releasing its barrage of flavors over the unassuming tongue. Swallowing didn't end it. Instinctively I closed my eyes as if to imprison the sensations, shut off their escape, keep them forever meandering. I sat there, stunned in afterglow, my eyes crossed, an idiot smile on my face.

"Good, huh?" asked Gordon rhetorically. "Wait till you taste the wilted spinach salad."

I thought he was joking. First Charles kisses your hand, then he overwhelms you with some totally disarming anonymous delicacy, then he serves you a bunch of wilted old spinach. Was this a restaurant or an experiment? Naturally I said nothing and in due time found myself staring down at a bowl of slick, though undeniably relaxed-looking leaves. I wasn't going to be a wimp about it, so my first forkful—which had every prospect of being my last forkful—was a healthy-sized spearing of the listless greenery.

Warmth and sweetness and a hidden crisp-edged chunk of bacon were not among my expectations. This was not spinach as I had known it; to call it wilted was mischievous, a way to catch you off guard. Would you call the Naked Maja wilted? Prone, yes; lying in repose, yes; but with tricks up all sleeves, plans for the evening. There was something going on in that salad that was probably against the law. No wonder they kept the doors locked.

"We should order dessert," Gordon announced, motioning to the waiter. Not much of a meal, I thought: an hors d'oeuvre and a salad. On the other hand, why eat another thing? How much better could it get? After a session of whispering and nodding with the waiter, Gordon seemed satisfied.

"You have to order the soufflé Grand Marnier before the main course. It takes about a half hour, you know."

I didn't know. I'd never heard of soufflé Grand Marnier, but the reference to time didn't surprise me. Whenever we went out with Gordon to one of his fancy restaurants, we spent the entire evening eating dinner. Back east—a California phrase which had the connotation of "back in the old country" and referred to anywhere outside California—back east we'd go to the Clam Box or the Red Chimney

and then to the movies or something. It made sense in the days when you didn't have Charles' rack of lamb Béarnaise sitting in front of you, beckoning with its very bones, enveloping you in the scent of tarragon. Once that happened and the taste of it has had its way with you, you've passed through some kind of portal. You hear yourself trying to explain the sensations dancing in your mouth, you listen to everybody else trying to do the same. You laugh self-consciously as if you'd been discussing your most intimate sexual preferences. You completely forget about the movies.

When Gordon invited us to his apartment in San Francisco for dinner, it meant that he had a new girlfriend. The fact that he personally didn't cook was no impediment to his hospitality. His girlfriend du jour was always beautiful and tan; she was a secretary from Illinois or Michigan who'd moved to San Francisco the year before; and she knew how to flambé crepes, make eggs benedict, and slice raw mushrooms into a salad. In the rare instances when the relationship lasted until the next time Gordon came down to Palo Alto for dinner, he'd bring his current girlfriend along. Naturally I'd feel impelled to make something special, like the sauerkraut and frankfurters recipe from his mother, or something from the Fannie Farmer Cookbook that had "a la King" after it. So considerate was Gordon that he'd sometimes forgo one of these home-cooked meals, insisting on taking us out to a restaurant in Palo Alto.

But there were no Charles or Ernie's in our neck of the woods. There was the Greek Taverna where the high point of the meal was the appearance of the Apollo-like owner whose Zorba dance around the dining room would culminate in his picking up the table—laden with filled plates, full wine glasses, and lit candles—with his teeth. Everyone laughed to see such a sight, but it wasn't about the food. There was the all-you-can-eat place next to the bowling alley, where my husband's prodigious powers of consumption eventually led them to revoke their "no limits even on lobster" policy. There was Ming's for Chinese, The Brave Bull for steak, and the House of Prime Ribs for obvious reasons; but none of it was any better than the hamburgers Stuart made on our little hibachi grill in the back yard, which Gordon enjoyed much more after we assured him we

were no longer buying the three-pounds-for-a-dollar chopped meat. We thought he wouldn't be able to tell the difference, and we were right.

To celebrate special occasions, we invariably went to San Francisco. Once on my birthday, once on our anniversary, and once when Stuart and Gordon's parents came to visit, we went to Ernie's. Plush was the word for the carpet that your shoes disappeared into, for the red velvet wallpaper, for the thick-cushioned chairs around tables set with silver candelabras under crystal chandeliers. Quiet good taste wasn't its intention. With a bit of Versailles, a touch of Coney Island, a splash of Hollywood, thanks to its role in *Vertigo*, Ernie's was a land of make-believe, a home away from home for presidents and pirates, for archbishops and prospectors, for robber barons and downright desperadoes. The two brothers who owned the place, and who were almost as well dressed as their tuxedoed waiters, spent their time greeting the regulars and motioning toward stairways and alcoves reserved for the culinary cognoscenti. The menu was a language exam full of *au poivres, cordon bleues, bourguignonnes, chaussons, brulées, pommes de terre, nantaise,* all worth learning to pronounce, inspiring the same speechless awe as the epiphanous lamb of god at Charles's. If Ernie's had been back east, it would have been stuffy and intimidating; instead there was warmth in its formality, wit in its wisdom.

When we left San Francisco for a year of doctoral research in Bogotá, Colombia, Gordon took us to Ernie's; our return also qualified for an Ernie's-level celebration. A lot was changing—it was the '60s after all—but Ernie's, we were sure, was eternal. Indeed the voice that answered Ernie's reservation line had that same old self-assurance, unperturbed, unrattleable. All seemed right with the world: the date and time reiterated, the number in the party, the request for the round table in front of the mirror. But suddenly the voice took an unprecedented tone of admonition.

"A reminder for the gentlemen of the party," it cautioned ominously, pausing before a pronouncement that revealed that Ernie's had not, in fact, been immune to the ravages of revolution. Even

Ernie's had to protect itself and its long-time patrons from those who would break the sacred codes that no generation had previously dared challenge. "Remember our policy" came the words, authoritarian, *in-loco-parentis,* ludicrously vestigial: "No turtlenecks."

Charles's Lamb

In a moment of weakness, probably whilst infatuated with a recipe-seeking damsel whose hand he was no doubt kissing most continentally, Charles revealed the recipe for one of his magnificent lamb dishes.

INGREDIENTS

8 small lamb chops, trimmed of all fat

2 slices prosciutto, chopped

1 small chicken breast, boned and diced

2 large mushrooms, finely chopped

2 shallots, diced

salt and pepper

pinch thyme

1 cup dry white wine

¼ teaspoon fresh tarragon, chopped

3 large sheets phyllo dough

butter

1. Preheat grill. Salt and pepper lamb chops on both sides and grill to rare.

2. In medium sized pan, sauté prosciutto, chicken, mushrooms, and shallots in butter until half cooked. Season with salt, pepper and thyme.

3. In small saucepan, heat wine with tarragon and ground pepper until wine is reduced to ¾ cup. Add wine mixture to chicken mixture and sauté until thoroughly cooked.

4. Butter three leaves of phyllo dough and cut into 8 four-inch square pieces.

5. Cover each chop on one side with sautéed meat mixture and wrap in a square of phyllo. Brush with melted butter and place on cookie sheet.

6. Bake in preheated 350-degree oven 10 minutes or until dough is golden.

The Munchies

"So how did you like the, ahem, herbs?"

That was the predictable question everyone asked when we returned from our year in Colombia. It was always asked with a knowing grin and a twinkling eye, as if we'd spent the year rolling joints and filling pot pipes with Colombia's finest. Coming back to post-summer-of-love San Francisco, we were embarrassed to admit the truth. We never saw a sprig of marijuana, and we wouldn't have known one if we had.

Stuart spent the days doing his doctoral research (on the consolidation of Colombian conservatism during the administration of Rafael Nuñez) at Bogotá's national archives, and I worked at the Rockefeller Foundation's Center of Tropical Agriculture, another aspect of the food world I knew nothing about. Before leaving for Colombia, I had sent my résumé, accompanied by a picture of myself in a red dress playing the guitar, to someone at Grace & Company. When I arrived in Bogotá, he told me that he didn't have a job to offer me but he was having a party that weekend and I was invited. Oh, but of course, my husband too.

At the party in Bogotá's wealthy Chicó district, Stuart and I encountered a roomful of Harvard graduates, both American and Colombian, who more or less ran the country. The man from the Rockefeller Foundation said they didn't have a job either, but considering my fluency in Spanish they could probably figure out something I could do at the Foundation's downtown office.

Every woman at the party, the wives of the Harvard graduates, was stunning. If only they lived in the States, I found myself think-

ing, they'd have such different lives. One of them looked at me sadly.

"How do you do it?" she asked. "Life is so hard for a woman in the States."

"Hard? What do you mean?"

"You have no servants, no maids. You have to do everything. The children, the cleaning..."

"Well, yes," I began, inexplicably defensive. "But we have—machines. Appliances. We call them labor-saving devices."

She smiled, nodding. "And no one to help you. Not even with the cooking."

Suddenly I could see her point with special clarity.

"I was so happy to get back to Colombia," she continued. "I was always exhausted in America."

The Rockefeller Foundation did devise a job for me, charting the protein content of elephant grass and various legumes, whatever they were. During my second week, one of the soil scientists told me he and his family would soon be returning permanently to the United States—Nebraska, I believe. He asked if Stuart and I would please hire their maid. We were dumbfounded. The idea of hiring a full-time, live-in servant was repugnant to us. It seemed elitist and undemocratic, if not un-American. After another week of dealing with daily life in Bogotá—you couldn't just run down to the neighborhood laundromat or supermarket in Bogotá; there were none—we rationalized ourselves into it. If we didn't employ Genoveva, we were told (by people who'd already rationalized themselves into it), she'd have no job and no place to live. Besides, Genoveva was supposed to be a pretty good cook.

Still, with our poverty-stricken, graduate-student mentality, we felt ridiculous having an in-house maid. On her first morning there, we tiptoed down to the kitchen, determined not to wake her. Within seconds, Genoveva rushed in from her room, looking frantic. We assured her that we weren't angry or put out, that we didn't have anything but coffee in the morning, and that she therefore never had to get up before we left for work. These were all wrong things to say. These tasks were her job, her livelihood, what she knew how to do. By doing them ourselves, we were demeaning her, robbing her of her

dignity and sense of worth. Reluctantly but remarkably soon, we adjusted to being waited on hand and foot.

Stuart became immediately convinced of Genoveva's competence the first evening when, with nary a comestible in the house, we found her at the stove, stirring up a cauldron full of simmering something. A deep inhalation provided no clue to the exotic mixture bubbling deliciously on the front burner.

"*Qué es esto?*" he asked with an anticipatory and approving smack of the lips.

"*Es la ropa,*" Genoveva replied, her dark brown features growing a shade darker.

My white blouse, a few towels, the pillowcases—that's what was gurgling away in the pot. The laundry, in other words.

"Ah," Stuart said, his relentless sense of humor triumphing over all our hunger pangs. "*Sopa de ropa!*"

Genoveva had one of those wise and inscrutable faces, like a stone carving at the entrance of an ancient tomb; so when she smiled, you felt like you were making contact with a lost world whose inhabitants think you're an idiot.

Once or twice a week, during the daily two-hour siesta, which, to my amazement, was strictly observed by the Rockefeller Foundation, I met Genoveva at the food market. My role, after watching her sniff and shake various arrangements of leafy plants and thick clumps of vegetation, was to pay, hail a taxi, and get ourselves out of there. Since I was more than happy to leave Genoveva in charge of the cooking, dinner was always a surprise.

"I didn't know you bought beets," Stuart would say, pleased at something semi-familiar.

"Neither did I," I'd confess, reminding him that I'd had no idea what lay under all the leaves and fronds Genoveva piled into the shopping bag. That some of it may have been marijuana only occurred to me after coming back to California. Genoveva never made brownies.

After a year, Stuart finished his research and we moved to a little apartment near Stanford. Our friends, who'd been mostly level-headed, if not glum, graduate students when we left, had been

transformed into funloving missionaries, constantly exhorting things like "You should try it. It'll set you free." These suggestions were made with an urgency suggesting that if we didn't make smoking pot one of our priorities, we were going to miss out on the '60s entirely. We weren't unwilling. After a few months, we even had what we thought was a contact.

Stuart's cousin Allen had been brought up in New York City attending all the right private label schools, dressing in custom-tailored suits and shoes, having only the finest and the best as his norm. When he moved to Berkeley, he had certain criteria: he wanted to rent a rat-hole in a slum, wear Salvation Army rejects, work a dead-end job, and smoke pot with every living breath. Within a month, he'd achieved his ideals. With oblique references to his "stash" and getting "turned on," he invited us over.

We sat in the living room on overstuffed patched cushions around a mahogany table that Allen had improved, or ruined, depending on your point of view, by painting blue daisies all over it. It was a housewarming gift from his mother, he smiled, and you could tell from the still-detectable fine workmanship under the daisies that she had no idea what kind of house she was warming.

"An antique," he added, obviously pleased with the transformation.

We stayed the whole afternoon, feeling a bit like Dustin Hoffman in *The Graduate* with no one in the take-charge role of Mrs. Robinson. Everyone was too embarrassed to bring up the delicate subject of getting stoned. A few days later we spoke by phone.

"That carved wooden box in the middle of the table with all the dusty looking hay sticking out—was that it?" I asked.

It was. He thought maybe we'd changed our minds; he hadn't wanted to force us.

Our next encounter was via Phyllis, respectable wife of a marketing executive at the same hotshot Peninsula electronics firm where I worked in the advertising department. She'd gotten some stuff, didn't know how good it was, but why didn't we come over and try.

"You're supposed to hold it in," she instructed as we sat in a circle, inhaling the smoke from a rolled up wad of leaves she called a

joint. When we weren't coughing and sputtering, we held our breath to keep the smoke in, hands clamped over mouths trying to avoid the eye contact that resulted in instant and uncontrollable paroxysms of laughter.

"Do you feel anything?"

"What are you supposed to feel?"

"Well maybe, a sort of, well as if you're standing on, like, kind of wavy I guess," Phyllis explained, who was never great at specifics.

After an hour of smoking, or attempted smoking as the case may be, we definitely got the munchies, but then we always did at Phyllis's because she made cheese puffs and smoked salmon mousse and amaretto cheesecake and had bowls full of macadamia nuts.

Finally, at a party that Stuart's brother, Gordon, took us to, appropriately named a Pot Roast, we inhaled enough, held our breaths enough, giggled enough, staggered around enough and ate enough screaming-yellow-zonkers to realize we had in fact tasted freedom.

I never made brownies either. But when Stuart's mother sent me a family recipe for mandlebrot—"It's very easy to make, dear, and Stuie loves it"—I tempered my sense of obligation with a little subversion. Not that she would ever know, but somehow, by routinely throwing in a few sprinkles of weed, I was at least disqualifying it for the good housekeeping seal of approval. Family recipes handed down from generation to generation were not my cup of tea. Little did I know.

A few years later, my parents came to visit, bringing along my six-year-old brother Matthew. For a few hours, due to some business I couldn't avoid, I left them alone in the house with a tin of mandlebrot. Only when I returned to the sounds of non-stop giggling did I remember about the secret ingredient.

"Those cookies..." my father said, laughing and kissing his thumb and index finger, then snapping back his wrist, a gesture reserved only for DeeTee's masterpieces. "Delicious."

Even Matthew, known as a fussy eater, loved them, my mother confided, chuckling for no reason and wiping the tears from her eyes.

Matthew had a big dopey smile on his face and was searching for crumbs in the tin.

"Could you give me the recipe?" my mother asked.

I'd heard that cooks always omit an ingredient so I felt justified in following that tradition. It was the first time that had ever happened—my mother asking me for a recipe. It was also, all these years hence, the only time. But ever since that night, whenever my mother wants to repay a kindness or bring a hostess gift or just make something to nibble on, she makes mandlebrot.

"Everybody loves it," she tells me every time, always adding, perhaps in modesty, perhaps in deference or perhaps because of that *je ne sais quois*, "It never tastes as good as yours."

Happy "Thyme" Mandlebrot

In its original form, this family recipe contained no "thyme." Although the "thyme" does nothing to improve the flavor and in fact is somewhat detrimental to it, guests usually gobble up these biscotti with giddy enthusiasm. They are particularly poetic served with Pot Roast, if you know what I mean.

INGREDIENTS

4 eggs	1 teaspoon vanilla
1 cup sugar	½ teaspoon almond extract
1½ cups flour	1 cup chopped almonds or
2 teaspoons baking powder	walnuts
dash salt	several good pinches of
1 cup oil	"thyme," or to taste

1. In bowl of electric mixer, beat eggs and sugar together 10 minutes, or until marshmallow-like.

2. Sift together dry ingredients. Lower mixer to slowest speed and add dry ingredients until incorporated.

3. Fold in remaining ingredients.

4. Lightly oil two loaf pans and pour in mixture, dividing evenly.

5. Bake in preheated 350-degree oven 30 minutes.

6. Remove from oven, let cool slightly, invert each pan onto cutting board. Raise oven temperature to 400 degrees.

7. Cut each loaf into ½ inch thick slices and place slices, cut side down, on cookie sheet. Return to oven for 5–8 minutes or until golden.

The Parsley Poet

ALL RIGHT, I ADMIT IT: I MADE LASAGNA. And, yes, I made it more than once. I made it every time I was called upon to fulfill my new role as faculty wife, thrust upon me when Stuart and I moved to Minnesota. He was hired to teach Latin American history at the University. I was supposed to stay home and plan dinner parties for the members of the history department and their lovely wives. We rented a rambling two-story house in St. Paul from a professor and his lovely wife who left everything behind, especially kitchen equipment. Cookbooks lined the walls in the kitchen, dining room and even in the study on the one shelf not reserved for books about the American Revolution. Open a kitchen cabinet and therein lurked pie plates, Dutch ovens and bundt pans, while in the drawers above them wire whips, measuring spoons and rolling pins lay in wait for the lady of the house. Casserole dishes in every conceivable size loomed in the china closet, and the largest Sunbeam Mix Master on the face of the earth looked on menacingly from the counter. It was a big house, but wherever I went I could feel the pressure: come down here and get to work, woman; what are you waiting for?

Back to the lasagna. I got the recipe from my friend Robin who had spent a year in Italy with her graduate student husband. She returned without the husband but with an authentic Florentine recipe for lasagna. In Italy, she had hated making the lasagna because it was part of her expected duties as "the wife." But with her divorce and the consequent restoration of her culinary free will, she began to enjoy making the recipe and the heartfelt appreciation it brought her. Friends swooned with pleasure whenever she served the dish and

showered her with praise for her efforts. She realized that to cook or not to cook was now her decision, not a nerve-wracking chore she felt required to perform on demand. It was in this spirit that I made the lasagna, in secret celebration, in sisterhood.

Nevertheless I had to modify the instructions. I dispensed with the frivolity of fresh tomatoes and herbs, replacing them with an eminently openable bottle of Ragu spaghetti sauce. The ricotta, some sort of cheese obviously rampant in Florence, I replaced with ordinary, non-intimidating cottage cheese. The mozzarella, which Robin claimed was a buttery smooth pillow in Italy, had obviously been improved by American product-development ingenuity into a round and rubbery ball, easy to slice into uniform slabs. Nor was there any need to grate the Parmesan, which came pre-pulverized into yellow dust in a convenient shakable green foil container.

Lasagna it was then for my first foray into official faculty-wife dinner parties. My guest list was inspired by alphabetical order rather than any deference to compatibility or mutual interests. Considering the population of the history department, I calculated I'd have to give three dinner parties before I got to Z. Any sighs of relief I planned to breathe after completing the alphabet were quickly foreshortened by the realization that this form of entertaining, as it was euphemistically termed, was a vicious circle, that the A to F wives would soon be returning the favor as we headed inexorably into the black hole of reciprocity. The following Monday, I drove over to the Minneapolis office of the New Mobilization Committee to End the War in Vietnam.

Like everybody else we knew, I wanted to stop the war, and it was certainly a better idea than cooking my brains out every time I turned around. The New Mobe was headquartered in a cozy, brown-shingled, porch-fronted, typical Minnesota house with rabbit-warren rooms everywhere, walls lined with dark wood, built-in breakfronts. Behind a massive old desk, almost buried under stacks of papers, cardboard boxes, and pamphlets, sat a young woman with dark hair pulled back, Susan B. Anthony style. I walked over timidly and told her I'd like to be a volunteer.

"I'm Nancy," she said, eyeing me suspiciously and making me

aware that the J. Magnin pantsuit I'd bought at the Stanford Shopping Center just before leaving California was not the sort of thing you wore to the New Mobe. "Sit down."

She was talking on the phone, stapling different colored pages together, lighting up a Camel. As she put down the receiver, mumbling something about "those idiots at the *Tribune*," her face broke into a pellucid smile.

"Great," she said. "When can you start?"

I was about to tell her that, although I'd never done anything quite like this before, I had marched the previous May at People's Park in Berkeley; however, it was clear that no prerequisites were called for. The organizations comprising the New Mobe, Nancy explained, ranged from the Young Socialist Alliance and Clergy and Laymen Concerned to the Young Republicans Club and the Trots, Nancy's affiliation.

"Trotskyites," she clarified in response to my ignorance-revealing, crunched eyebrows. "Being against the war is about the only thing all us groups have in common."

Members from these organizations scurried through the New Mobe office, running the mimeograph machine, answering phone calls, taking orders from Nancy and soon from me. Our focus was Moratorium Day, a Stop-Work-Stop-the-War protest scheduled for October 15, to be followed, assuming the war didn't get stopped, by another anti-war rally on November 15. The work, though mostly menial, was as vital as it was endless: stuffing envelopes, licking stamps, coordinating bus schedules, sending out press releases, printing up flyers. Anybody would do anything; hierarchy didn't exist, not even when it came to making coffee. There had to be coffee—it was the fuel supply—and so, when it ran out, new coffee got made by the nearest or the freest or the most caffeine-deprived, regardless of sex, color, creed or place of national origin. Including men.

After the November anti-war march and a few minor protest activities, the New Mobe had to vacate its premises, in more ways than one. When all else failed and there were still bills to pay, we decided to hold a bake sale. We knew we could count on people—well, women—to return to their flour bins and Sunbeams so we could pay

the telephone company, the printer and the bumper-sticker-maker. These were situations worth cooking for. There was something noble about making cupcakes to settle the Xerox bill for Moratorium flyers. There was, in the words later used to describe the spirit of a group of Minnesota anti-war heroes, a "higher allegiance."

Marlene, one of the women I met in the course of these activities, described herself as a community organizer. Whatever that meant, she knew everything about non-profit groups and socially responsible organizations doing good work that nobody ever heard of. She and I tried to think of some way to meld her experience and my background in advertising and copywriting. We decided to start a sort of advertising PR agency that would specialize in non-profit organizations. Needless to say, we had no competition.

When we sent out press releases announcing the formation of our agency, The Split Infinitive, headquartered in Stuart's and my basement, we never expected a call from Robert J. Smith, whose column appeared on the front page of the *Minneapolis Star and Tribune*. He was intrigued by the fact that our company holidays would be the birthdays of women like Susan B. Anthony, Beverly Sills, and a pro-abortion doctor named Jane Hodgson; and that we were searching for women graphic designers and printers to do business with. Mr. Smith found all this most amusing, calling us "women in a man's world." He made sure the high point of his article was a remark not from my partner or me but from my husband who replied, when Smith asked him what he thought of this exciting venture of ours, "I hadn't noticed." Nevertheless, thanks to Smith's front-page story, we were deluged with phone calls and we launched The Split Infinitive the following week with a full roster of clients.

As with so many things at the time, the battles were more fun than the victories. We felt, being women, that we were in the middle of things, and that, though admittedly not on the winning team at the moment, we were part of some great experiment. When we were humiliated—"Throw those bimbos out of here," said one client when we showed up to collect the long-overdue bill for our work; "Stick your boobs out, girls" instructed a *Trib* photographer for a story about our agency—the smiles we were smiling froze on our

faces. We ceased looking down or looking away or letting things pass. We began to talk back. We used the F word. We opened our own car doors, we demanded the menus with the prices. We weren't alone: when we looked around, women were everywhere.

The marriage didn't survive. The consternation quotient was too high, the yearning and discontent too potent, even for two people who basically got along. I moved to a cottagey-looking house on a tree-lined street in St. Paul and took the agency with me. During the day, Marlene and I used one of the bedrooms as The Split Infinitive office, but at night the place was mine. It was the first time in my life I'd lived alone. Sometimes I'd sit in the living room, lay some logs in the big brick fireplace, breathe in the exhilaration of feeling free. I was starting a relationship with someone I barely knew: myself. I never knew quite what to expect; I was full of surprises.

One day I walked into the kitchen and opened the refrigerator. There was nothing in there but a pint of yogurt. Someone had suggested I might like yogurt, but I didn't know yet. I hadn't tried it. It might have been nice to have something in the refrigerator that I knew I wanted to eat. But I wasn't ready for that. I didn't want to stock up, be prepared, have things on hand. This was my refrigerator and my world. Finally.

I'd always written poetry, but suddenly I was producing reams of the stuff. I became associated with a group called Minnesota Poetry Out Loud and we did readings in the Walker Art Center and other major venues. One night I was on the same program with Robert Bly. With his masks and swirling robes, he was a dazzling poet-performer, a wizard who conjured up the ancient and tribal but shook his audience like a stage-slamming rock star. Sometime that evening I read my poem.

"It's called 'Parsley,'" I said, clearing my throat:

I wouldn't want to be Parsley,
only to be sprinkled on things at the end,
going around the edges of platters,
garnish to the good stuff,
making the pallid look palatable.

What kind of reward is that for
keeping yourself green all the time,
Lying seductively on the carrots
till you're picked off?
Some people might say
"Parsley, you may never actually contribute
to the taste of anything,
but you won't detract from it either."
Still, I wouldn't want to be Parsley,
I wouldn't want to be her.

He applauded, Robert Bly did. He was the first to applaud and the loudest. Thereafter, whenever I saw him, he'd look at me for a few minutes trying to place me, and then he'd say, "Oh, yes. You're the Parsley Poet."

So there it was after all, an immortal link with the food world: Parsley. And I had only myself to blame.

Fried Parsley

Parsley's hidden charms emerge with the help of a little heat.
This simple recipe demonstrates that even parsley has a life.

INGREDIENTS
 3 bunches parsley
 6 chives
 oil for deep frying

Divide the three bunches into 6 equal
bunches. Tie each at the stem end with a
chive. In a large pot of salted boiling water,
blanch parsley for 30 seconds. Remove with
slotted spoon and blot dry. In a large, deep
skillet, heat one inch of oil to about 375
degrees. Fry parsley a few minutes, turning
occasionally. Drain on paper towels and serve
immediately.

Serves 6.

IV. Getting the Message

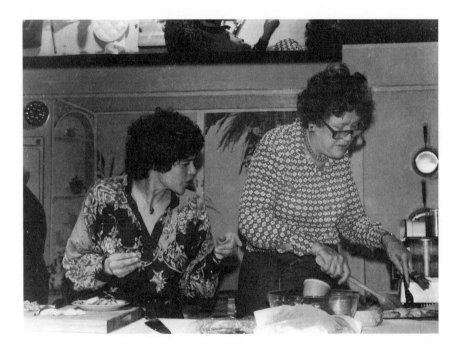

The Second Volume

I NEVER THOUGHT I'D EVER BUY THE SECOND VOLUME. There were enough recipes in the first volume of *Mastering the Art of French Cooking* to keep a person occupied, not to mention two people, for a lifetime of dinner parties. In this case, the two people were me and a man called Peter. I suspected our budding relationship might endure when he willingly accompanied me to Gibraltar one summer where I searched for relatives and for the recipes my grandmother used to make: the *bacalao* soup, the smoky, unctuous artichokes with peas, the honey-drizzled *ajuelas* with the colored sprinkles. When I decided to leave Minnesota and move back to California, Peter abandoned his tenured professorship at the University of Minnesota and came with me. We bought a house in Belmont, California, and spent hours in the kitchen cooking together, mostly from *Mastering*. We watched each other's faces as the first taste of a dish we'd never tried before made its way from tongue to the poetry areas of the brain—although we expressed the depths of these pleasures more often in moans and sighs than in anything resembling a sonnet. I wasn't sure that Peter entirely agreed with my theory that even sex was a sublimation of eating, but he did make the point that some people thought just the opposite. At any rate, our enjoyment of eating was, contrary to my previous perspective, augmented rather than diminished by the planning and the shopping, the cooking and the candle lighting—the foreplay, as I often thought of it.

Words played a part in my enchantment with *culinaria*, and *Mastering* was full of delicious examples. *"Tranches de jambon"* sounded better than "ham slice" and, even though my mother had often

served such a dish with mustard, she never served it with *moutarde*. As for sauces like *Aurore, Nantua, Choron*: who knew sauces had names, or even needed them? If a recipe had *cornichons* in it, that was reason enough to make it—just so you could say, "See those little pickles? They're called *cornichons*." *Pithiviers*, even though it took three days and didn't exactly turn out, came trippingly off the tongue. Likewise *clafoutis* and *quenelles* and the lilt of all the laughter that usually accompanied our brave but often failed renditions of these classics. Veal was human, *veau* divine, but Veal Prince Orloff was easier said than done. For recipes like Beef Wellington, with its multiple hurdles and prerequisites, checks and balances, it was helpful to be obsessive or compulsive or both. Making dessert from *Mastering* was like adopting an avocation. The weekend before you planned to serve it wasn't too soon to begin searching for the ingredients, acquiring the equipment and scheduling tasks for your every waking hour. Presenting something like Charlotte Malakov in its full glory meant that you couldn't just dump your ladyfingers and almond cream into your old aluminum saucepan and hope that people wouldn't notice the battered *batterie de cuisine*. You had to do more; you had to have a friend like Frances.

I met Frances Mayes shortly after moving back to California at a celebration of International Woman's Day Year (or was it International Women's Year Day?) at Stanford University where we were both invited to read our poetry. "Parsley" may have had something to do with it, but soon we were discussing the uncanny congruities between food and poetry and how this phenomenon might be due to heightened powers of sensitivity and sensuality, traits with which basic syllogistic logic would suggest, we were both generously endowed.

Frances lived in a long curving house that snaked around a swimming pool visible from every room except possibly the bathroom. Her husband, who seemed destined to become the president of IBM one day, knew a lot about wine. He knew enough not to drink it out of plastic cups like the rest of us; even at their own poolside parties, he was the only one with a long-stemmed crystal wine glass. In Frances's kitchen, she anointed bread and vegetables with elixir from

small bottles of balsamic vinegar before anyone, even poets, had ever heard of it. She already owned a copy of the second volume. And she was always more than happy to lend me her charlotte mold.

One day in an airline magazine, I read that Simone Beck, one of the three authors of *Mastering*, was giving cooking classes at her home in the south of France. I wrote to her immediately. She replied that she was taking only five students but still had two openings. Frances and I signed up to go at the end of May.

I called Simone Beck, per her instructions, when I landed in Nice. She told me to go to Cannes and she'd pick me up at the railroad station there the following day. Thanks to the Film Festival, Cannes looked like the Hollywood of the Riviera, with Pink Panther motifs slapped across the white-marble balconies and majestic entranceways of its otherwise palatial hotels. By some fortunate turn of events, I met Charles Champlin, the famous film critic of the *Los Angeles Times*. When he mentioned that he'd just returned from interviewing Simone, I remarked on the coincidence, telling him I was about to take her cooking class. He looked at me strangely and told me I must be mistaken. The confusion was resolved when we discovered he was referring to Simone Signoret.

Because of my limited budget I was happy to discover the Restaurant Lyonnaise Provençal, which offered a four-course meal for eighteen francs, or about four dollars. Because this was my first real meal in France, I allowed myself the splurge of an extra two-and-a-half francs for a quarter liter of wine. The squid arrived in a boat-shaped dish under a dark tomatoey sauce rich with herbs and with something deeper to say, something more profound than a tomato's usual discourse. Carrot Provençal was just strips of sweet carrot with orange zest and lots of small but important olives. *Salade* appeared as a simple bunch of leaves with a surprising message: lettuce can have taste. The cheese course was accurately if too audibly described by an unmistakably American guy a few tables away. "The camembert," he repeatedly informed his dining partner and everyone else in the room, "is dynamite."

The Becks picked me up at the train station, as promised, and drove me through the billowy, green hills and past the wren-brown

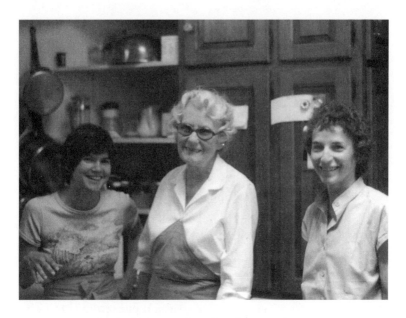

With Simone Beck and and Frances Mayes

vineyards of Chateauneuf de Grasse. It would be a day before anyone else arrived so I had my choice of rooms in the rustic yet elegant cottage Madame Beck called "La Campanette." Surrounded by flower-beds and vegetable gardens, it looked like it was sitting in the middle of a bouquet. Simone's house, directly up the hill, was slightly newer, having been built in 1725. She said nothing about the people in the third house on the property, possibly to protect their privacy. I had my suspicions, but I didn't ask. I'd find out soon enough. Simone graciously invited me to have dinner with her and her husband, Jean, warning me that they were just having leftovers. From that moment until I walked through their doorway two hours later, I fantasized about that meal.

Leftovers, indeed. Escargots or caviar, I imagined. On the terrace or under the festive glitter of chandeliers. With champagne or with some other French drink beloved in the region and known to few outside it. An acquired taste, she'd warn, using a French phrase whose meaning I would divine from context. I'd opt for the French drink, *naturelement.*

And then the meal. Or rather the first course: when would it be served? Linger: that was the French way. In France, eating—which is to say dining—wasn't a marathon race like it was in America. Simone would see by my attitude that she didn't have to explain that to me. I wasn't the usual American. I'd nibble and sip, live totally in the moment.

In some cultures, you're supposed to slurp your food to show appreciation, make a lot of noise when you eat. I wasn't sure about the mores in Chateauneuf de Grasse, but I was prepared psychologically to click my teeth and lick my lips in ecstasy if called upon. I'd watch to see what they did.

Unfortunately I didn't have the right clothes. Because Peter and I had planned to be traveling all summer carrying only backpacks and because I wanted to buy some things along the way, I'd packed only a few outfits that I intended to throw away when I bought something new. The red dress with its white polka dots and ruffled collar was slightly ridiculous, of course, but it was only a stand-in for the big flouncy granny gown I'd be finding in London's Portobello Road street market or the sundress with the pearl blue violets awaiting me in Seville. My only consolation, as Simone Beck swung the door toward her in her grand-gestured Normandy manner, was that she obviously didn't have the right clothes either. The distinctly amorphous style of attire Simone had chosen for our soirée bore a striking resemblance to the housedresses my grandmother used to wear in Brooklyn. Perhaps she chose it deliberately to make me feel right at home, but it wasn't at all what I'd expected.

"This is Jean," she said of the tall, slightly hunched man heading toward me with smiling eyes. His sweater vest and slipper-like shoes did nothing to make the bedraggled traveler feel out of place.

"Do you like soft boiled eggs?" Simone asked as I stepped inside. "One or two?"

Soft-boiled eggs? Why would I want soft-boiled eggs with all the tantalizing treasures of the French table just ahead. Maybe this was like slurping: you insulted them if you didn't.

"Two," I replied.

"Tonight you have many choices," Simone said, leading me into

a softly lit room with bookshelves along every wall. She directed me toward an overstuffed couch. This was more like it.

She asked me about my trip, apologizing for not being able to pick me up earlier; she had a lunch appointment with M.F.K. Fisher in Aix, she explained. On the table between us sat a tall clear bottle, possibly plastic, containing some colorless liquid. The French drink, I smiled knowingly, watching her reach for it, pick up a tumbler and ask, "Water?"

"Ah," she sighed, whisking me into the dining room across the vestibule. Someone had covered the table with trays and bowls. "As you see, the class on Friday ate practically nothing from the lesson. They were afraid to be too full for dinner at Moulin de Mougins. Well," she said with an inviting grin, "so we have many leftovers."

I was instructed to fill a plate with whatever I wanted, cafeteria style, and meet her back in the other room. Next to the soft-boiled eggs sat strips of buttered toast: soldiers my grandfather used to call them, but here they were *moulles*, if I heard her correctly. Nothing else looked remotely familiar. I scooped up some green stuff surrounded by white stuff, I cut a wedge of the red-flecked yellow square; I speared a few hunks of what I hoped was eggplant because if it was meat the color was not one with which I was familiar. This unpromising gastronomica would become downright romantic, I was sure, once Simone revealed their lusty French names. Following her across the hall, I caught sight of a white stucco-like fireplace curving sensuously down from the ceiling. The room was full of dark wood bookcases, paintings by Kwiatkowsky and Challio, two dogs and two cats. My eyes devoured every detail; this was a sacred moment. The question of where to set down my plate was being answered before my very astonished eyes as I watched Simone position what looked like a TV snack table smack in front of the television set. Jean nodded to us as he went to get his own green stuff and white stuff. I thought we should wait for his return before we began the ceremony of dining that I was still imagining, despite mounting evidence to the contrary. Not only did Simone Beck switch on the television and dive audibly into her soup before Jean was even out of the room, she finished every last drop before his return, simul-

taneously resolving my food slurping question in the process. Even so, as the guest I still wasn't going to slurp something she said was called *soupe de cresson*. It didn't seem right.

Any concerns I had about keeping up my end of the dinner conversation were obviated by the floods of emotion suddenly gushing forth from the television set. Jean and Simone immediately fell silent, their unblinking eyes riveted to the TV screen. It was obviously a soap opera with more than its share of tragedies per minute, but I didn't understand a word. One thing was clear though: we weren't getting dessert till it was over.

A crescendo of organ music prompted Madame Beck to switch off the TV and leave the room. She returned with a big bowl of chocolate mousse, half a bowl actually, the leftovers from a recipe she'd been testing in the Friday class for possible inclusion in her new cookbook.

"A good experiment," she declared, lifting a large clump of it onto my plate, "but it didn't work."

"Fromage?" she asked, as if it was an afterthought, as if the cheese course wasn't a breathlessly anticipated novelty to her American visitor, as if she didn't know. There were five—*Roquefort, reblochon, boursault, Gruyère* and *fromage des fraises*—and I hoped it was okay to taste them all. The Becks didn't seem to mind, but neither of them did likewise. They were discerning; they knew what one would taste like against the other, which first, which last, which not at all. Maybe some day I'd know that, but at that moment I felt lucky not to. I gave them all equal time, tried to fix them in my mind the way you try to remember the noses and eyes of people you want as friends. A few minutes of this one, and I knew I'd never forget it. A long, contemplative pause with that one, and I'd love it forever. Scattered around the plate were cherries, sweet, fleshy jewels from nearby orchards, Simone explained; she'd picked them up while in Aix with M.F.K. Fisher.

Soon afterward, Jean walked me back to the cottage. Glancing over at the lights blazing in the third house, Jean solved the mystery of its inhabitants. "I guess Julia Child is entertaining tonight." We listened to the long, hollow calls of something far away though all-

surrounding, a fog of sound. *"Les grenouilles,"* Jean said; the frogs. Suddenly there was another cry, different entirely, insistent, demanding, a prima donna sound. A pheasant, Jean explained. As I looked down from that dew-misted slope, the roof of La Campanette seemed to glow, its shingles caught in snowdrifts of moonlight. The air smelled of strawberries and rosemary and tall grass shaking itself free of the day. The sky glittered with blue glass stars. Watching Jean climb back up the hill, I felt honored to be there, to have spent the evening with him and Simone, and to have had that meal with them even though it didn't have any of the little pickles in it or Nantua sauce or pithiviers. Maybe this evening's repast was from the second volume. Tomorrow, when our course began, I'd find out.

The Way How It Should Be Done

THE NEXT MORNING, I AWOKE TO A SOUND that left no doubt about who lived in the house across the garden from Simone Beck. The unmistakable, breathless warble of Julia Child skittered down the hilly lawn, a sing-song tumble of trills and delighted clucking, an aural *pas de deux* of diva and rooster. It made me feel at home as I went for a run along the thread-like paths of the pastoral retreat they called Plascassier, its meadows the color that I imagined *haricots verts* would be. Was it the scent of perfume, the main industry in the nearby village of Grasse, that filled the air? Or was it just that the air was alluringly French, shimmering with all the promise of Provence?

By late afternoon, the four other students arrived—Jenny Connolly from Johannesburg, Kathy Hendricks and Candy Thrasher from Atlanta, Frances from California, though also from Atlanta originally. Simone Beck summoned us to her house where she introduced us to kir royale, a mix of crème de cassis and champagne, and welcomed us with trays of impromptu nibbles that looked suspiciously like miniaturized reworkings of our previous night's dinner. Served with tall flutes of the beautiful rose-colored kir, everything tasted magnificent.

Referring to us as "her girls," she told us to call her Simca and announced that our classes would begin at nine in the morning in the kitchen at La Campanette, where we should make ourselves coffee. When someone asked about a coffeepot, she said not to worry, the coffee was powdered. Of course she was teasing, we all thought, until the morning, when we actually unscrewed the jar.

At 9 A.M., I watched her walk down the slope, her blond hair

somehow not incongruous with a liberally lined faced built on strong-angled bones. The basket she was carrying bulged with something covered with a wrinkled linen napkin.

"Croissants," she said nonchalantly, as if she hadn't gotten up hours earlier to roll out these gold-tinged folds of dough just for us. "They may be still a little bit frozen. They were left over from the class last week."

Oh.

The strawberries were a different story. They had just been picked. Just. Their fragrance, a delicate but knee-buckling sweetness, danced through the room. Without even touching them, you could taste them. I picked one, its texture more surprising than the sensation of feeling it dissolve almost instantly on my tongue. It was a strawberry all right, but it had none of that styrofoam durability of the Safeway version. You couldn't pack up a box of these tender berries and ship them across the country; you could barely transport one from basket to mouth without the most loving dexterity. They were fluffs of flavor, evanescent, barely there, and yet they were vigorously luscious if not downright erotic.

Next came the aprons, one for each of us. They weren't deep-pocketed, professional chef-style cover-ups embroidered with "L'Ecole des Trois Gourmandes," the official name of Simca's cooking school. They were everyday-housewife aprons, different colors and patterns. The most interesting thing about them was how they revealed Simca's appraisals of us. Only after some scrutiny did she decide who got the pink flowered number with the frilly ruffles; the dainty, lace-trimmed plaid; the no-nonsense blue-and-white striped. Did she like me, I wondered, tying myself into the one with the grapevines: were the thorns significant? Kathy, probably the most serious cook among us, brought her own apron, her initials woven into the fabric. Simca wore a white blouse, a dark blue skirt and a light blue apron that day, and every day, in fact.

She was accompanied by one of her kitchen helpers, a squat, hunched woman with unexpectedly happy eyes, who was named Jeannette. In her red apron with one droopy pocket on each side, Jeannette washed the spoons and the spinach, padding around in

khaki-colored sneakers covered with stickers proclaiming "I Love You." Wearing a green apron, Simca's other long-time assistant, Therese, removed the requisite copper pots and wire whips from the wall and tried to avoid stepping on Phano, the dog, whose decision to cease snoring obviously signaled the official beginning of class.

We pulled up chairs, took out notebooks and started writing down every move Simca made: separating egg whites in the palms of her hands, cleaning the copper bowl with coarse salt, cutting up the butter for Béarnaise, melting it for Hollandaise, ordering vanilla powder from Petite-Quenault in Paris (where *else?*).

When I ventured to ask if her way of caramelizing sugar was her own technique, she looked at me with dismay and said: "Zis eez not a technique; eet eez za way how eet should be done." To several other foolish questions, she repeated the same advice: "You weel find zat in za '*Mastering*.'"

She worked on a marble slab or on the big chopping block table we gathered around. She guided us individually in slapping the *pâte brisée*, making a roux, wrapping up the rolled crab soufflé, flipping crepes. After about four hours, we were surrounded by such things as cheese soufflés in pastry (*croustades savoyardes*), leek and sorrel soup (*potage parmentier*), fish and spinach mousse (*couronne de filets de sole aux épinards*), frozen caramel mousse. When Simca declared it time for our French kir, we de-aproned and wandered out to the back patio for lunch. We were served by a young woman wearing a red-checkered apron that looked like the tablecloths in Italian restaurants in San Francisco, where she was from. Jan Weimer (a writer who would some day be the food editor of *Bon Appétit*) had volunteered to help as a favor to Simca, a chance to be around her. After a few days, Jan revealed in excited tones that she had to leave at four the following morning. Before we could speculate unduly about the cause of her provocative, pre-dawn getaway—truffle smuggling was among our first suspicions—she explained that she had reservations for dinner in Austria the following evening and she wouldn't miss it for the world. The chef, she swooned, was a genius. His food, all food, had gotten to Jan in invasion-of-the-body-snatchers proportions. She wanted to know everything, taste everything, cook

everything. It was absurd; it was a little crazy. And it was also hap-pening to me.

We used our afternoons to visit the Matisse Chapel, Biot's glass-works, the Maeght Foundation Museum (full of Miros and a Bon-nard and some crinkly Giacommettis); we walked through St. Paul de Vence, with its cobbly, ancient streets and a bakery, which made *callisons*, the almond-shaped cookies of Provence. We also tasted *chataigne*, an almond chocolate chestnut cookie, and the Grasse cookie, *fougasette*, flavored with orange flowers and tasting too much like perfume. Thanks to our hearty lunches, we never had any appe-tite left for dinner, a dilemma we vowed to remedy Friday evening, our last night.

On Thursday, Simca had a cocktail party for "her girls" and a few of her friends, one of whom was Julia Child. When we arrived, a simple matter of climbing up the hill, Julia was already there, sipping the ubiquitous kir and eating *fois gras* with a woman named Arlene, the editor of a food magazine I'd never read named *Bon Appétit*. Julia greeted us with such embracing enthusiasm, there was no time to be awe-stricken, and no need. Meeting her felt like a reunion with someone I'd known but hadn't quite met, a mere formality that had been overlooked until that moment. In the picture I have of us chat-ting together, my ridiculous red and white polka dot dress looks like a clown costume, but at least it doesn't look out of place next to her blue and white polka dot dress. We obviously had similar sartorial tastes.

On Friday, we had class as usual but ate nothing afterwards. We were saving ourselves for Roger Vergé and his renowned three-star Moulin de Mougins not far from Simca's. We'd invited Simca as our guest—actually she told us it was customary to do so—and we knew going with her would be like walking in with a movie star. We could hardly wait. Jan advised us that it would be expensive—she hinted at a figure of $50 a person—but at least we didn't have to drive to Austria.

Tucked into trees near the mill of its name, the restaurant was cozy and rustic, a disarming but welcome contrast to our expecta-tions of marble and crystal. Even so, there was something regal about

the experience as we sat at the round table with our mauve napkins in our laps, whispering. Waiters floated through the room delivering crown jewels like a tiny, trillion-layer salmon omelet and a crystal chalice of something called *sorbet de pamplemousse*, which was referred to as a palate cleanser. Then came *langoustine* in a sauce of champagne, cream and port; the duck with the potato timbale; the chocolate "rose" with vanilla glace and custard; the plate of miniature cakes and *fraises de bois*. It was almost midnight by the time Roger Vergé escorted us into the kitchen, which was dark and empty of all clues about how the evening's miracles had been performed. It was like going backstage at the ballet after the dancers had all gone home.

The next day, as a grand finale, we thought we might visit the Escoffier Museum in Villeneuve, a shrine to the master chef who set the code of French cuisine. Concerned that we might be considered unworthy, we asked Simca what she thought about our going. She looked thoughtful before delivering her usual no-nonsense brand of wisdom.

"Sometimes it's dusty," she advised in solemn tones.

Kir Royale

Fill chilled champagne glasses with bubbly.
Stir in a dash or two of crème de cassis. That's
really all there is to it: eet eez za way how eet
should be done.

The Risotto Test

"I LOVE RISOTTO. DON'T YOU LOVE RISOTTO?"

Fortunately the man I was scurrying behind wasn't waiting for an answer. He pulled open the door of one of San Francisco's South of Market restaurants and we entered air radiating garlic and simmering soups and the kind of heat that usually means pizza.

"And this place makes great risotto. Maybe not the greatest in the world, but really good risotto. And, well I don't know about you, but I always feel like if the risotto is good the rest of the food is probably pretty good too."

I smiled, trying not to look worried. Risotto. I rolled the word over and over in my mind, like chewing gum. I didn't remember it from the *Mastering*. Nor did it sound very French. Here I was about to have lunch with a man who might give me a food writing assignment at the *San Francisco Examiner* and I didn't even know what risotto was.

"I'm having the risotto. How about you?"

"Sure, yeah." That was the way to find out. Hopefully it wouldn't be some squirmy looking innard or something in shells that you were supposed to know how, or even whether, to remove.

"Which one?" he persisted.

"Which one what?" I had to ask. Bluffing can get you only so far.

"Which risotto? Personally I always have the old, basic risotto with the saffron and Parmesan. You know, the Milanese."

"That sounds perfect." I was hoping he'd change the subject pretty soon. Even if I were madly in love with risotto, I would have been ready to talk about something else by then.

"So," he said, peering at me over the wine list, "about your article."

His name was Harvey Steiman. He was the Food Editor at the *Examiner*. The cooking class with Simone Beck would make an interesting piece, he thought. After giving me a few suggestions, he told me to write it up and he'd see how it worked. Naturally he wasn't making any promises: The newspaper was Union and I was a freelancer, he explained; so this couldn't be an official assignment.

A freelancer. I didn't think of myself as a freelancer. I did think of myself as a poet, though, who recognized that even the most encouraging responses to my work came unaccompanied with anything you could spend at Safeway or offer the bank in return for staying in the house. While I waited for poetry to make a big comeback in America, I chose the profane over the sacred and pursued those aspects of wordsmithery for which I could send a bill at the end of the month. By this commerce-driven definition, I could still call myself a writer, setting up my own little advertising–PR company called Reilly & Ferrary Associates after my middle and last names. The name was supposed to convey the sense that the firm was more than one person sitting in a little office at my home in Belmont. But there was another reason. I knew from my Minnesota agency experience that most of my clients would probably be men and that they would feel more confident giving work to an agency run by a man. This theory was borne out repeatedly at initial meetings with potential clients.

"Who's Reilly? Where is he today?" they'd ask, assuming that Reilly was a man because his name came first, as it should by the laws of nature.

He wasn't available, I'd explain, assuring them that we'd both be involved in their account should they award it to us. I handled all the client contact and the writing and I contracted with several graphic designers for artwork on brochures and ads. My roster of clients included construction companies, publishers, colleges, even the Stanford University School of Nursing. I had no food-related or restaurant accounts. Nor did I want any. Writing about food was not going to be work. It was, if I ever got to do it, going to be fun.

In preparing my article, I pulled together Simca's menus and recipes from the course, read over my notes and scribbles, got my pictures of the cooking class developed. For good measure and inspiration, I also hunted up the menu from our meal with Simca at Moulin de Mougins and the diploma Simca presented each of her "girls" awarding us official status as graduates of L'Ecole des Trois Gourmandes.

When I was thirteen and my family moved from Brooklyn to Springdale, Connecticut, I produced several issues of what I called *The Springdale Gazette*, the purpose of which was to make fun of what I considered the hick-town goings on about town. Those sarcastic, puerile, and smart aleck pieces constituted my entire journalism experience. I knew how to write a Petrarchian sonnet, I'd crafted reams of press releases, brochure blurbs, and advertising copy, but newspapers remained a mystery. I strongly suspected there were important rules of journalism I should know about—like weren't you supposed to tell who, what, when, where and why? Oh well. Too late. Harvey was waiting for the article. I had a little rule of my own: Get their attention. I decided to start there.

When I sent in the story, I included a photo of Simca surrounded by her five eager smiling students. I hoped that if all else failed he'd like the picture enough to run the story with it. Something worked and the article was published in the *Examiner* in the summer of 1978. A French-language newspaper, *Le Californien*, based in San Francisco, translated the piece and published it shortly thereafter, also with the picture alongside. My first food writing venture, possibly my last as far as I knew, was, to my amazement, published in two languages almost simultaneously.

I was not nonchalant. I began planning articles and cookbooks, essays and food columns. I carried a little notebook at all times, scribbling in my observations on eating habits, culinary events, recipe possibilities. I read food magazines—*Cuisine, Gourmet, Bon Appétit*—with an eye to supplying them with articles.

Frances Mayes and I decided to write a cookbook tailored to the specific needs of the 70's culture, full of enticing, easy to make, character-rich dishes embellished with brilliant commentary and soul-stirring poetry. We called it *The Thirty-Minute Epicure*. My deepen-

ing friendship with M.F.K. Fisher flourished in a constant flow of letters between us. In one of them, I told her about our book and how its timely premise reflected both the fast-paced world we lived in and a devotion to epicurean-level eating. She was not overcome with admiration for the project. She took issue with the idea of new-fangled concoctions that purported to deliver the kind of complexity and depth of flavor that only honest, pay-attention, stand-by-the-stove cookery could produce. Nevertheless she would, she promised, provide us with one of her very own recipes for the book. We had visions of highlighting her contribution in some special way, maybe printing it on crinkly, expensive paper so the book would automatically open to that page. When we saw the recipe—a dumping-together of canned soup, packaged ingredients and frozen vegetables—we were shocked. Maybe she's trying to tell us something, we theorized. We dared to speculate on omitting the recipe from the manuscript, a dilemma that, thanks to the unresponsiveness of the half-dozen publishers to whom we sent our proposal, we never had to resolve.

Fortunately my obsessiveness about everything culinary found many other outlets. When my poet-friend, John Daniel, visited from England, we joked about the charms and seductions of English cuisine and Irish cuisine, but it was Scottish cuisine that had us laughing ourselves into a squealing, breathless frenzy tumbling around the rug. Apart from a quote by Jonathan Swift, our almost complete ignorance of the subject of Scottish cooking didn't deter us from these amusements nor from deciding we should write a book about it, if only because we'd so impressed ourselves with its tentative title *Oat Cuisine*. Working on this semi-serious venture, I discovered the joy of research, immersing myself in food history and old cookbooks, tirelessly reading and exploring anything about or related to the subject of oats. Except for oatmeal and several cookie recipes, I wasn't inspired to cook many of the rather unflamboyant oat oriented dishes I found, nor was John enthusiastic about taste-testing batches of haggis baggis, the apparent crown jewel of oat-based gastronomy. This was another dilemma that, thanks to the publishing world's response, needed no resolution.

Having taken Simone Beck's cooking course, I saw no reason why

I couldn't offer a series of classes based on what I'd learned from her, plus some of the culinary knowledge I'd picked up on my own—minus, of course, haggis baggis. I designed a flyer for "Recipes from a French Country Kitchen" and tacked it to bulletin boards in the laundromat, local grocery store and Printers Ink, my friend Susan's bookstore in Palo Alto. I sent a press release about the course to the *San Francisco Chronicle* and, when it appeared, I braced myself for the throngs who would be descending from all over the Bay Area. With John's help, I moved the redwood picnic table out of the kitchen to make room for as many chairs as I could fit facing the sink. That's where I stood on opening night, with my cabbages and chickens, poultry shears and unglazed pot of *herbes de Provence*. My nervousness dissolved quickly into the din of enthusiasm from students who greeted each instruction as divine revelation with an awe that was anything but silent. For two people, they certainly made a racket. Still, it was worth it—it was exhilarating, actually—and the following week, there were three.

When I read that Calvin Trillin was coming to town to promote his book, *Alice, Let's Eat*, I thought it would be thrilling to interview him and write a story about him and his book. I met him at the Stanford Court Hotel with my little steno pad filled with questions. He'd just said goodbye to Alice and looked slightly nervous at the prospect of facing a real San Francisco reporter. I began by mentioning a few discrepancies I'd noticed in some of the dates in his book. Instead of being impressed by my obviously diligent and careful reading of his work, he seemed rather annoyed. After these initial tough questions and their unsubtle insinuations that perhaps he'd taken some liberties with strict adherence to fact, he became noticeably less friendly. I tried to lighten things up by talking about how nice the Stanford Court Hotel was, point out the free peanuts and bouquets of cala lilies. He looked at me suspiciously as if he knew I was employing deviously clever journalism techniques to catch him off guard. Suddenly I realized I had no idea how to conduct an interview, but I thought it better that Calvin Trillin think I was crafty and nefarious rather than totally inept. As soon as I could, I got out of there, to our mutual relief.

I didn't know if Julia Child would remember me from the party at Simca's, but when I found she would be in San Francisco, I was anxious to see her again. Her personality, her impact on the culture, her magnetism were subjects I wanted to explore; I was equally intrigued by the way she resonated with the times, with people of all ages and interests. I called her sister, Dorothy, in Sausalito, and made arrangements to meet with Julia after the demonstration and book signing she was doing in the city. I contacted the *San Francisco Bay Guardian*, the Bay Area's major alternative newspaper, which specialized in investigative reporting and not in food articles. I proposed writing an essay about her significance, her almost cult-figure status, her ability to fascinate, entertain and attract such a range of followers. As for my credentials, I could by then claim that I was an experienced interviewer.

The tumultuous rain on the day of her appearance didn't dissuade the happily drenched multitudes giggling and clapping throughout Julia's brilliant bumblings and crowd-pleasing mishaps. They loved her not as a performer but as the friend they already knew from her programs, her books, her television appearances, her imitators. Even more amazing, she knew them, or so she could make it seem.

I called my article "Child of Our Times." When it was published, I sent her a copy. In my letter I had the audacity to ask her reaction to observations about how the current growing interest in food seemed in such marked contrast to a general intimidation about, even a fear of, cooking.

"Your idea about the fear of cooking is, I think, an excellent one," she responded, "and one I haven't seen put forth anywhere. I think it is very true and needs to be said." She went on to suggest that I contact various publications such as *Bon Appétit*, "whose editor, Arlene Inge, seems always interested in getting new material and hearing from new authors." At the *International Magazine of Food and Wine* "there is a Helen Witty…whom I have been in correspondence with from time to time." As for my piece about her: "I certainly thought it was a simply marvelous article" she wrote, "one of the best I've ever read, and I am very much touched and complimented. You do write awfully well!"

In closing she advised "keep on pushing out the articles, and never lose hope…you certainly seem to have a lot to say and a good style."

In black ink, she'd written Julia over the typed words Mrs. Paul Child.

I was ecstatic to receive such a letter and honored that she bothered to provide so many suggestions. In fact I felt a little guilty because, as T.S. Eliot might have put it, I was not a food writer nor was meant to be.

Or was I?

Risotto Californien

"I can tell you're from California" was the somewhat disparaging greeting accorded this dish when it was served to some vegetable-suspicious Easterners; "It's so full of greens." So try it already.

INGREDIENTS

2 quarts chicken stock
¼ cup olive oil
4 green onions, sliced
2 cups Arborio rice
Salt and freshly ground black pepper
¼ pound snow peas, strings removed
½ pound asparagus, cut into 1-inch pieces

2 small zucchini, coarsely chopped
2 tablespoons chopped fresh parsley
2 tablespoons chopped fresh chives
1 cup grated Reggiano Parmegiano

1. Bring stock to a boil and keep it on a slow simmer. In a skillet, melt the butter and sauté the green onions. When onions are wilted, add the rice and stir until well coated with oil. When rice becomes shiny, start adding the stock, one ladle at a time. Allow the first ladle of stock to be absorbed into the rice before adding the next, but never allow rice to become completely dry. Add salt and pepper to taste.

2. When rice is half done, about 12 minutes, add the vegetables. Continue to add the stock, stirring continuously (you may not have to use all the stock). After another 12 minutes test the rice by biting into a grain. It should be firm but not hard. Add the parsley, chives, and cheese. Serve immediately.

Serves 6 to 8.

Gazpacho Andaluz

The following is from the yellowing pages of Frances's and my unpublished cookbook, The Last Minute Epicure. *This Spain-based recipe is obviously from my pile.*

INGREDIENTS

3 cups tomatoes
1 large cucumber
1 green pepper
2 slices stale bread
1 clove garlic
1 medium onion
½ cup water
5 tablespoons olive oil
½ cup red wine vinegar
salt and freshly ground black pepper

1. In blender or processor, combine all ingredients and chop coarsely.

2. Chill several hours or overnight.

3. Serve with any of the following garnishes: sliced scallions, green pepper strips, chopped cucumbers, sliced black olives.

Serves 6.

The Feast Made for Giggling

WHEN I PICKED UP THE *Chez Panisse Menu Cookbook*, I never expected it would lead to an invitation to Craig Claiborne's sixty-second birthday party in East Hampton, Long Island. Written by Alice Waters, whose restaurant had already become a modern-day legend in the eleven years of its existence, the book affected me strangely. It offered recipes, of course, love poems to chervil and carrots, to squash blossoms and to handfuls of newborn peas. A good portion of the book, however, consisted of menus created for occasions like "Nouveau Zinfandel Week," "A Dinner for Beaudelairians," not to mention "A Special Event to Celebrate Allium Sativum, Film, Music and the Vernal Equinox."

For the most part, the recipes for the extraordinary dishes served at these special meals did not appear in the book. So what was the point, I wondered at first. Why tantalize with these unattainable possibilities? I'd heard that cooks sometimes leave out an ingredient, but it didn't seem fair to leave out all the ingredients. Was this whole book an ad suggesting that you can experience this food only by coming to Chez Panisse—"so make YOUR reservations today!" I spent hours wandering the book's pages, revisiting the events memorialized in the celebratory banquets. Occasionally, lured by the appetite provoking powers of something like caramelized red onions and cassis, I would relocate to the kitchen and peruse the book there so I could eat and think at the same time.

Finally, one day, I got it. I understood completely: the menu, as Marshall McLuhan might have said if he'd walked through Berkeley's Gourmet Ghetto, was the message. The book was about

California, the lives we were living and trying to live, the myths we ridiculed and revered, our heroes and our hopes. It was about coming here from everywhere, trying anything once, breaking the rules.

The *Chez Panisse Menu Cookbook* was about me.

I contacted Pat Holt, editor of the *San Francisco Chronicle* book review, and told her I'd like to write about the book. Her gentle "no" was not unfounded. Such a review belonged in the food pages: "Not my territory." I tried to explain; she tried to listen. She did listen. She said yes.

I returned to the book looking for support for my thesis, now that I'd blurted it out. The book was very much an adventure story of the California lifestyle, full of spirited pronouncements and declarations of independence.

"Our goal is to be totally self-sufficient," it proclaimed, referring to the restaurant, "so that we need not depend upon the unreliable quality and inconsistencies of the commercial" food establishment. It blamed the abysmal state of American food on mechanization and the alienation it engenders. In other words, we must—literally and figuratively—cultivate our own gardens. How Californian, I thought. Likewise Waters' exhortation to consume only what is fresh and in its prime. Be on the lookout for baby leeks and sweet basil in May, she advises; for nasturtium flowers and Comice pears in October. Her respect for the intrinsic goodness of natural and unadulterated food, a common theme in Northern California society, was embodied in such idealistic goals as "interfere as little as possible with the transition of good and pure ingredients from their origins to the tables."

Even her most offhanded asides reflected a distinctive California character. This is still frontier country, free from the constraints of stodgy tradition, she observed. Don't repeat eternally the one achievement "you have mastered; that promotes a stagnant attitude." Be adventurous. "Never look back, burdening yourself with the memory of the dinner (or whatever it was) that didn't work."

Throughout the book, California emerges as a place where we can make up our own definitions as we need them. Thus a "Special Occasion" (one of the book's main divisions) can be, in Waters' lexi-

con, "any special treat—-fresh tomatoes or suckling pig—whose arrival you welcome." No child has to be born, no bans of marriage announced to provide an excuse for the picking of just-ripe vegetables. The tomatoes are our own reward. And her dedication to "community and personal commitment and quality" is endemic to the region's identity.

The purpose of "Memorable Menus," describing forty-six dinners served at or by Chez Panisse, was obviously not to provide models of balanced or healthy combinations of dishes, as in an ordinary cookbook. This section was rather a collection of occasions, a docent tour of eating events with accompanying critiques. It was a gallery of Waters' work: A White Truffle Dinner; the Gertrude Stein Dinner; or the Back to New Orleans for Your Birthday dinner, in honor of David Lance Goines, the book's designer. This section, like the whole book in a way, was a little like visiting a museum and a little like peeking through the curtains to see whom the neighbors have invited for dinner.

Essentially, the book's magic lay in the excitement Waters generated, the encouragement she gave to forsake rules and recipes, to worry less about technique than integrity. Or so it seemed to me as I analyzed the book, wrote the review and packed it off, with fingers crossed, to Ms. Holt.

On Sunday, August 1, 1982, my article, entitled "California Dining as Lifestyle," appeared on the front page of the *San Francisco Chronicle Review: The Northern California Magazine of Books, Arts and Music*. It was my first book review, and the fact that it wasn't published in the food section was especially appropriate. My interests in all aspects of food seemed boundless. I wanted to learn everything, to explore food every which way: as heritage and history, as language and communication, as pleasure and love and power. Just for a start.

Four days later, Alice Waters called to thank me warmly for the review and invited me to lunch the following Friday at Chez Panisse. I'd been there twice, both somewhat disappointing. The first time, a visitor from Minnesota, for whom hunting wildlife had been commonplace since childhood, found nothing exciting about venison on

the prix fixe menu. Could he order a steak instead, he wanted to know? Of course, they said.

The previous June, Peter had taken me to Chez Panisse for my birthday. I found my copy of the menu, in case she should ask what I'd eaten:

SALADE D'HARICOTS VERTS AUX NOISETTES
Chino Ranch green bean salad with hazelnut cream vinaigrette

HUÎTRES GRILLÉES AU BEURRE CURRY
Charcoal-grilled oysters with a curry butter

PIGEON À LA DIABLE
Pigeon baked with mustard and breadcrumbs served with
a leek confit

CERISES AU COGNAC
Brandied cherries served with ice cream

The prix fixe menu of four courses for $25 represented a major splurge, especially since the meal—a quartet of exquisitely beautiful but spare still lifes—left us hungry. The dessert course, a tidy trio of cherries surrounding a marble-sized scoop of vanilla bean ice cream, was a kind of minimalist cherries jubilee, more like a reminder of the dish than a full-blown rendition. It was ethereal, lyrical, pristine—in a word, frustrating. As compensation, we stopped by Baskin-Robbins for an ice cream cone on the way home. Peter was still angry with Chez Panisse for that meal; he blamed them. I, on the other hand, figured the fault was mine. If I were really a sophisticated food person, I wouldn't have been hungry. It just wasn't done.

I'd never met Alice Waters, or even seen her. While immersed in her book, I was often tempted to contact her but thought I should wait until finishing the review. I didn't want to be biased any more than I already was, thanks to the Haldeman story which, cooking aside, might have been the restaurant's finest hour. One night, at the height of the Watergate scandal, an astonished H.R. Haldeman

slunk out of the restaurant after Alice informed him that he wasn't welcome on the premises.

There were other reasons I thought I'd like her. To Alice, food was politics, but it wasn't all politics. Food was cerebral, but it wasn't all cerebral. It was sensual and social and urgent. Plus it was art. Alice Waters wasn't the Betty Crocker Homemaker of Tomorrow. She was more like Joan of Arc, more like queen and conqueror. Her championing of the local green bean grower and goat cheese maker, nasturtium gardener and free-range-poultry farmer was revolutionizing restaurant kitchens where can openers and freezers had become the tools of the trade. Once you understood cooking as an extension of your mind and beliefs, you couldn't disregard that vision without betraying yourself. This was the territory she'd sworn to protect and defend, and now was the time of her reign.

She was sitting at a table upstairs in a cozy, cushioned corner of the restaurant when I arrived. With her sun-drizzled hair and her face glowing like the vase of sunflowers just behind her, she looked more like a midwestern farm girl than a monarch.

"Oh, hi, hi. So glad you could come. What a nice article you wrote. Really."

Wow, this is great, I thought handing her my copy of her book and settling in for a long, languorous afternoon with the subject of my most recent article. This is what happens when you are A Writer. My experience with hubris was short-lived.

"Oh, do you know Dick Graffe? From Chalone?"

This man, setting two bottles of wine on the table, was obviously not the waiter. He shook my hand and pulled over a chair at the same time. He had a reddish face, framed in golden brown curls, and small shimmery eyes that danced between us during the introductions. I assumed Chalone was a little town I'd never heard of and might well have blundered into asking where it was if he hadn't switched his focus completely as he proceeded to uncork the bottles. Just as well; Chalone, I could see from the label, was not only the name of a winery; it seemed to be his winery. We sipped the two wines and he talked about them at length. I told him several times

that they were really good, trying to shut him up so we could get on to something more interesting, like my article. Only the arrival of menus broke his concentration.

"What shall we eat?" Alice asked melodically, reading selections from the menu as if it were sheet music. "Oooo, the Illini Silver Queen corn, definitely," she swooned. "One of the pizzas?"

There were three pizzas and a calzone stuffed with goat cheese and prosciutto. There was also a baked goat cheese on lettuce. I knew she liked goat cheese—the Chez Panisse Menu Cookbook was full of the stuff, but I wasn't about to suggest anything. Was I going to make a better choice than Alice Waters in her own restaurant?

She whispered a question to one of the waiters—something about tomatoes—and a plate of them quickly appeared. A motley crew they were too, all different shapes and sizes in every color but tomato-red. A salmon-orange specimen no larger than a grape seemed like a small enough commitment if its taste were to be as pale as its color. It was warm on my tongue, a capsule of morning sunlight; one hesitant bite and it burst into a bouquet of unexpected flavors: citrus, salt, apricot. The plate had become a kaleidoscopic splash of glittering tomato gems: amethysts and emeralds, coral, amber and gold. The corn, also unpromisingly pallid, was buttered from within, grassy but sweet as nectar. Each newly arriving taste—the nutty cubes of feta, the squirty slips of cucumber, fleshy lettuce leaves—was honored with an initial silence as we breathed its fragrance. While we tasted, we talked, trying to describe the sublime, asking about origins, praising, sighing. It wasn't like talking about food; it was like talking about miracles.

"What next?" Dick asked, referring to Alice's busy schedule.

"The birthday party at Craig Claiborne's at his place on Long island. I'm supposed to bring food for the buffet. Any ideas?"

It was a combination birthday celebration and publication party for his new book. He'd invited about three dozen chefs and cookbook authors and they were all supposed to cook there or bring something. She pulled out the invitation:

YOU ARE CORDIALLY INVITED BY
Craig Claiborne
WITH
Pierre Franey
AS CO-HOST
TO

A FEAST MADE FOR LAUGHTER

to celebrate the publication of
his autobiography of the same name
(his 62nd birthday and 25th anniversary
with *The New York Times*)

SATURDAY, SEPTEMBER 4, 1982
AT ONE O'CLOCK

15 Clamshell Avenue
East Hampton, New York 11937
R.S.V.P. by August 15th
Please present this card at the entrance
It will admit two

She pointed to the last line.

"See? I can bring someone. Would you like to be my guest?"

She meant Dick, of course, but she wasn't looking at Dick for some reason. She was looking at me. And she was waiting for an answer.

"Me?"

"Could you? It's in New York, you know."

Coincidently I was going to Long Island anyway, I told her. A wedding in the family.

"Lovely."

Was this really happening? Alice Waters inviting me to Craig Claiborne's birthday party in Long Island on a date that I was going to be there anyway?

"Wow. Yes, great. Thanks!" I was alternately breathless and

giggling like an idiot. This was another of my not terribly sophisticated moments in the food world.

"Great. I'll see you there then." She handed me back my book.

In the car, I flipped open the cover to see what she'd written:

To Jeannette
Thank you for your very special review.
Affectionately, Alice
8-13-82

It was only three weeks till Craig Clairborne's party. I could hardly wait to see what she'd bring.

Cherries Jubilee

INGREDIENTS

 3 tablespoons butter
 2 cups of cherries, pitted and halved
 1 tablespoon sugar
 ½ teaspoon vanilla
 3 tablespoons cointreau or liqueur of your choice
 vanilla ice cream

1. In medium-sized sauté pan over medium heat, melt butter. Add cherries, sugar, and vanilla and sauté gently until cherries are well coated and flavors blend.

2. Remove from heat, spoon in liqueur and carefully return to heat. Liquid will probably ignite as it nears the flame or you can strike a match—use extreme caution. Move contents of pan around until flames subside, then serve over scoops of vanilla ice cream.

Serves 4

The Name Tags

"I'M NOT GOING."

I was sitting across from M.F.K. Fisher at the bumpy, wooden table in her kitchen. She'd invited me to lunch, as she often did, always to my astonishment. I thought I was introducing a felicitous topic when I mentioned Craig Claiborne's birthday party. I told her Alice Waters had invited me as her guest, and she smiled sweetly, too sweetly, I soon realized. It was a smile that meant: It was nice of Alice to invite you; it's nice that you're going; but the whole thing is ridiculous if you ask me.

"It's a small intimate dinner party for 400 of his closest friends," she explained, carving into a small block of cheese with a butter knife that wasn't quite sharp enough. "Would you like some of Ig Vella's Jack?" Her bony fingers stroked her forehead, brushing aside a few annoying though imaginary wisps of hair.

"Well, you know, Mary Frances, I'm going to be in New York anyway," I mumbled apologetically, "family wedding on Long Island."

More of that smiling.

"Quite a coincidence, huh?" I was only making things worse. "I'll take lots of pictures."

By then she was adjusting the plums ripening in her wrought iron egg tree, or whatever that squiggly black contraption was.

"Please do," she said emphatically, by which she meant, "Please don't."

But that's exactly what I did.

As I turned off Clamshell Avenue into the entrance of Craig Claiborne's property, people with champagne glasses dotted the four-acre

lawn surrounding a gigantic yellow and white striped circus tent. Handsome though it was, it was not, I was sure, Claiborne's permanent residence. A natural wood and many-windowed house sprawling over Three Mile Harbor looked more like it. Clutched tightly in my hand was the invitation Alice had given me with the words "Present this card at the entrance" printed in bold type on the cover. No one was collecting them, nor had anyone bothered to bring theirs, as far as I could see. I stuffed mine into my bag.

I recognized Danny Kaye immediately. He was smoking a cigarette at a table just outside the chef-filled kitchen, as if to be ready when they were. Chefs abounded. Thirty-six of the most famous of them had been invited to prepare their favorite dish for this party celebrating Claiborne's sixty-second birthday, his twenty-five years as food editor of the *New York Times* and last, but probably first, the publication of his new book called, just like the party, *A Feast Made for Laughter*. The *San Francisco Chronicle* asked me to write a review of the book and possibly an account of the party, assuming it was sufficiently literary. When Danny Kaye turned my way, I took his picture.

Inside the tent, more chefs were arranging food-filled platters on the long, linen-covered tables ringing the perimeter. A handsome black woman in a brown and white striped shawl-dress stood behind a small hill of golden brown chickens festooned with translucent red berries and bouquets of green herbs.

"That's Edna Lewis," someone informed me, "and that's her squab with basil."

I took her picture. In the center of the tent, next to stacks of gleaming white plates, bright red napkins and baskets of silverware, a pile of long pink menus matched names with offerings. There were three categories: Chefs, Food and Wine Celebrities, and the one in which I found Edna Lewis, Cook Book Authors. "Author of *The Taste of Country Cooking*," was her description. The woman dressed in a custard-colored V-neck sweater and flowing chocolate brown skirt—surely she did that on purpose—was Maida Heatter, I discovered, though I might have guessed. As this author of many dessert books surveyed the large discs of thickly chocolated tortes, a parade

of walnuts circling their tops, I took her picture also. But where was Alice, I wondered, locating her name under "Chefs" identified as "Owner/chef of Chez Panisse, author of *Chez Panisse Menu Cookbook*."

The woman in pearls and basil-green silk dress looked frantic as she cut into the contents of a large baking dish. I thought something was wrong until I stepped closer and the air turned Italian, sundrenched and seductive, a reminder that food, in all this elaborate fanfare, was the point.

"It's spinach cannelloni with tomato noodles," she explained, still looking worried. The dish wasn't on the printed menu, I noticed, so I couldn't identify its creator. Maybe she was an extra, a back-up in case they ran out of the good stuff. I felt sorry for her when she offered me a taste; with thirty-six real chefs on the premises, I wasn't inclined to waste my digestive juices on experiments.

"It says lasagna on the menu," she told me, "but I changed my mind."

I found it. "Vegetable Lasagna" printed opposite the attribution "Marcella Hazan, author of *The Classic Italian Cook Book*." Oh my God. Marcella Hazan is personally serving you her pasta, I scolded myself, and you're not prostrate before her with gratitude? Humbled and humiliated, I accepted her offering.

The little pillowy morsel melted on my tongue, rekindling the taste of an almost-illicit, long-ago evening in Bologna. My appreciative moans had a temporary effect on the curve of her mouth, which turned upward into a cautious, unconvinced smile, though her big, sad eyes still looked full of tragedy. Maybe she just wasn't looking forward to feeding 400 people.

Diana Kennedy (author of *The Cuisines of Mexico*), Madhur Jaffrey (*An Invitation to Indian Cooking*) and Penelope Casas (*The Food and Wines of Spain*) were putting finishing touches on their masterpieces. Mingling with the soul-stirring scents of their Turkey Mole, Clams in Coconut and Green-Chile Sauce, and Baby Eel Salad were pastry-wrapped salmon mousses, rabbit patés, and bouillabaisse ready to be served by their creators, some of them chefs from New York's illustrious restaurants: Alain Sailhac from Le Cirque,

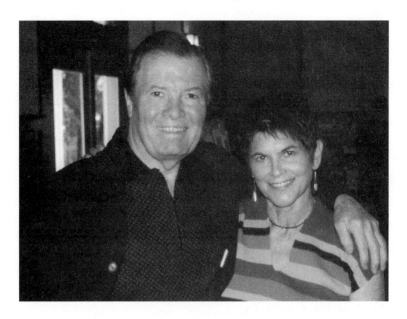

With Jacques Pepin

Andre Soltner of Lutece. Edward Giobbi (*Italian Family Cooking*) walked past with a whole baby lamb on a spit. He'd been in Claiborne's kitchen, a two-room, restaurant-sized laboratory where Pierre Franey, Claiborne's co-author and long-term associate, was busy helping with the final warm-ups. Jacques Pepin (*La Methode*), blithely playing bocce ball on the rolling lawns between tent and house, must have felt that his art-deco-carved watermelon baskets, filled with seviche, were quite ready for presentation. Restaurateur/ chef George Lang stepped back for a final assessment of his hundred-ingredient pie, a blocky structure that looked like the cornerstone of a building. A small crowd gathered around Bernard Clayton's crusty warm sculptures, round loaves sprouting shafts of wheat and clusters of grapes and the letters CRAIG CLAIBORNE, all golden brown and smelling of fire and smoke.

Still no Alice.

When I finished taking pictures inside the tent, I wandered around to the white café tables set among hefty but hospitable elms where famous people I didn't know fingered their flutes of cham-

pagne, chatting incessantly. The handsome, chiseled-faced man with wild, curly gray hair sitting at the table in front of a pile of logs looked familiar.

"Do you know…?" Is that by any chance…? I stammered to a kindly looking nearby gentleman, reluctant to commit to a specific guess.

"Yes, that's Joseph Heller," he whispered gently, "and he's talking to Kurt Vonnegut. And that's Betty Friedan."

"Thank you so much," I said, positioning my camera. He was an editor at the *New York Times*, he told me, his first and last names lost in the confusion of the moment. Later I realized he was Arthur Gelb and much later—years later—we would both be working for the same newspaper. Or more precisely, I'd be working for his newspaper.

"You know," I complained, focusing on other unknowns, "you'd think they'd have name tags."

"Yes, but nobody needs them," he laughed, "except you."

He made sure I was laughing too before he said "Good luck" and began to wander off.

"Oh, wait," I called, spying an opportunity to redeem myself somewhat. "I do know who *he* is."

The full-bearded man dressed in white was sitting behind a log fire presiding over huge iron frying pans and directing a small troop of toque-topped helpers. The button on his white, brimmed cap said "Totally Hot" yet he looked like a giant snowman leaning on a cane to keep from toppling over. Paul Prudhomme, the menu revealed, was in the process of making his signature Blackened Red Fish. Another familiar face was Clarke Wolfe, who'd moved to New York from San Francisco's Oakville Grocery. His mouth was as full of Maida Heatter's torte as was humanly possible when I asked him what he brought to the feast.

"My stomach," he answered, without missing a crumb.

And then, suddenly, there was Alice in a white-yoked linen dress laced at the shoulder. She wore a forties-style black cloche hat, a spray of tiny pink and purple blossoms pinned over her ear. She was carrying a tray of roasted gold and red Chino Ranch peppers,

perhaps the simplest dish of the day, yet the most profound. Unadorned, they tasted sweet, intense, and fleshy, if not messianic. It wasn't a recipe or a specialty she was setting before the king. It was California. With her fresh face and eager, sparkling eyes, she looked like a saint, possibly a martyr. Take ye and eat, was her message; this is how we do it out there in paradise.

Miraculously Paul Prudhomme arose and walked over to her as Claiborne welcomed her with a sunny smile. I took a picture of the three of them, their happy faces beautiful in the sun, each in its way. Retrieving my copy of Claiborne's book, I walked over and asked him to sign it to my daughter.

"She's just a baby," I explained, "she couldn't come today. But some day the book will be hers. Her name's Natasha."

He tilted his head to the side, thinking, then took the pen, wrote something on the second page and handed the book back. As soon as he moved on, I read the inscription:

"For Natasha. Blessings. Craig Claiborne, 4 September 1982"

I loved what he wrote. I loved it more than the book itself, which I found stilted and contrived, even insincere. Unfortunately that's how I'd have to write my review for the *Chronicle*, not a very nice thank you note for his "Feast," the book or the party. Actually, though, they were the same. Both "Feasts" had a sort of Pirandello quality with the cast of characters—the exact same characters for the most part—searching for the author, for context. Suddenly I was struck with the eerie thought that this was all frighteningly relevant to me, especially if I continued exploring and writing about the world of food. These people were the main players in that world, and I'd just met them all in one place in one short afternoon. It was like attending the coming attractions of my life. At least I hoped so.

Three Pepper Pappardelle with Goat Cheese

This is definitely chezpanissy, full of the simple stuff that restaurant has brought to glory. It would make a nice potluck contribution to anybody's birthday party. Well, almost anybody's.

INGREDIENTS

 3 peppers, different colors (green, purple, orange, red, yellow; your pick)
 3 tablespoons olive oil
 2 leeks, cleaned and sliced at one-inch intervals
 1 teaspoon each fresh thyme, basil and oregano, or ¼ teaspoon dried
 salt and freshly ground black pepper
 1 pound pappardelle
 ¼ pound goat cheese

1. Place peppers over gas burner, under a broiler or on a grill. Roast until skin blisters and blackens, turning often.

2. Place in plastic bag until cool. Scrape off skin with paring knife. Cut peppers into thin strips.

3. In medium-sized sauté pan heat olive oil and cook leeks with herbs until silky-soft, about 10 minutes.

4. Cook pasta and drain. Mix in leeks and peppers and toss. Crumble goat cheese, add to pasta and toss again.

Serves 4

The Proposal

I HAD NO IDEA I'D EVER SEE JOSEPH HELLER AGAIN. From his perspective, he probably didn't know he'd ever seen me in the first place. But I had his picture in my album, a semi-fuzzy shot of him and Kurt Vonnegut in mid-sentence, taken at Craig Claiborne's birthday party. Who would ever have thought that some day I'd be taking Joseph Heller to dinner in San Francisco? But such, I was beginning to understand, was the power of food.

In my own disorganized way, I'd been learning quite a bit about food. Something would catch my attention—artichokes or wild rice, for example—and I'd strip the shelves at the Burlingame Library of anything remotely related to the subject. I'd requisition every magazine and newspaper article to which Readers Guide made even a passing reference. I blinked and squinted for hours behind the San Mateo Library's microfilm reader. When I started wondering about something—where Christmas cookies got their names and shapes and why they contained certain ingredients—I'd hunt down every theory, myth, and folktale. Explanations that were scholarly and logical were no more interesting to me than the most far-fetched old wives tales— often much less interesting, in fact, and often less plausible. It was so thrilling to discover that the Greek cookies, *kourabiedes*, encircle a clove as a symbol of the spices brought by the Magi. And that mince pies first appeared in medieval cookie jars as an oblong shaped pastry commemorating the humble manger. The Rumanian pastries called *turtes* are thin leaves of dough twisted and wrapped like strips of cloth—the swaddling clothes of the Christ child. Or so they said, truth be damned. I had no idea who Mimi Sheraton was but I wanted

213

to write her a thank you note the day I chanced upon *Visions of Sugar-plums,* her book entirely devoted to Christmas cookies.

Not infrequently someone would publish my pieces, *Focus Magazine, The San Francisco Bay Guardian,* a San Francisco culinary newsletter called *Foodtalk*—but when an article earned a hefty number of rejection slips, I'd put it in a folder and slip it into my file cabinet. Each of them took prodigious amounts of work but from my perspective, there was no such thing as spending too much time on them. It was like getting a PhD in food studies plus a master's and a bachelor's, all at the same time. There was no other way to do it.

As my name started appearing in print, I received a few requests to do articles on specific topics. And then one day, a man named Steven Barclay called to ask if I'd be interested in an event at the College of Marin in San Anselmo.

"Craig Claiborne is coming to town," he said, rekindling Wayne-Thiebold-like images of multiple chocolate birthday cakes in East Hampton.

"We were wondering if you'd be interested in interviewing him onstage before a live audience."

Originally the idea was that Craig would prepare a talk for his evening appearance. As the date loomed closer, Claiborne decided a give-and-take interview would be livelier, Barclay explained.

"Of course, you'd have to read up on his stuff," he continued.

I knew his "stuff." For my not overly complimentary review of Claiborne's' book, *A Feast Made for Laughter,* I'd become familiar with the events of his life and with all his published cookbooks and many of his articles. I considered whether I should mention my review, aware that shooting myself in the foot was probably not a smart career move. I did it anyway.

"As a matter of fact," Steven admitted, "Craig mentioned that there was one person in San Francisco he didn't want doing the interview because of some nasty article she wrote." I was about to commence the weeping and gnashing of teeth and I had only myself to blame.

"But he also said," Steven continued, "that he doesn't remember her name."

A few days before the event, Steven called, his voice betraying concern. Claiborne remembered; that was all I could think of as Steven described Claiborne's itinerary and schedule, including several local TV shows.

"What he'd like," Steven began tactfully, "is if you could go to the KRON-TV studios tomorrow afternoon. He'd just like to meet you beforehand. I mean, if that's okay with you."

I thought I was nervous, walking into the TV studio the next afternoon, but my fingers weren't visibly vibrating, like Claiborne's, when we shook hands. The following night, March 8, 1984, at the College of Marin, Steven explained the set-up: two chairs onstage, two mikes, comfortable, casual, easy. The three pieces of paper containing my remarks and questions looked as frayed as I felt, but according to Steven, this was nothing compared to Claiborne's nervous state. No one in the audience would have guessed any of this. Maybe his best friend might have detected his discomfort, but to all appearances, he was charming, funny, expansive, and happy to answer any questions, even the tough ones, not that there were any. The toughest was the last one. I asked: "You mention that after writing your very personal memoir, you actually felt unburdened about a lot of things. Could you comment on that?" Although he recognized this as a reference to the sexual relationship he describes with his father, no one unfamiliar with his book would have. In his reply, he avoided any mention of the subject.

The best part came after the final applause when Steven announced that he, Craig, and I would go to dinner together at a nearby Marin restaurant, Le Coquelicot. He'd already made the arrangements. I could only imagine how nervous the proprietors of the restaurant must have felt at the prospect of serving Craig Claiborne dinner. As we were being seated, they fluttered around us warbling welcomes and honored-to-have-yous, proffering menus with assurances that anything, on or off the menu, was at his disposal. That was precisely what he wanted to hear.

"Great," he said, without much fanfare. "I need a drink."

They had, they proudly expostulated, a formidable wine list of both French and California vintages, plus his favorite champagne—

evidently they'd done their homework. As they stood there beaming, Claiborne leaned over and said something to Steven.

"Oh, yes, of course." Steven then turned to the hand-wringing twosome. "Mr. Claiborne would like a drink. What kind of liquor do you have?"

Their faces paled and reddened almost simultaneously. They had no liquor license; they only carried wine.

"Yes, but what about, you know, in the kitchen. For cooking purposes."

They looked at each other. Through their dried lips came the hoarse, doleful admission: "We have no hard liquor on the premises."

"Hmmm." Steven half groaned. "What about off the premises? Is there a liquor store nearby?"

Not at that hour, they informed him mournfully, retreating to the kitchen presumably to inventory the alcohol quotient of every liquid in the house.

How about another restaurant, some place with a liquor license? Absolutely nothing was open, Steven admitted, this was Marin, not New York City. In fact, strictly speaking even Coquelicot was closed. They'd stayed open for this special moment. I sat silently, feeling completely guilty, responsible, and strangely elated. Imagine being capable of throwing someone into such a dither? It was a false sense of power deriving solely from my role as interviewer and dining companion to Craig Claiborne. But it was exhilarating while it lasted.

The food was deliciously calming, each perfect little course generating such appreciative and gracious commentary from The Master that the owners, who would have settled simply for forgiveness, returned to their radiantly beaming status. They brought us beautiful silver oysters, their edges turned to a golden, crinkly crispness; thin satin ribbons of calamari and roasted red peppers; a butter-smooth house-made paté. Claiborne was delighted with the sturgeon, Steven with his rack of lamb and I with my chubby little prawns, ever so subtly perfumed with Pernod. We all loved the roasted chestnut mousse, "a marriage of earth and heaven," someone

commented in an excess of exuberance. I think it was Steven or one of the waiters. I hope so.

Not counting my many lunches with M.F.K. Fisher, this was my first hard core dinner with a national celebrity. Within months, I was doing so regularly, thanks to San Francisco's *Focus Magazine*, its editor, Mark Powelson, and his staggering delusions of grandeur.

"We want you to do restaurant reviews," he informed me one day, explaining his exalted vision for the magazine. Contributors to KQED public television received the publication free, consulting it for its program listings and stories of local interest. I loved writing for *Focus* because they were so open to food-related articles that allowed me to delve into the heritage and history of my proposed subjects. Their educated audience appreciated that there was more to food than a blurb and a few recipes. With the addition of restaurant reviews, Powelson intended to position *Focus* as the most important source of food and dining information in the food-crazed city of San Francisco. This would make the magazine so valuable that people would want to buy it or subscribe to it, whether or not they were KQED supporters. As he saw it, he was handing me a job anyone on the face of the earth would beg for—reviewing restaurants in San Francisco.

I wasn't interested.

I liked writing about subjects of substance, learning while doing, harboring the hope that it was significant work and that a few readers beside me, Peter, and M.F.K. Fisher might even keep my ruminations in their file cabinets for future reference. What was the point of writing restaurant reviews? The places closed, the chefs moved on, the most incisive and brilliant writing was utterly disposable. It was a waste of talent and energy.

Not at all, Mark countered. The fact that I'd never written a restaurant review and had no experience didn't faze him. This was a golden opportunity, a chance of a lifetime. It was also—slowly came the dawn—a form of blackmail. If I didn't become the restaurant reviewer, I didn't write for *Focus*.

There was more.

In order to make a major splash, they wanted me to invite only

famous people to dinner and write a combination interview and res-
taurant review. I didn't know any famous people, I protested, much
less how to invite them to dinner. You'll figure it out, they advised
confidently.

I tried Lynn Redgrave. She was doing a play in San Francisco—
playing a nun in *Sister Mary Ignatius Explains It All For You*—and I
proposed taking her to Donatello, not far from the theater district.
She said yes. I tried Alice Adams. She had a new book out, *Superior
Women*, and was doing a publicity tour. I suggested Stars, Jeremiah
Tower's new razzle-dazzle clubby showplace with aspirations to be-
come San Francisco incarnate. She said yes. Marion Cunningham,
who had completely revised and rewritten the *Fannie Farmer Cook
Book*, though the publisher, Knopf, did not deign to put her name
on the cover—"With an Introduction by James Beard" was the only
credit—said yes to my invitation to the Bay Wolf, a young but des-
tined to endure California institution. Perhaps she was hungry for
any sort of recognition.

As for Joseph Heller, I knew he was coming to San Francisco to
publicize his newly published *God Knows*. I tracked down his pub-
licity agent and proceeded to trip over my words in an effort to ex-
plain the inane idea that he, Joseph Heller, might go to dinner in
San Francisco with me, a complete stranger. I threw in a few dis-
connected phrases about Craig Claiborne's birthday party, meeting
him there, Kurt Vonnegut, a generally incoherent jumble that met
with the usual response. Yes. She'd put it on his itinerary. Where?
When?

Outside the restaurant, Joyce Goldstein's Square One, I paced
nervously waiting for Heller, his fiancée, Valerie, and the *Focus* pho-
tographer. Since Peter was more familiar with all Heller's work than
I, I was glad he could come along in case things got seriously literary.
I couldn't imagine engaging Joseph Heller in a discussion of Hawai-
ian opaka-paka or mishmaya ragout or any of the other ethnic chic
items on the menu.

He was as handsome as I remembered him: slender, tan, a square-
jawed face crowned in a silver white frizzle like thick whipped cream,
his eyes dancing. The photographer began arranging us in a series of

With Joseph Heller

awkward poses explaining that *Focus* wanted both of us in the picture but that my face was not to appear in the magazine. This was intended to prevent restaurants from recognizing me and according me special treatment.

"Oh," said Heller in singsong cadence, obviously impressed. "Would everybody in San Francisco know your face?"

"Not exactly," I mumbled, aware that this was the understatement of the year, "at least not at the moment. But, you know, I guess people are always on the lookout for reviewers."

We were shaking hands, my back to the camera and the next thing I knew we were dancing along the sidewalk. He swung me under his arm and I whirled out and back, lindy-style, and we couldn't stop laughing. Peter and Valerie didn't join us but the photographer

took our picture and sent me a copy. I framed it and put it on my kitchen wall. Forever.

For his first test of the restaurant's prowess, he ordered a martini, sipping it thoughtfully as we exchanged stories about Brooklyn. (He was born in Coney Island in 1923). I told him my father had a broomholder business in Coney Island in the forties. His employees wore uniforms with their names sewed on the pocket as identification—only they turned out to all be named Joe. He wasn't one of them, he told me. He joined the Army Air Corps in 1942, graduated Phi Beta Kappa from NYU in 1948, got his MA at Columbia and, by '49 was at Oxford on a Fulbright.

"Somebody should inform whoever made this martini," Heller whispered to the waitress as she handed him the menu, "that they know what they're doing."

To my surprise, though he was no cuisinist, he had quite a bit to say about food, criticizing the experimentation and prissiness rampant in the trendiest places.

"The problem with many restaurants these days," he said, "is that they are doing things to food that possibly should not be done." He spoke with the strongest Brooklyn accent (not counting my cousin Kenny) I'd ever heard, but a good-hearted smile was embedded in its longshoreman-like rhythm. "Given the choice between a lot of poor food and a small amount of very good food," he explained, "I would always choose a lot of poor food."

He seemed to enjoy the meal. He focused on the most unpretentious selections like the green salad with pears and walnuts and the rigatoni with sausage. He was delighted with one of the items on the dessert menu—Jonathan apple tart with raisins and streusel topping served with rum crème anglaise—but he felt it needed some editing.

"Do you think you could turn that into a piece of apple pie with cheddar cheese?" he asked the waitress.

When she returned, she reported that she'd managed to scrape off just about all the streusel but the raisins were rather tenaciously baked in. Because there was no cheddar, she asked him a question that left him visibly stunned.

"Would you like some goat cheese with your pie instead?"

To the man whose novels poke fun at God and the entire course of human civilization, this unorthodox pairing struck with the shock of sacrilege.

"Goat cheese? Uh, no thanks," he answered, barely stifling a wince.

Overall, there was no faulting the service. It was attentive and sensitive, the artfully arranged plates of food graciously laid before us. Were they setting out little extras, or was this the way it always was at Square One? Heller obviously noticed, chalking it up to the perks of dining with a famous reviewer. The truth was it made no difference who I was; it was Heller they spotted and treated as a special guest, never resorting to the crassness of violating his privacy. They were thrilled to have him there, Joyce Goldstein told me a few days later when I called to verify a few ingredients; oh and what did I say my name was?

In addition to restaurant reviews, I continued writing book reviews of food-related works and I explored and wrote about topics that interested me, some to be published, some not. When I met Fred Hill, a new arrival from Boston and the Eastern front of book publishing who was setting up a literary agency in San Francisco, I deluged him with article ideas. I wanted to write for the *New Yorker, Harpers, Atlantic Monthly*. I wanted them to want essays about food, keen and funny observations about eating and its role in a changing world; anything of mutual interest. Fred gave me the names, told me who to write to and how, offered suggestions. But this wasn't what he came out to San Francisco to do. He wasn't interested in raking in ten percent of the kind of pittance paid by magazines. Among other things, he wanted to be the West Coast's cookbook maven, as he termed it.

"Why don't you get serious?" he asked suddenly one afternoon as I sat in his office sifting through my file folder of the brilliant ideas I'd sent him to date. "These articles, you could do them forever. Why don't you write a cook book proposal?"

I was insulted. I was hurt. I didn't want to do a cookbook any more than I'd wanted to do restaurant reviews. But I knew blackmail when it wafted through the room.

Joe's Apple Pie

This is apple pie the way my dancing partner, Joe Heller, would have liked it. Straight up, neat, no goat cheese. The cheddar is optional, though it wouldn't have been for Joe.

INGREDIENTS

Crust:

> 2 cups flour
> pinch salt
> 1½ sticks sweet butter, frozen and cut into small squares
> 6–8 tablespoons ice water

Filling:

> 6 big apples, Gravensteins if you can get them, peeled and cut into chunks
> pinch salt
> pinches of nutmeg and cinnamon
> ½ to ¾ cup sugar
> ¼ teaspoon vanilla
> juice of a small lemon
> 2 tablespoons all purpose flour

> wedge of cheddar

1. In bowl of food processor, pulse all crust ingredients except ice water until mixture resembles corn meal. Add water, dribbling it in until mixture just begins to come together, but don't let it form a ball.

2. Gather dough into a ball, flatten slightly, refrigerate for an hour or so, roll out dough for bottom and top crust. Fit bottom crust into pie pan.

3. In large bowl, mix together all filling ingredients. Fill bottom crust with apple mixture and place top crust over it, crimping edges. Cut 2 or 3 little slits in top.

4. Bake in preheated 425-degree oven for 30 minutes, reduce heat to 350 and bake for an additional 20–30 minutes, or until golden. As for the cheddar, you're on your own.

The Message

"YOU MADE *WHAT* FOR JULIA CHILD'S LUNCH?"

I couldn't believe my ears. The chef had been given the opportunity to prepare a box lunch for Julia Child. It was supposed to be casual and unfussy, just a little something before her afternoon appearance at Macy's San Francisco. He packed it in a football-sized gift box tied with blue ribbons and was delivering it to the sort of back stage dressing room where Julia, her sister Dorothy, and I were waiting. I only hoped they hadn't heard what he said. I took the boxes from him—there were three of them, one for each of us—and slid them onto a table by the door. Then I realized he was kidding; he must be kidding.

"Come on, tell me. What's in them?"

He looked frazzled, an appropriate response for someone who had invested all his creative energies into the challenging but intimidating task of whipping up a box lunch for Julia Child. He also looked annoyed.

"I told you. Tuna fish sandwiches."

Maybe he hadn't realized which Julia Child he'd been asked to make lunch for. He'd slapped together a couple of sandwiches for some ordinary Julia Child, an earthling who hadn't helped change the course of America's eating habits in her twenty-five years—it was 1985—of cookbook writing and television cooking shows. Surely he knew not what he did—or didn't do, as the case may be. Or perhaps the strain had been too much for him and he'd completely lost his mind. His eyes looked a bit jumpy, now that I peered more closely. Proof of his derangement surfaced almost immediately as Julia, attracted by the commotion, turned to greet him.

"Oh, hellooo, you're the chef aren't you?" came the chortly tones, full of welcome and gratitude. The billowy abandon of her teal rayon blouse swarming with flickery white splotches contrasted with the workhorse immovability of a navy gabardine skirt. Cinnamon-orange hair, the same color as her lipstick, made thick, loopy curls across her forehead. She was smiling and talking, the metallic music of her voice pitched halfway between some kind of horn and a reed instrument not yet invented.

She shook the chef's hand, commending him for going to all the trouble, advising him he shouldn't have. She was right about the latter.

"I hope you like tuna fish sandwiches," he blurted out with no shame or embarrassment, clearly out of touch with reality.

"Why, yes. We love tuna fish, don't we Dorothy?"

"Wonderful. I thought you would. Especially when I saw this magnificent specimen." He went on to describe how he'd gone down to the fish market at dawn, poking and slapping a dozen different fish before deciding on the nice fat one he brought back to poach for these sandwiches.

I felt foolish for thinking any chef in his right mind would present Julia Child with a Star Kist chicken of the sea. Meanwhile Julia never flinched. She'd already dived right in, unperturbed about whether her sandwich had begun with a can opener or a court bouillon. (I remembered M.F.K. Fisher telling me, in her unique mélange of praise and condemnation, "Julia will eat anything.")

Over lunch, whenever I started to discuss the day's program, the tuna kept getting in the way.

"Isn't this just marvelous?" This a reference to the way the chef—"such a nice young man"—had cloaked the sweet chunks of fish with a creamy aioli that was "marvelously tart" and studded with chopped fennel instead of "ordinary old celery." As for the sourdough, fire and smoke trapped in its crusty ridges and curves, he must have taken the loaves directly off the baking stones: that was the consensus. A lull between sandwich and dessert gave me my chance.

"Is there anything in particular you want me to say out there?"

No, she was sure whatever I said would be fine.

I felt surprisingly at ease myself about the day's event, except for a disconcerting incident with the Macy's PR person, who had just whispered an infuriating instruction that Julia didn't know about. Whenever I interviewed Julia for an article, she always made it seem like we were friends, chatting. On a publicity tour for her previous book, *Julia Child and More Company*, she'd come to San Francisco to do a cooking demonstration and book signing, also at Macy's. I joined the welcoming committee at seven in the morning at her hotel, the Huntington on Nob Hill. With an amused grin, she watched the parade of sleepy-eyed but fit-looking businessmen emerge from the elevator in shorts, look at her sheepishly—even MBA's recognize Julia Child—and trot across the street for their morning jog. At the store, Julia and her entourage had been led down an alley and into some sort of service-entrance back door, presided over by a neckless security guard who eyed Julia suspiciously.

"Who is that woman?" he asked, his eyes following her every move. I was tempted to answer, "Why, that's the Lone Ranger," but I wasn't sure he'd see the humor in it, considering the hour.

One of Julia's friends and assistants, Rosemary Manell, had already started pulling rabbits and onions out of grocery bags, assisted by Pam Henstell from Knopf, the book's publisher. After taking a few pictures for my article, I offered to help, truly honored when Julia handed me a head of garlic and asked me to mince it finely. Determined to do an impeccable job, I carefully pried out two or three cloves. I rubbed them between my fingers in a massage-like motion, trying to coax off the papery covering. Instead of slipping off smoothly like a satin robe, it just crinkled and crumbled. What did come off glued itself onto my fingers; the rest of it didn't budge. Using my fingernails, I scraped and clawed around the stubborn little cloves to no avail. Still attempting to appear unruffled and competent, I reached for a nearby paring knife and began carving the surface of the clove, finally whittling it down to the size of an olive pit. This I cut into three or four slices on the bias, not unimpressed with my own handiwork. I became aware that Julia was standing perfectly still, watching my every move. Play your cards right, Julia, I was thinking of saying, and I shall reveal my secrets of garlic sculpting.

"Jeannette?" she called out as if it were a question. "What are you

doing?" There was a suggestion in her tone of voice that there was a right way to mince a garlic and this wasn't it by an order of magnitude. I could protest that the method had definitely not been included in Simone Beck's course at L'Ecole des Trois Gourmands, but this wasn't the time or the place.

Shaking her head as if in disbelief, she grabbed another clove and slammed down on it with the flat side of a giant saber, smashing it to a pulp. Then she worked the blade over it until it was practically liquid. As for the papery stuff, it lay on the chopping block in tatters.

"Thanks," I said, gathering up the remaining cloves. "Is there anything else I can help you with?"

She just laughed, unfazed by the crescendo of crowd-gathering sounds just outside the auditorium. Someone was adjusting the overhead mirrors so that those in the back could see her sautéing mushrooms and green onions and the garlic that Rosemary had kindly rescued me from. Once the doors were opened—the floodgates might be a more accurate term—people swarmed in. Most were women, all ages and descriptions, all with the same look of awe on their faces. As Julia's first squawky words trilled their way across the reverently silent throng, the group complexion softened into smiles, then grins and wide, throaty laughs. They were eating out of the palm of her hand and they weren't even eating.

After the demo, she signed about a million books and then she wanted to visit the cookware department. As we stepped into the elevator, a few people recognized her instantly. Hardly able to contain their excitement, they poked their friends or whoever was closest, rolling their eyes in Julia's direction, mouthing their message: "That's Julia Child." When the elevator opened, Julia noticed an in-store post office, walked over and stood in line. Her height alone made her a presence, so it wasn't long before the person in front of her turned his head discreetly to take the measure of whatever was looming over him. He immediately began to babble.

"Oh, it's you. Oh my goodness. Julia Child. Please," he said, stepping aside with a bit of a flourish, begging her to go ahead. Seconds later, all the others became aware of the stir and then each of them in turn stepped aside in a kind of domino effect. She would have none of it.

"No. I'm in no hurry. Absolutely not," she protested, directing everyone back into line.

A few weeks after this event, she wrote me a postcard: "It was fun being with you that day, and I hope we can renew the experience with or without garlic!"

That wasn't the only time I'd seen Julia since meeting her at Simca's in 1978. I enjoyed writing about her gastrobatics, her jolly nature and her contagious humor. She was eminently quotable: "If cooking is evanescent, well, so is the ballet"; men were often better cooks because they have a "what the hell attitude." And her advice to cooks, perhaps even more relevant to writers: "Above all, have a good time" she counseled, but "keep your knives sharp."

I'd written an article about her appearance at a benefit for The Children's Garden in San Francisco's Palace of Fine Arts; I'd reported on the evening she and René Verdon cooked dinner at his San Francisco restaurant, Le Trianon, as a benefit for KQED, the public television station. I'd even interviewed her about her favorite San Francisco restaurants: "…once we went to Mike's Chinese Cuisine on the advice of Jack Shelton. I think it was over on Geary. We thought it was extremely good." She also mentioned, in passing, Campton Place, Le Trianon, L'Etoile, and Masa's, which "we found very ethereal."

For me, Julia embodied and resolved the enigma concerning women and food. She did so-called women's work and she liked it. Not only that but she derived success and fame from it, maybe even fortune. She'd harnessed her interest in food into a viable career if not a full-fledged mythology, and at an age when most women, and especially most men, aren't venturing into a new and extraordinarily public territory. She was almost fifty when *Mastering* was published, fifty-one when she first appeared on TV as the French Chef.

These accomplishments had seemed the perfect subject for an article for *Ms Magazine*. Aware that there was a certain undeniable irony about *Ms Magazine* honoring a woman's achievements in the field of cookery, I was confident the editor would see this as an opportunity to say that true liberation means a woman can pursue any field she chooses, even cooking!

The editors didn't see it that way. "Very nice but not particularly

feminist" came the hand-scribbled verdict clipped to my returned manuscript. I was embarrassed by the *Ms* rejection because, like so many women who greeted the very first issue, in 1971, with a sense of triumph and who had subscribed instantaneously, I considered the magazine my own. It spoke for me. It ranted and raved for me. It was strong enough and smart enough to counter all the demeaning and belittling and devaluing that went on in *Playboy* and *Esquire* and *Penthouse* put together. I couldn't explain the editors' appraisal so I decided to send it to Julia, along with a copy of my review of her book, *Julia Child and More Company*, which had just been published in the *San Francisco Bay Guardian*. She wrote back that she "loved both those articles.... I thought the one rejected by *Ms* was especially good and also very amusing. You certainly write well!"

And so, as Julia, Dorothy, and I sat there eating our tuna fish sandwiches, I was glad Macy's had asked me to interview her that day. The event celebrated her newest venture, a series of videotapes in which she explained and demonstrated basic cooking techniques, garlic mincing undoubtedly among them.

Nestled beside me was my own newest venture, a copy of *The California American Cookbook*, just published by Simon & Schuster. I had already autographed this copy to Julia Child and had been waiting for the auspicious moment. And then, a few moments before, there had been this nasty business with the rules-are-rules, scowl-infested Macy's PR person. This was the same Macy's PR person who had promised that if I did this interview, it would be worth more than mere money, a commodity she insisted was in short supply at Macy's. I wasn't too savvy in the ways of book promotion, but I assumed one could do worse than to introduce one's new book in front of the Child-revering masses within buying distance of Macy's bookstore. Just a few sentences, I'd been told, but enough to give the audience the flavor of the book. This moment in the sun would, she whined apologetically, more than make up for the paltry sum Macy's was paying for doing the interview and might even result in the book's first avalanche of sales. Visions of cookbook-ravenous women stampeding down the aisles to lay claim to a copy of *The California-American Cookbook* had just stopped dancing in my head.

"You are not to mention your book today," the Macy's PR person commanded in scolding tones, her brow a landscape of petrified frowns. "This event is about Julia Child's new videotapes and we don't want anything to detract from that." When I protested that this was a breach of our agreement, she turned on her heel with a little smirk as if to say if I was dumb enough to trust Macy's, I had only myself to blame. I was wondering if any jury would convict me if I murdered her there on the spot when I noticed the gleam in Julia's eyes, her whole face in bloom. She was looking at my book.

"How beautiful!" she said, flipping through the pages. "You must be thrilled."

"Oh, I, well, yes actually, and we, my co-author and I, we autographed this copy to you."

"Thank you so much. Wonderful. Simon & Schuster, very good people. Tell me, how did you come to do the book?" I explained that I had not been enthusiastic when my agent first mentioned my writing a cookbook because, although I embraced any opportunity to write about food, I didn't consider myself a cook who could whip up 200 original recipes. Julia nodded an all-too-understanding nod, possibly recalling my garlic butchery of a few years before. I kept scanning her face for signs of incipient yawning as I related probably too many details about developing a book about California's historical romance with food. As for the recipes, I chanced upon an article in the *New York Times* about a woman named Louise Fiszer who taught cooking in her own little cooking school/cookware shop in Menlo Park, about twenty minutes from me. I was captivated by the style and spirit of her recipes and the way they seemed to convey the kind of California message I wanted to write about.

I called Louise at her shop and she invited me over. We got along instantly, intrigued by the many parallels in our lives. We both came from Brooklyn, only miles from each other; we were two weeks apart in age; we both had recently bought a newfangled contraption called a computer that neither of us knew how to use.

Once we started to develop the book proposal, we worked beautifully together, dividing tasks, respecting each other's opinions, resolving differences, of which there were incredibly few, if any, with no hurt feelings or wounded egos. We even learned, because it was

With Louise Fiszer

essential to our project, how to work on the computer using the brain-straining word processing system called Word Star. Our agent received wildly enthusiastic responses to our proposal from several New York publishers—or more correctly put, he masterminded those responses by creating a bit of a frenzy and cultivating a bidding war mentality. To seal the deal, Simon & Schuster offered us a contract for $50,000. Not bad for 1983 and two unknown authors of their first book.

Strictly speaking, it was my third book proposal, the first being *The Last Minute Epicure* with Frances Mayes. The second was a cookbook concept I developed with—or in spite of—Judy Rodgers, a young cook at the Union Hotel in the small Northern California town of Benicia. She insisted she had no time to work on the book proposal per se, so she gave me a sheaf of her menus which I used to create the table of contents. After I finished the proposal and began to receive enthusiastic responses from publishers, Judy decided she didn't want to do the book after all. It was too American, too Californian. She was afraid that a book about contemporary cooking would typecast her, that she'd lose credibility as a French chef before

she even had any. I was crushed at the time although I realized that if the book proceeded as it had to date, it would be a one-sided co-authorship.

"And so," Julia asked, bringing me out of this annoyingly vivid reverie, "is your collaboration with Louise a good one?"

"Yes. The best," is all I said, with a smile prompted by recalling my friend Frances's summing up of the situation: "The fact that it didn't work out with JR almost makes you believe in God."

"Well, this is a beautiful book indeed. You and Louise should be very proud."

A few minutes later, we walked onto Macy's makeshift stage greeted by the thunderous applause of a crowd that packed the air-plane-hangar-sized room. I gave my little speech about Julia's impact on all of our lives and her venture into the new world of videotaped cooking lessons. When I passed the microphone to Julia, the walls seemed to be caving in from the room-rattling temblors of applause.

Holding up a copy of one of the videotapes, she waved to the cheering masses. The decibel level decrescendoed only when she started to speak. That's when I realized it wasn't a videotape she had in her hand: it was my book.

"Come on. Don't be shy. Show everyone this beautiful new book. This is Jeannette's new book, *The California American Cookbook*," she called out, reading the cover to the audience. "It's full of absolutely marvelous recipes."

More clapping from the obedient Child-adorers, a bit subdued and possibly even confused (Jeannette? Who's Jeannette?), but an ovation nonetheless. On stage left, Macy's PR scowler was gnashing her teeth. I bestowed upon her one of my sweetest smiles.

Before Julia finished her talk, the audience was already furiously buying sets of her videotapes and mushrooming toward the stage to have her autograph them. I had to act fast. I pulled a big white apron out of a shopping bag and laid it before her.

"Would you please sign this to my four-year-old daughter, Natasha?"

"Of course," she said, scrawling all across the front in bright blue ink "To Natasha. Bon Appétit. Julia Child."

"Does she like to cook?" she asked, intently dotting all three i's.

It was a logical question, considering the circumstances. It didn't seem to require deep philosophical reflection. But it made me wonder if I should be giving my daughter an apron after all, if this was one of those things that were "very nice but not particularly feminist." Would I be reinforcing the traditional girlie messages, blurring for Natasha the distinctions I'd tried to make clear for myself? Ideally I didn't want my daughter even to know that there was a time when women couldn't do whatever they wanted; and even though that time was still very much with us at her four-year mark in 1985, there were indications that her generation might feel its constrictions less strongly. Their talents and potential might flourish, if not unhampered at least less encumbered. That is, if they weren't confused by gifts of aprons and other such symbol-laden trinkets.

As I tucked the apron back into the bag, I took a last serious look at it. For a second I was startled. How could I have missed something so obvious? Of course this apron would make a fine present for my daughter, for anybody's daughter. Its message was not "Stand by the stove" or "This is your life" or "Anatomy is destiny." Far from it. Its message was "Bon Appétit."

Tuna Fish Sandwich for Julia

"First catch your hare" is the age-old culinary advice meaning, basically, begin at the beginning. And so it is when making a tuna sandwich for Julia. After catching the fish—or buying it at the market if you're so inclined—poach it, mix it with the same stuff you would if you'd opened a can, substituting fennel for celery. Serve it on sourdough. It's almost as good as the real thing.

The *Times*

I WAS MAKING NATASHA A PEANUT BUTTER SANDWICH when the phone rang. As the woman gave her name and said something about the *New York Times*, I steeled myself for the sales pitch. Actually it would be convenient to subscribe, I was thinking, a lot easier than driving to Ed's Smoke Shop in the next town, the nearest place in our vicinity to buy the *Times*. Belmont must be coming up in the world if the *New York Times* was calling to offer us home delivery.

"You must be surprised to have the *Times* calling you out of the blue," the woman said, probably resorting to one of those sales tactics to make the potential customer interact. My lack of response wasn't due so much to sales resistance as to the fact that I was licking a glob of peanut butter off my thumb, wondering how it moseyed over there. I was also watching Natasha and her friend, Beth, jumping up and down on the old couch cushions, precariously close to our one good lamp.

"Yes I am, actually," I replied, eager to get on with it.

"I really love your work," she remarked enigmatically, "and I was wondering if you could do some writing for the *Times*."

Writing for the *Times*? This was a new twist on selling subscriptions. Who was this crazy lady anyway?

"As the Food Editor, I'd like to talk to you about it if you're interested."

Her name was Margot Slade, she reiterated, obviously aware I'd missed it at first mention. She found my work funny and spirited, just the thing to spark up the Wednesday *New York Times* food section.

I couldn't agree with you more, I wanted to say; it's a wonder the *New York Times* has been able to get along all these years without the zing and wit of my words. I wanted to come up with some light-hearted rejoinder to impress upon her that that she'd made a wise move and that she hadn't gotten the wrong number. Sardonic witticisms and wry *bon mots* ricocheted around my brain but what came out was "um, wow, yeah."

Margot Slade was laughing.

"I know it isn't every day you pick up the phone to find the *New York Times* asking if you'd like to write articles. Maybe you'd like a few days to think about it."

"Aha, so you've done this before, Margot," I said, feeling free to join the laughter. I told her I was originally from Brooklyn, as if this would put us on equal footing and give me some added validation. I certainly wasn't going to mention that I now lived in a place where my nearest proximity to the *New York Times* was Ed's Smoke Shop. As we continued talking, we kept wandering into those little kindred spirit zones that can jump-start relationships, make you feel more comfortable sooner that you know you should. She would call back in a few days, she assured me in cheery tones; meanwhile I should think about "all this." Somehow I'd managed not to drop the phone.

Only after I reviewed every word and inflection of this conversation with Peter did I realize the problem. It had all sounded too good to be true; I might have known.

By the time she called back, we both realized our mutual misunderstanding. She'd been talking about a job in New York and I'd wanted her to mean I could write from my home in California. Hoping that she might still consider that an option, I suggested that California was not exactly off the beaten path when it came to food-related activities. In fact, there were those who considered California the epicenter of all the excitement in the food world. Not that California could compare to New York, I hastened to add with an infusion of amiable sarcasm of which Margot, fortunately, was a fan. There was plenty to write about, and I was right in the midst if it. She was listening, she said finally; I should come up with some ideas for feature articles and get back to her.

And so it began.

My first article was about a Sichuan Food Festival centered around a twenty-two-course banquet sponsored by San Francisco's Chinese Culture Center. I spent days doing research, trying to understand where each ingredient, each morsel, every implement and color and gesture fit into the mosaic of traditions that were themselves mysteries to me. I interviewed the organizers of the festival, members of the Chinese Culture Center, art commissioners, chefs, historians, rice painters. And I ate every crumb of the twenty-two-course meal from tree fungus wontons and Pandas at Play to black hair mushrooms. I wrote the piece and rewrote the piece a million times, sending it into the *New York Times* only when I was confident of every jot and tittle, and more or less content with the rhythm and style of the writing.

When Margot called to say that she loved it, I felt each sinew in my body release one by one. I had just about melted into the chair when she added something about a few questions she had and would I be around for a while. When you hand in your finished article to the *New York Times*, I soon learned, that is the beginning. Margot had some questions, but not nearly as many as a couple of sub-editors and nowhere near the number of nit-picking detail-clarifiers required by the copy editor. None of these people seemed to think I had anything to do but answer the phone and supply Chinese minutiae on demand. No dynasty was too ancient, no sumptuary stricture too esoteric that I shouldn't have it in my notes.

On the day the article was published—Wednesday, April 1, 1987—the drive over to Ed's Smoke Shop seemed both too slow and too fast. What if it wasn't in after all? What if stuffing all those details they kept asking for turned the article into a fact-riddled, joyless encyclopedia entry? What if they forgot to put my name on it?

It was okay. Despite the hours of editorial cross-examination, the published article read much as I'd submitted it with little tinkering by those omnipresent masters of trivial pursuit. That evening Peter and I went to a gathering of historians and various other academics for most of whom writing about food had no validity. I never had to worry at those occasions about being pestered to death about what I

was doing. What they were doing was always so much more substantial and fascinating to them, from their latest theses to the high points of their oral exams, no matter how many decades may have passed under the proverbial bridge.

An announcement being made in front of the fireplace under a raised glass of wine prompted the usual reverent hush, as we waited to hear whose new research was about to demolish whose now-outmoded paradigm. Something about an article and a byline and the *New York Times*. And then everyone's glass nodded in my direction.

A few days later it was over. Forever. I was sure of it the minute the woman on the phone identified herself as Fran, an assistant to Margot in the *Times* food section. They'd received a letter questioning my article.

"Shall I read it to you?"

"Please." I felt sick.

As she started to read, I realized what it was about and who it was from. Bruce Cost, a San Francisco chef who fancied himself an expert of all things Asian and was writing a book on the subject, had already called me the previous day with some quibbles. I could tell he was just upset that I hadn't consulted him and that consequently his name, which he was trying to link inextricably with the Asian market, did not appear in the article. Who knows how many sales of the book he hadn't yet written were lost when his name wasn't mentioned.

"Thanks," I said weakly when Fran finished reading; "he called me about that yesterday. I'm not sure what to do."

I thought I was going to cry. My first article in the *New York Times*, attacked, discredited. I was too humiliated to speak.

"You mean he called you about this?"

"Yes," I groaned.

"You already answered him about this?"

"Yes. Yesterday I think it was."

"Well then, what's he bothering us again for if you've already taken care of it? Do you want me to toss this or send it on to you?"

I couldn't believe it. It was as if the sun just came out.

"Why don't you send it to me, Fran? I'll take care of it." No sense having those nasty words hanging around their office where someone might see them when I could have them safely at home, burning in effigy.

The incident, as I soon learned after writing several more articles for the *Times*, was symbolic of the respect and trust and confidence the newspaper accorded its writers. Yes, they put you through hell to make sure everything was right and documented, untainted by vested interests, true to the language even in metaphor. But your words and your work were honored, sacred in a way. If you wanted to call in your story in the middle of the night, read it word by word into the phone, someone would be there to transcribe it. Of course you could mail it in or, a few years later, fax, modem or email it, but if you wanted to scribble your story on napkins or on the back of matchbooks, you would never confront the ridiculing, deprecating, rule-quoting dismissiveness of less self-confident publications. It may have been based on hubris—if they gave you the assignment, they knew it would be fit to print or they wouldn't have given it to you in the first place—but it meant you'd do anything for them.

As always, I learned by doing. For my next *Times* article, when I finished researching every book on vanilla—an orchid, who knew?—I searched out articles and recent research. Only then did I discover that vanilla was being produced genetically by a little company in San Carlos—just a few storefronts away from Ed's Smoke Shop. For my piece about capers, I steeped myself in the lore about crannied walls and the caper-rich food lore of the Yugoslavian countryside; but exhaustive investigation of the kind you do for the *Times* led to a woman who was growing the small, lovely buds in Gilroy, about two hours south of San Francisco, the heart of garlic country. Her appreciative customers included such prime movers of California cuisine as Michael Wild at The Bay Wolf and Alice Waters at Chez Panisse.

Whatever the subject of the article, I almost always received letters expanding on some point or offering more information: Did I know that Arabs eschew the caper bud in favor of the fruit which follows? Israel's caper buds flourish in the same rocky ambience as in

Yugoslavia? A Greek store on 9th Avenue in New York has capers cured in salt which are much superior to the jarred ones? How could I be such a tease as to extol vanilla and not provide a list of sources?

But one response got the attention of the *Times* food section and their security personnel, as well as the FBI.

"I have something very weird to tell you about," Margot began, describing the scene before her. A letter addressed to me with the return address of the federal penitentiary at Marion, Illinois was being carted off gingerly by uniformed armed guards. Someone on the *Times* staff had recognized the name of the sender, one Butner Janish, as a former professor convicted of sending poisoned chocolates to the judge who had sentenced him for producing an assortment of illegal substances in his university laboratory. Apparently the judge's wife opened the chocolates with insalubrious consequences. At any rate, the consensus at the *Times* was that opening letters from this guy was not a good idea, so off went my fan mail to a padded cell to be blown up or detoxified or whatever they were going to do with it.

Irony played a major role in my new career. The food world was definitely a dress-up, neatness-counts arena. Everybody, especially the women food writers, seemed to be supported by someone, free to go anywhere, conversant about spas, masseuses, and manicurists throughout the known world. On any given evening, I might accompany visiting *Times* writers Bryan Miller or Molly O'Neill to review one of San Francisco's haute restaurants. On other evenings, after first negotiating a baby sitter, Peter and I would join our friends, Leonard and Rik, in San Francisco at what they called the Food Halls, also known as the garbage cans behind their upscale neighborhood grocery store. The quality of the store's discards was exquisite, plus they carried hard-to-find items like Belgian endive and chanterelles, generally unavailable anywhere in Belmont.

On the afternoon I was driving to St. Helena for the exclusive, by-invitation-only, groundbreaking ceremonies of Opus One vineyards—the wineworld-shattering joint venture of the American Mondavi and French Rothschild wine empires—I'd spent the morning picking through Safeway's back-table zucchini. Because of a scheduled balloon ride over the vineyards-to-be, guests were

instructed to dress casually, which made a fortunate fit with my sartorial shortcomings. After Robert Mondavi and the Baroness de Rothschild lifted up one shovelful of dirt each, to the explosive applause and camera-clicking of reporters and television news crews and whoever else we were, dinner was announced. We were escorted into a massive tent, the likes of which I hadn't seen since Craig Claiborne's birthday party. Silver and crystal glittered from the lavishly appointed tables and a bevy of tuxedoed waiters bearing flutes of champagne miraculously appeared. I was seated, undoubtedly because of my magnetic charm and not because I wrote for the *New York Times*, right smack next to the Baroness de Rothschild. She seemed to sense that bantering about relative Bordeaux vintages wouldn't be much of a two-sided conversation nor did she ask, for obvious reasons, who did my nails. What she did say shocked me into temporary incoherence:

"I like your earrings."

"I…oh…you…these…ah…*merci*" was the gist of my bilingual repartee.

"Actually I got them in Paris," I added, finally. Despite the smile that bloomed on her face at this mention of her native land, I immediately regretted the admission. Now what? Do I tell her where? Oh well, what the hell.

"I got them at the *Marché aux puces.*"

She had no trouble translating the phrase into "flea market," but she just kept right on smiling.

"Aux puces," I repeated, struck by the pun and not knowing to leave well enough alone. "Rhymes with Opus."

"Opus. Aux puces. But, of course," she said, laughing and obviously enjoying the association of fleas with the opulence and regal trappings of the newly-forged, Franco-American wine aristocracy. One got the impression that the name Opus One had not been her idea. I wasn't sure whether this flea association was something she couldn't wait to bring up at the next board meeting, or if it would just remain "our little joke." Nevertheless she was by far the most down-to-earth baroness I'd ever met.

One day I sent Margot one of the quirky pieces I'd written that

had been universally rejected and that I'd put on "hold" in a manila folder "until the day when someone would appreciate it," I'd told myself. There was more than one unappreciated article in that folder; I sent her my observations on how you could read someone's character by the kind of dessert they served you.

"Have you got any more of these quirky pieces?" Margot asked when she called to say she would run the "desserts for psychoanalysis." I sent her one about the impossible-to-bake Italian breads in Carole Field's book and one with some ruminations about M.F.K. Fisher on the occasion of her most recent birthday. For other underappreciated pieces in my rapidly emptying manila folder, she directed me to the travel section, the Sunday magazine and the Book Review.

The editor on one of my Book Review articles was Anatole Broyard, a man whose name, to me, had about it a smattering of legend. When he called up with some questions about my review of the newly published edition of M.F.K. Fisher's *Physiology of Taste*, my six-year-old daughter, Natasha, answered the phone. She was chatting several minutes before announcing, "It's for you, Mommy." When I discovered who it was, I couldn't wait to ask her what she and Anatole Broyard were talking about for so long.

Meanwhile, I gritted my teeth in preparation for a major intimidation experience. To my surprise he seemed to be talking about lunch.

"I like this way of having lunch with writers," he confided while I, through the phone wires, could hear the unmistakable sound of Saran Wrap being sworn at.

"This stuff," he muttered. "I have so much trouble with it. At home, whenever I try to tear off a piece of Saran Wrap, my wife looks at me with ill-disguised contempt. You know, Virginia Woolf once said 'Men are so sterile.' Do you think she was talking about Saran Wrap?"

I told him yes, I thought so, an earlier version no doubt.

The plastic crinkling subsided and we got down to the business at hand, which was "to go over a few things," as he put it, "none of them very important," he added graciously.

Peter Carroll

With M.F.K. Fisher

"Now here on page three, you've committed in my estimation one of the least forgivable transgressions," he said, "using an adverb as an adjective."

Where was page three? Why couldn't I find page three. How could I have written a whole piece without a page three?

"Maybe it's not page three," he said, admitting he was then in the scroll-down mode on his word processor. "I can't tell on this computer screen. There are no page numbers. Anyway it's where you call someone the 'then-editor' of *Gourmet*. Now, you're too good a writer to use this kind of construction."

That's the way he went about it. Where I was good, he would be so delighted the phone wires seemed to jiggle; and where I was bad, I was too good to be bad. He was masterful.

We went back to discussing lunch for a while—his bean and sausage dish from the *Times* cafeteria: "It had not even one slice of

sausage in it, thank God. It was bad enough as it was." Somehow this led to an instance of hyperbole in my copy.

"You don't need all these words to get your point across. It's almost like 'painting the lily.' Did you know it was 'paint the lily' that Shakespeare said, and not 'gild?'"

I never knew that, I confessed. He didn't allow me to feel very humbled before he moved on to extolling my grammatical erudition.

"You use the terms ablative case and the nominative of direct address in referring to Latin translations. Well, we just don't have anybody around here anymore who can verify such grammatical references. The experts in this sort of thing died years ago.

"You may not believe it," he added with a sigh, "but out there are hundreds of old ladies with quill pens in hand just waiting to write us letters about misuse of the subjunctive mood. You understand."

Oh, yes, I told him, remembering a little story I thought he'd like.

"I once had a friend named Doris, a true Hispanophile. She used to say that Spain is a land in which the subjunctive is relevant."

He laughed as if he meant it, as if we'd just walked from the study into the living room.

"There aren't too many people I can tell that to anymore. Nobody gets it."

He knew that, of course. That's why we were in the living room and why he was telling me about something that once happened to him in the south of France. There in some misty long ago, he had a bean dish, a famous one, though he couldn't remember what it was called.

"Cassoulet?" I ventured.

"Yes, that's it. Cassoulet. Well, the people we were visiting at the time were so excited about making the dish, we must have searched through several small towns for endless numbers of ingredients. Then our hostess began cooking and adding things and stirring and testing. You'd think she was composing the Goldberg Variations. She was at it for days. When it was finally done, it was delicious, full of duck and sausages. But we had to eat it for days before it was gone."

We wandered back into the manuscript, in and out; he was like a gardener, weeding. He had a few cuts to suggest, but they were so minor, he assured me, "you won't even feel them."

He never seemed to be telling me anything. We just chatted, and the thing, my article, got a little better, more focused, as we went along. When we finished, he thanked me.

"You will go down in the annals of the *New York Times* Book Review as one of the most patient writers I've ever worked with," he said. "It's been a pleasure. Thank you very much."

"It's been wonderful working with you," I said, a bit sorry that it was over. "Thank you so much for your help."

"You didn't need any help," he reassured me. "We're just quibbling here."

As soon as I hung up, I asked Natasha what he'd said to her. She answered with the absent-minded, matter-of-factness of six-year-olds.

"He said 'your mommy has written a very nice story.'"

I walked into the living room and searched around for my old album of the Goldberg Variations. It was a little scratchy, but I played it anyway, for the rest of the afternoon.

Thanks to one of Margot Slade's brainstorms called "The Nations Table," I seemed to be writing for the *Times* during my every waking moment. "The Nation's Table" ran every other week in the Wednesday food section and consisted of two or three short pieces about food events, products, customs or characters from some part of the country NOT in New York. It was the *New York Times*'s way of showing that they really did know there was food west of the Hudson; Margot was correct in her prediction that it would bolster interest in and readership of her section.

I had written, at Margot Slade's request, the prototype articles for "The Nation's Table," the ones she presented to management as examples of what she was proposing. Once the feature was approved, she asked me to be a regular contributor, which meant a regular stipend and my byline in the *Times* once or twice a month. My little spiral notebook was soon bulging with names of mom and pop

cannoli makers in San Mateo, food-art galleries in Tiburon, honey producers in San Pedro. I tried to avoid writing about anything promulgated by big PR companies or launched via splashy promotional campaigns and press releases. That would have been too easy. My way took time, truth being I didn't know any better. But it felt good to be able to tell people about the Gray Panthers program for showing seniors how to cook just about anything on a hot plate, and about a vocational training program in Sacramento based on teaching young people the economics of pizza-making, and about a couple who gathered and dried seaweed for a living. I was able to veer into near-food events like The Imitation Hemingway Contest sponsored by Harry's Bar in San Francisco (an imitation of Harry's Bar and American Grill in Florence, itself an imitation of the original in Venice about which Hemingway wrote, "You can find everything on earth at Harry's. Except happiness.") As long as it happened in California, it was my story.

Occasionally I helped out with the California aspect of an article by a *Times* staff writer like Bryan Miller or Florence Fabricant. For a report she was doing on salmonella, Marion Burros asked me to find three local, brand-name turkeys and have them sent to her, express mail. As I drove to the mailing house, I had one of those epiphanies that people usually experience in more bucolic and transcendental situations than driving down El Camino Real with a trio of frozen turkeys.

A lot had happened since that day, a couple of decades before, when I'd felt the womanly role required me to cook that unbakeable bird. Now I could roast that turkey, and do a hell of a job of it, if I wanted to. Or I could write a story or whole book about it, if I wanted to. Or I could even ignore it. The choice was mine.

I guess that's all I really wanted.

Meanwhile I was working on the second and third of the seven books I was eventually to write, including a memoir/biography of M.F.K. Fisher; I was gathering notes and keeping journals on food stories that would someday, unbeknownst to my wildest dreams, become regularly published columns in *Travel Holiday, Country Home,*

the *San Francisco Chronicle.* For the latter, I developed a gossipy little column under the pseudonym Velveeta Bocagrande, a name devised to contrast with the elitism, self importance, and corporate hand-holding slowly but sadly creeping into the food world. Thanks to stints as restaurant critic for *Focus,* the *Chron* and various other publications, our daughter, Natasha, was growing up with a refrigerator often stocked with intriguing, wire-handled white boxes full of leftovers.

"What's in there?" Natasha would ask, her pretty little face beaming with anticipation.

"Venison," I'd have to confess. Or sometimes wild boar. It was never, as she always hoped, macaroni and cheese.